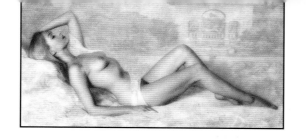

Photography
& Imaging
Yearbook
2002

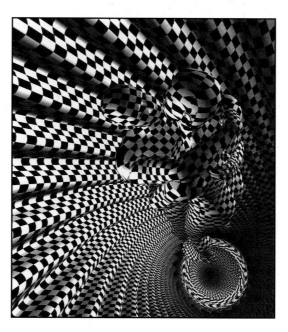

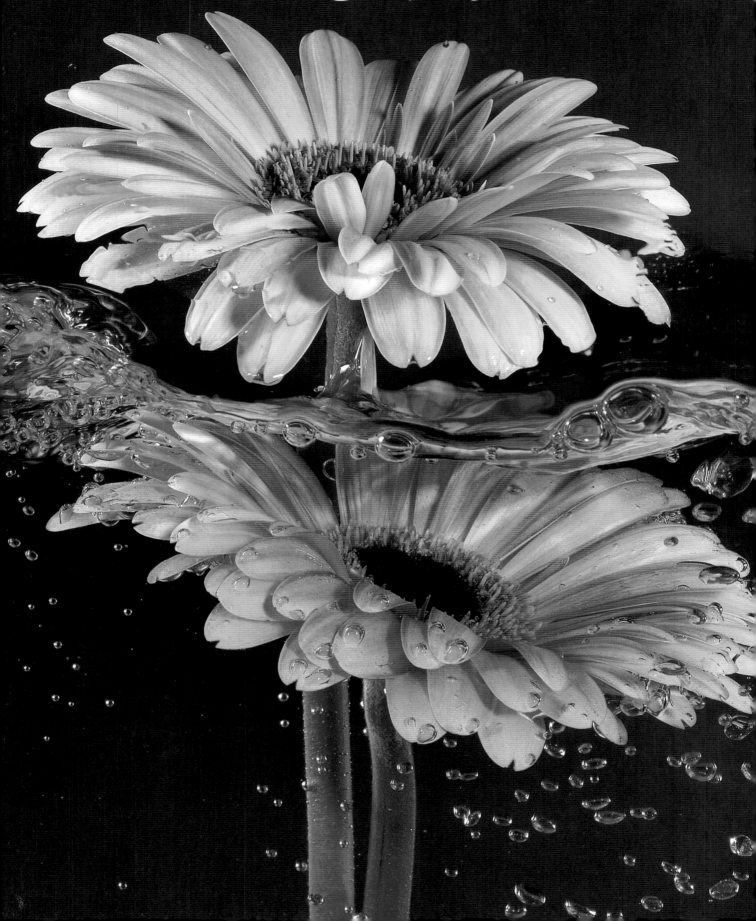

Photography & Imaging

Yearbook 2002

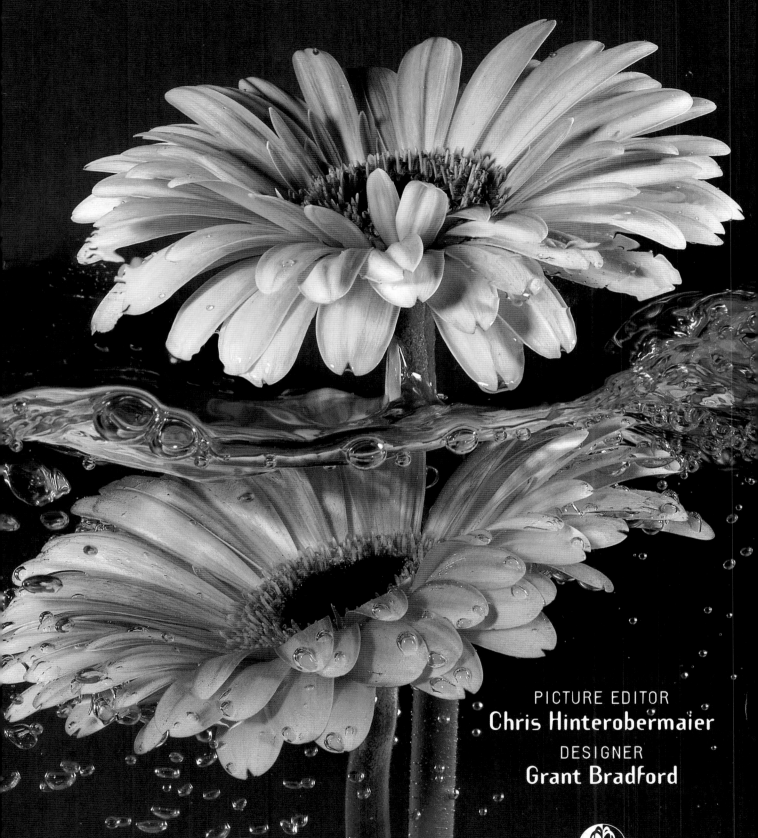

PICTURE EDITOR
Chris Hinterobermaier
DESIGNER
Grant Bradford

FOUNTAIN PRESS

Photography & Imaging Yearbook 2002

Published by
FOUNTAIN PRESS
NEWPRO UK LIMITED
Old Sawmills Road
Faringdon
Oxfordshire SN7 7DS

Picture Editor
CHRIS HINTEROBERMAIER

Designed by
GRANT BRADFORD
Design Consultants
Tunbridge Wells, Kent

Reproduction
NEW CENTURY COLOUR
Hong Kong

Printed by
SUPREME PUBLISHING
SERVICES

© Fountain Press
Newpro UK Ltd 2001
ISBN 0 86343 314 6

Title spread photograph
by Phil Callow ARPS

Contents

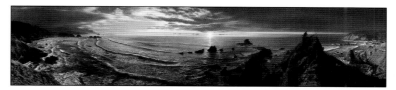
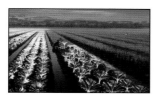

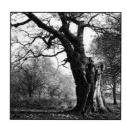

Introduction

The new millennium has brought with it enormous changes in virtually every aspect of photography. Certainly the continued growth and development of digital methods comes to mind but one should not overlook changes in the traditional areas as well. For example, every major camera manufacturer has released new SLR and range finder cameras in both 35mm and medium formats, many of which have the most sophisticated metering and focusing systems ever produced. The selection of new lenses has at least doubled with super fast high quality optics now available in many more focal lengths as well as zoom lenses with extraordinary ranges. There have also been new colour and black and white films whose quality and speed have set new standards.

Meanwhile, the digital camera, first introduced so arrogantly in 1985 with the pronouncement that "film is now dead," has finally begun to appear in functional, practical and affordable forms on both the consumer and professional levels. Britain's biggest consumer electronics retailer, Dixons, has for the first time seen digital cameras sales higher than conventional cameras. The home colour darkroom, once the preserve of a select few, is now widely available in the form of an inkjet printer costing about the price of a consumer SLR.

The distribution of photographic images has gone from occasionally including a few 'snaps' in a posted letter to the common practice of attaching digital images to e-mails as well as the posting of these pictures on home pages and photo-sharing Web sites. The result is the distribution of photographs to family and friends on an unprecedented scale. In short, we are now in a golden age of photography in which new and improved technologies are spreading the use of photography as never before. At the same time, the traditional methods of picture taking and picture making are still very much with us. There will probably be no other time when the representation of the traditional and the new will be so complete in their co-existence as they are at this moment in history.

Change, however, never occurs in a vacuum and critics of the new technologies have complained that such advances have caused photography to lose something important. In short, they say the old ways of making pictures are somehow more authentic than the new forms. In the decades closing the last millennium, their target was the 'automatic technologies' of auto/programmed metering and auto focus and now it is digital photography posing the question: "Is digital photography really photography?" Sadly, these critics have attributed too much importance to photography's methods while over looking one undeniable fact. That it is has always been the purposes of the photographer that has infused photography with its heart and soul and, indeed, its authenticity. In fact, the Yearbook is as much about why people become seriously involved in photography as it is about individual images. This is especially true of the portfolio section where a body of work can disclose how a photographer feels about a subject giving the rest of us the unique experience of seeing that subject through the eyes of another.

We have only to listen to the words used by this year's portfolio photographers to see how deep the personal commitment runs. Thus, you read of how one photographer has striven to recover the "lost realities" of the modern era by recording a primitive culture or how another uses photographic tools that have only recently become available to "visualize dreams." Others speak with reverence of the "spirit" and "magic" that radiates from their subjects explaining how they have struggled to convey these qualities through their photography. Each of these people feels very strongly about what they are doing and each is using their chosen tools (traditional or new) as the best means to bring their thoughts and feelings about a subject into some tangible and authentic representation. That has been and always will be the heart and soul of serious photography and the very reason for the existence of the Yearbook.

Joseph Meehan
Salisbury, Connecticut, USA
Senior Technical Editor, PhotoDistrict News
Former Editor of the Photography Yearbook

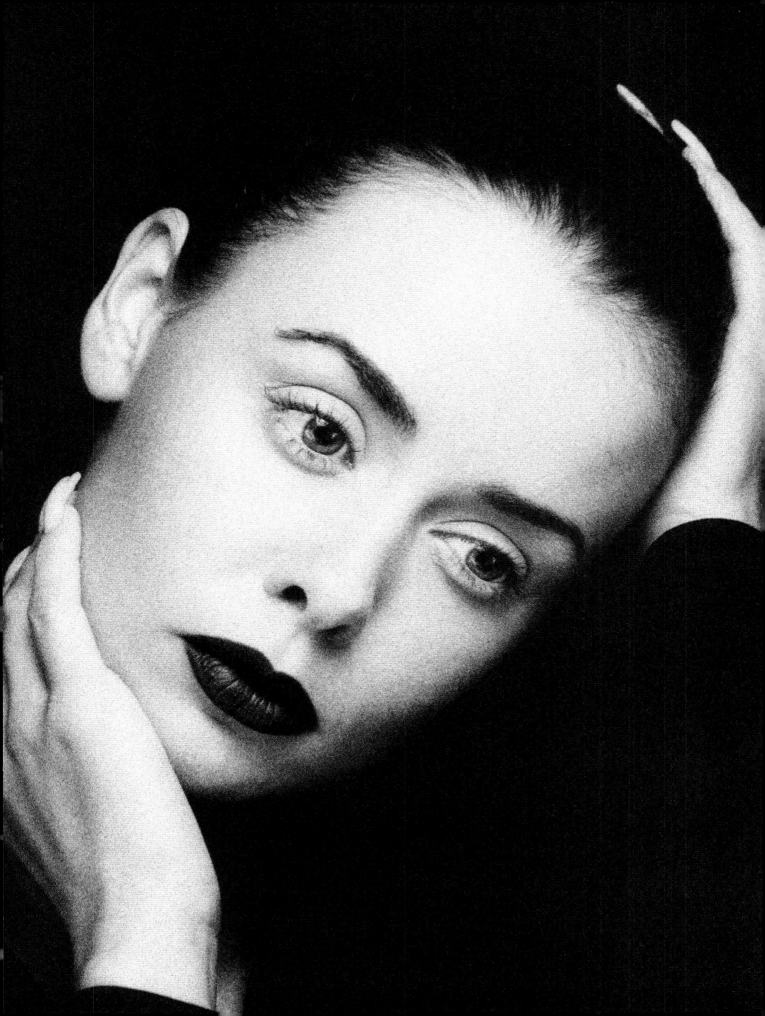

Dreamtime

Elena Martynyuk

Elena Martynyuk fell in love with photography when she was a child. Consequently today she works as a professional photographer specialising in portraits taken in her own studio in Odessa, a cultural and industrial centre on the Black Sea. *"Although I got a classic art education most of what I know about photographic art was not learned at college, but through the experience of thousands of hours in my darkroom, by continually giving all my blood and sweat to create better photography than the day before."*

"Despite my professional work, which also includes theatre and stage photography for Russian ballets I have a strong interest in artistic photography, most of it is personal non-commissioned, freelance work." People are Elena's favourite theme, either portrait or nudes. *"Men and women around me are my main source of artistic ideas, quite often people from the street as well as actors or ballet dancers from the theatres are my models"* she says. *"For me imperfect beauty makes a model qualified to act in front of my Hasselblad, but it is their expression and their personality, that give the full range of feelings, that motivate me to work."*

Careful preparation, individual styling of the chosen models and a clear idea of the final result is Elena's starting point. But taking the shot is only the beginning of an extended task to reach the final perfect image.

The darkroom is her creative headquarters, in a way Elena is an old-fashioned personality who loves to spend many hours manipulating her negatives, using neither computer or modern western quality paper. In Ukraine as in Russia monochrome photography is still an important area. Despite many professional colour labs existing nowadays, artistic photography is limited to the black & white media. *"I love to tone my pictures"* says Elena, *"it gives them a very personal touch of colour and reflects my personal romantic attitude."*

Looking back over hundreds of masterpieces, realised through *"spending 20 years in creative darkness"* as she describes her favourite working place and achieving tremendous international success, winning top awards all over the world. Elena Martynyuk now concentrates on personal exhibitions and the efficient marketing of her work. *"I see my future in the West, I would love to see my work presented in the USA and in the top European photo galleries."* No doubt she will achieve her dream.

To contact Elena Martynyuk e-mail to: elemar7@yahoo.com

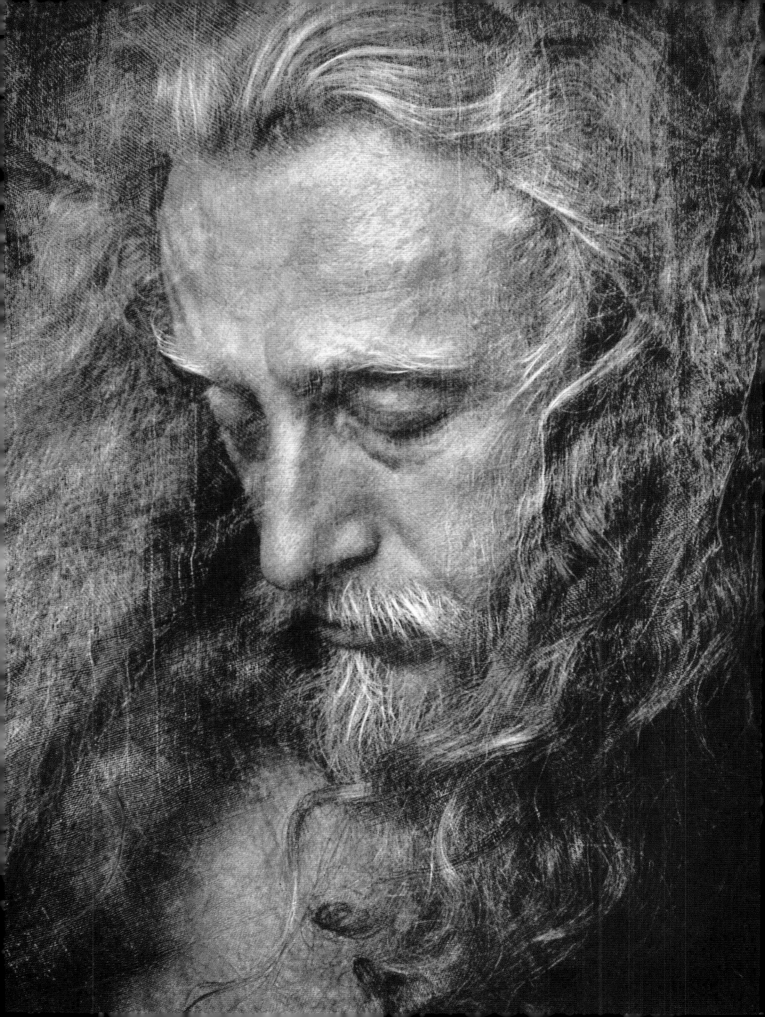

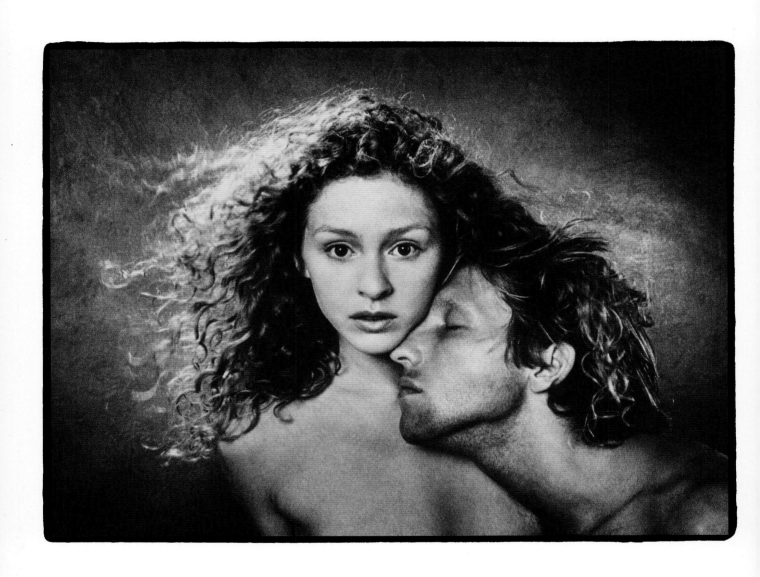

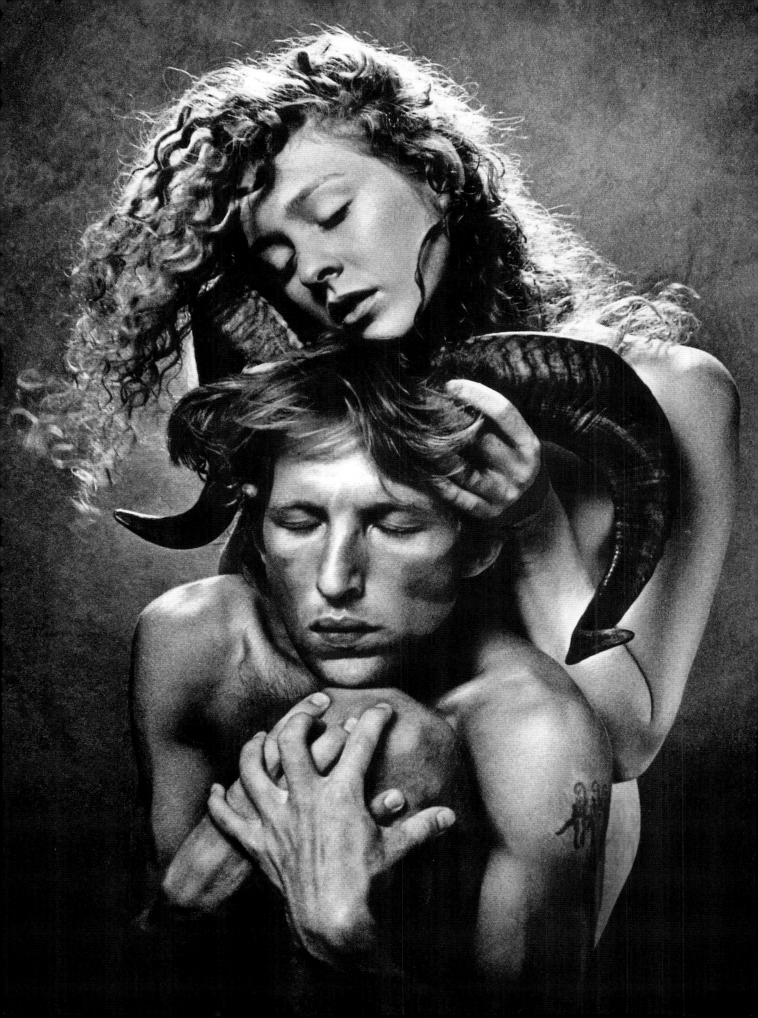

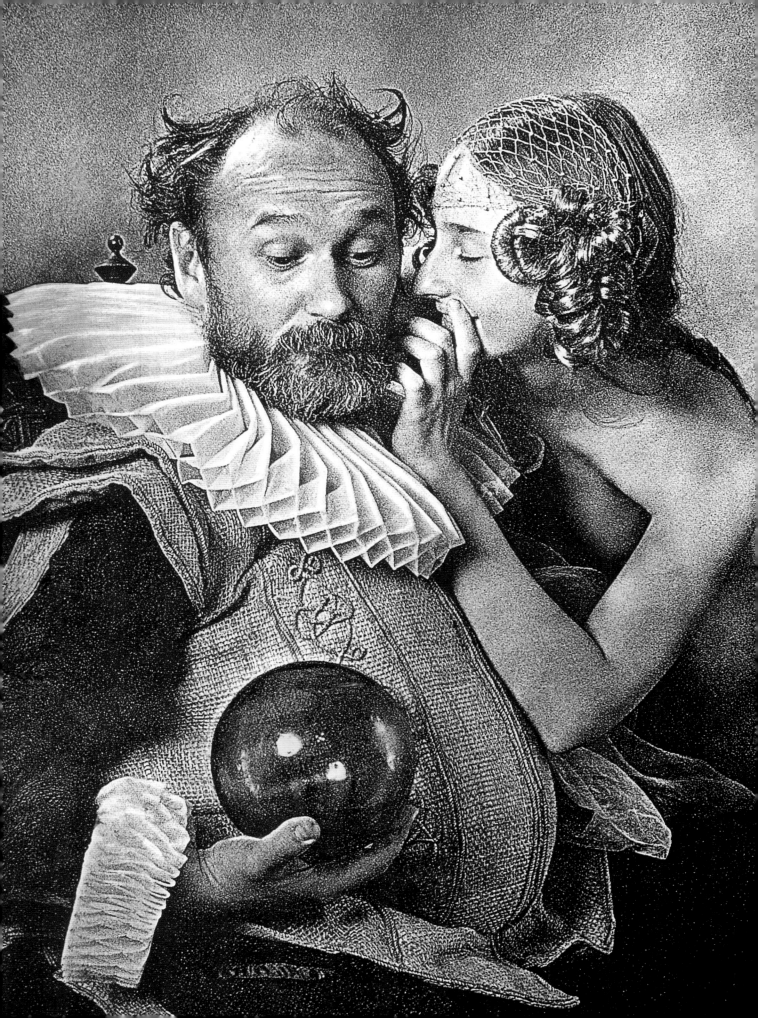

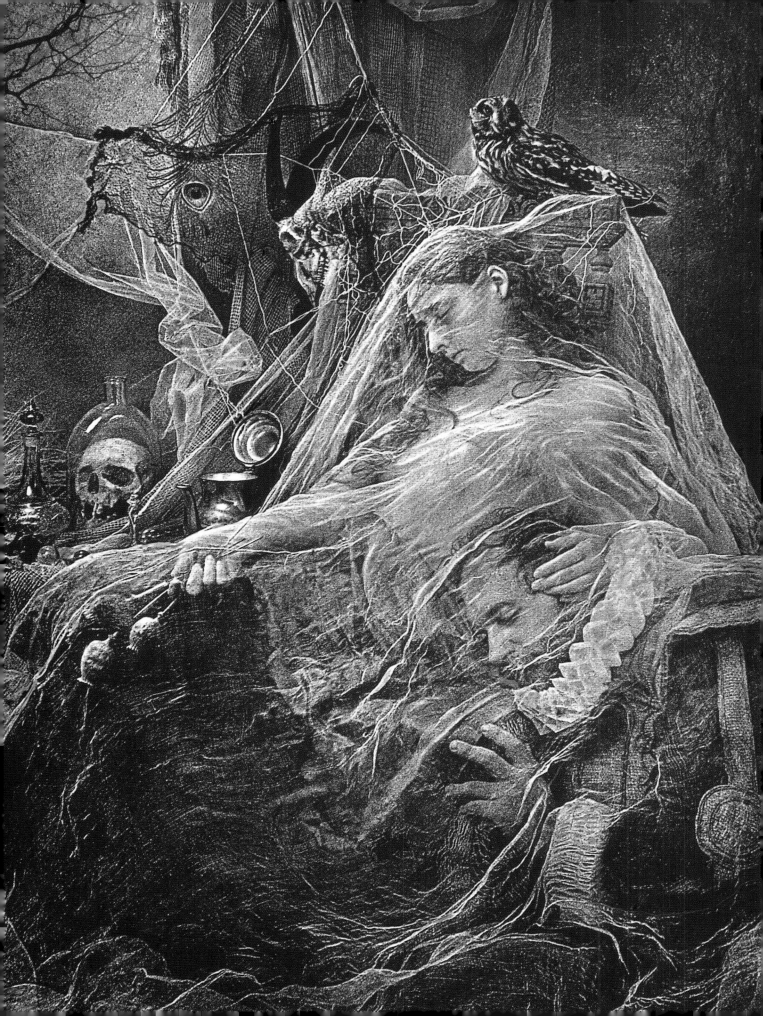

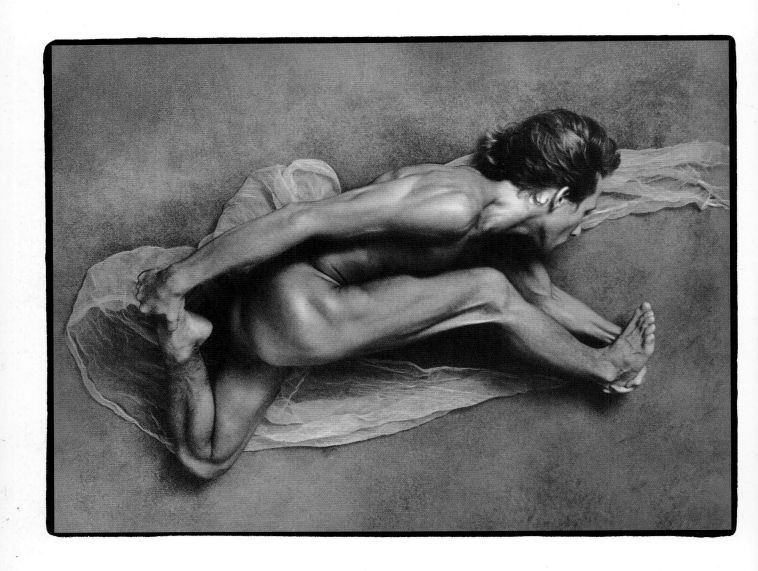

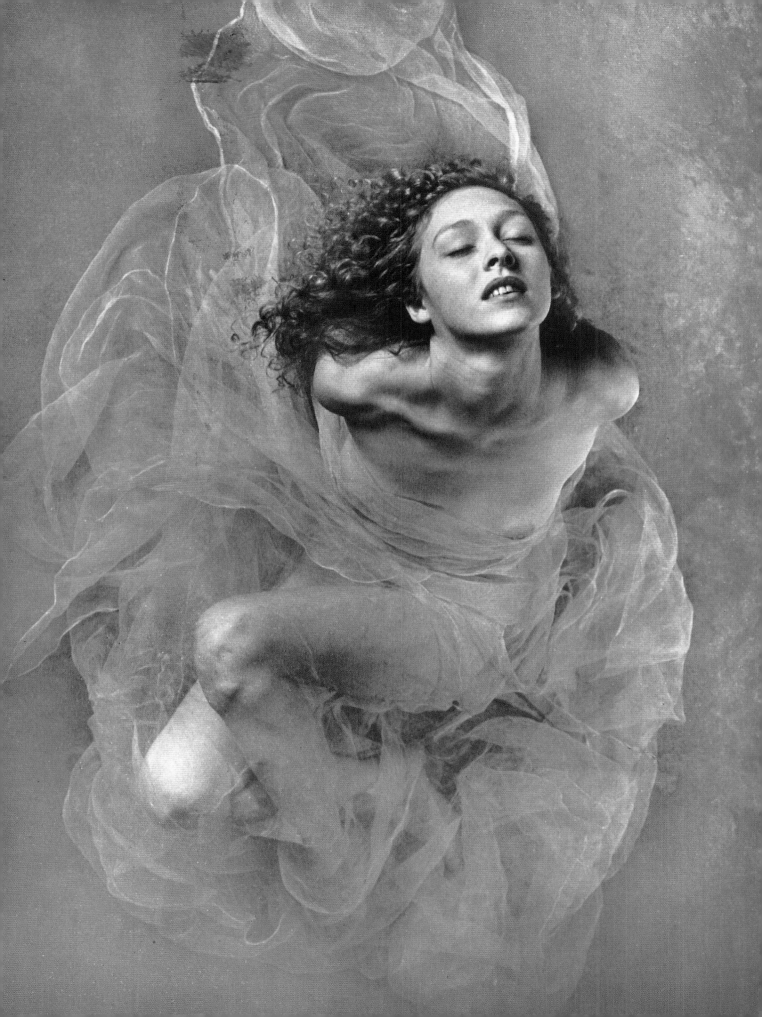

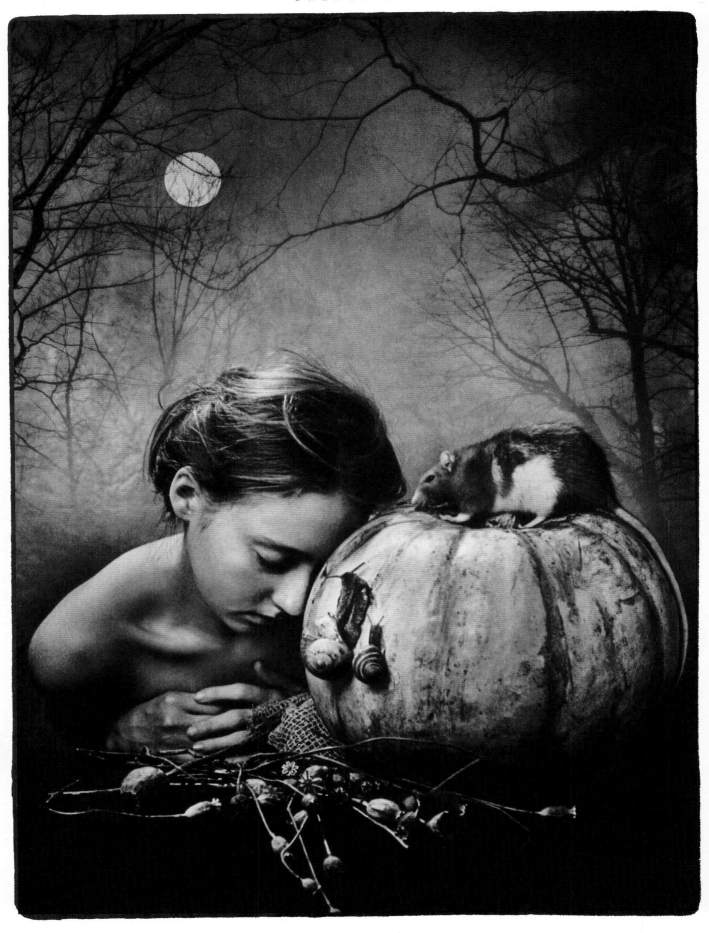

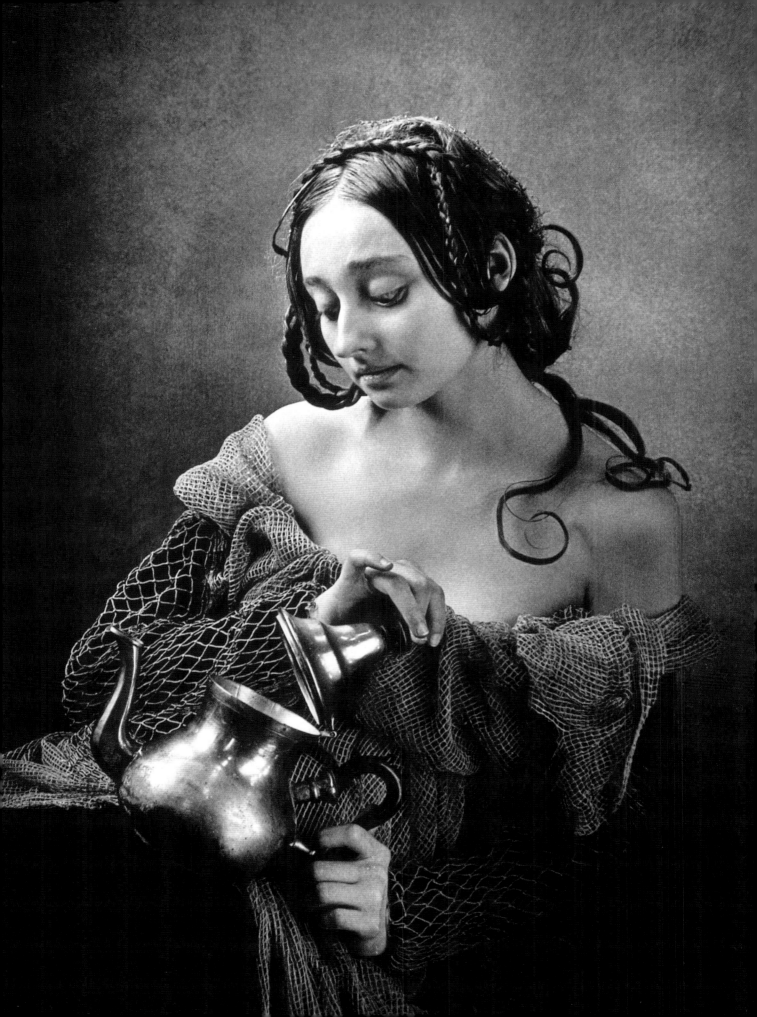

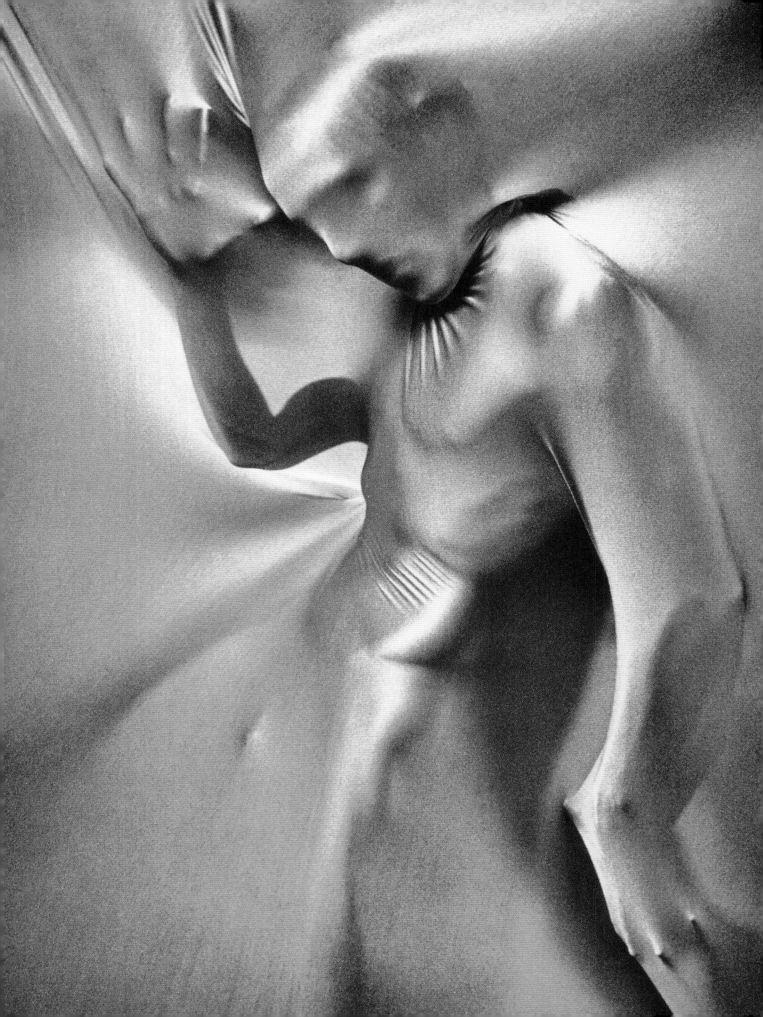

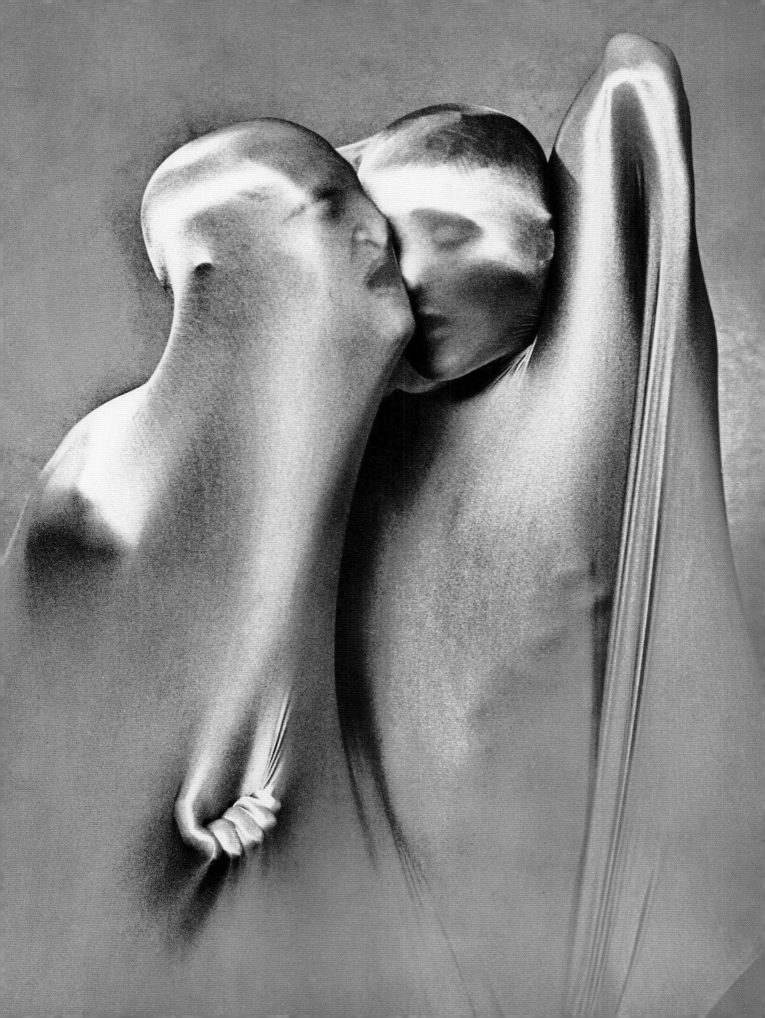

Landspace
Photographs by Bob Kim

Bob Kim was born in Seoul, Korea in 1961, and moved to the US with his family in 1975. Kim studied fine art at the Maryland Institute College of Art and graduated with a BA in 1983. He began working in the area of offset printing, using both digital pre-press and traditional colour-etching processes, during which time he fell in love with photography.

Kim's artistry is a unique combination between the eye of the camera and the eye of the mind. As an outdoor photographer, capturing images of incredible beauty is only the beginning of his work. Back in the studio he creates subtleties of details, light and colour that result in works of fine art. Kim's goal is to create a living scene expressing both the beauty and the emotion of nature.

His work begins in the raw outdoors, with photographic images taken using Hasselblad and Nikon cameras and lenses and Fujichrome Provia and Velvia film. Images are then converted to digital format using a high-end drum scanner. Once in digital format, Kim uses a number of applications like Photoshop, Painter, Live picture, Coco and Scitex to create an original image reflecting his personal interpretation of a scene.

Kim's works are richly colour saturated and sparkle with dazzling details. Prints are created using the newest direct digital enlargers and modern substrates such as Fuji Crystal Archive and Ilforchrome Classic, resulting in production of top quality archival fine art prints. His prints are limited editions individually created, signed and numbered.

Kim lives with his family in Washington State, he photographs intensively throughout the Western United States and Canada.

To see more of his stunning work visit www.kimspanorama.com
To contact Bob Kim email to bob@kimspanorama.com

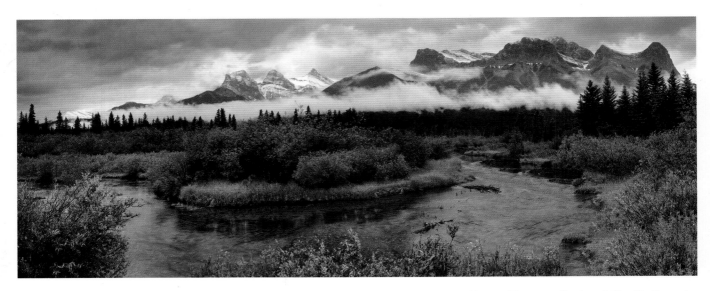

Above: Thirteen Peaks of Banff, Canada.
Right: Starvation Creek, Oregon, USA.

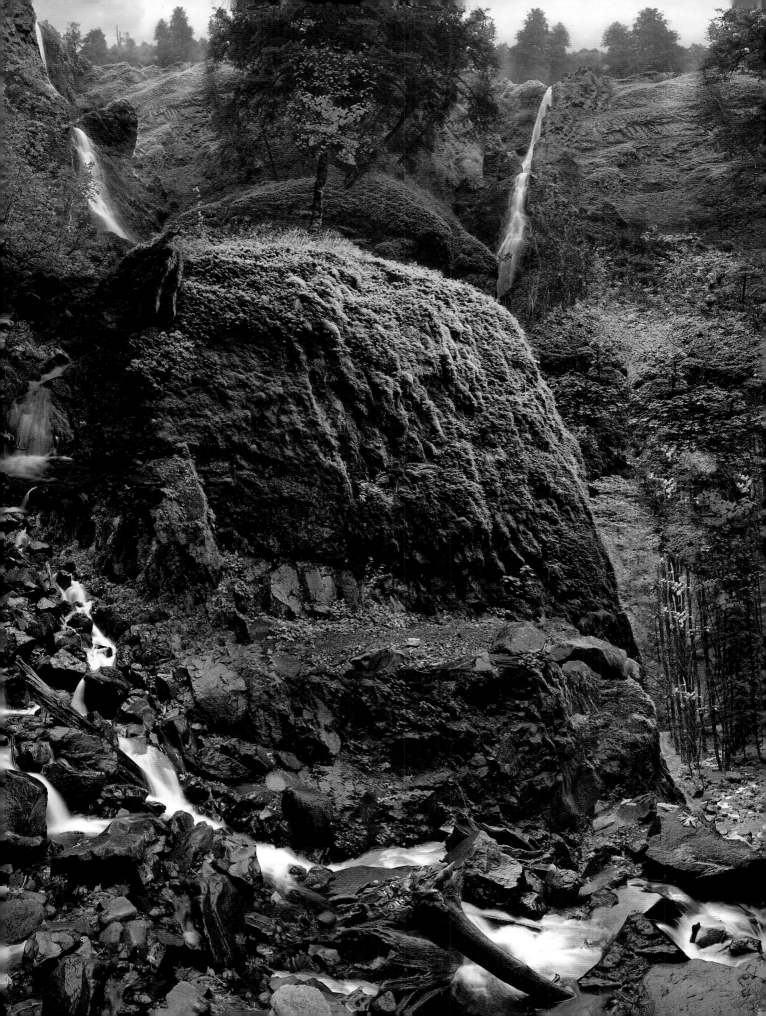

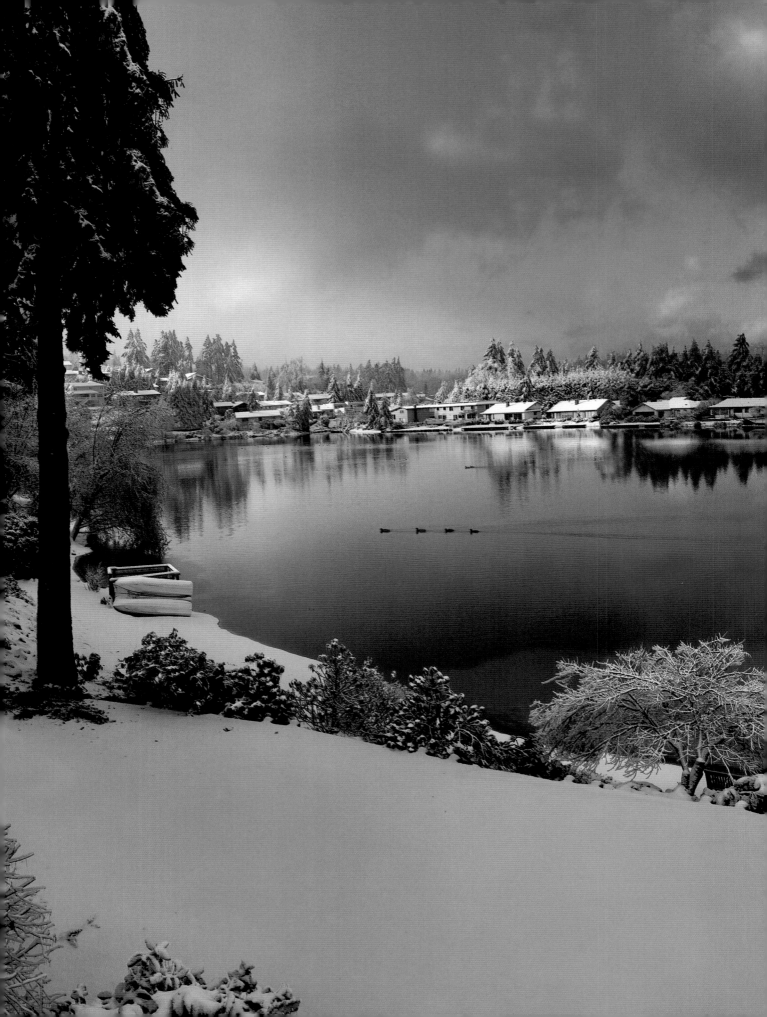

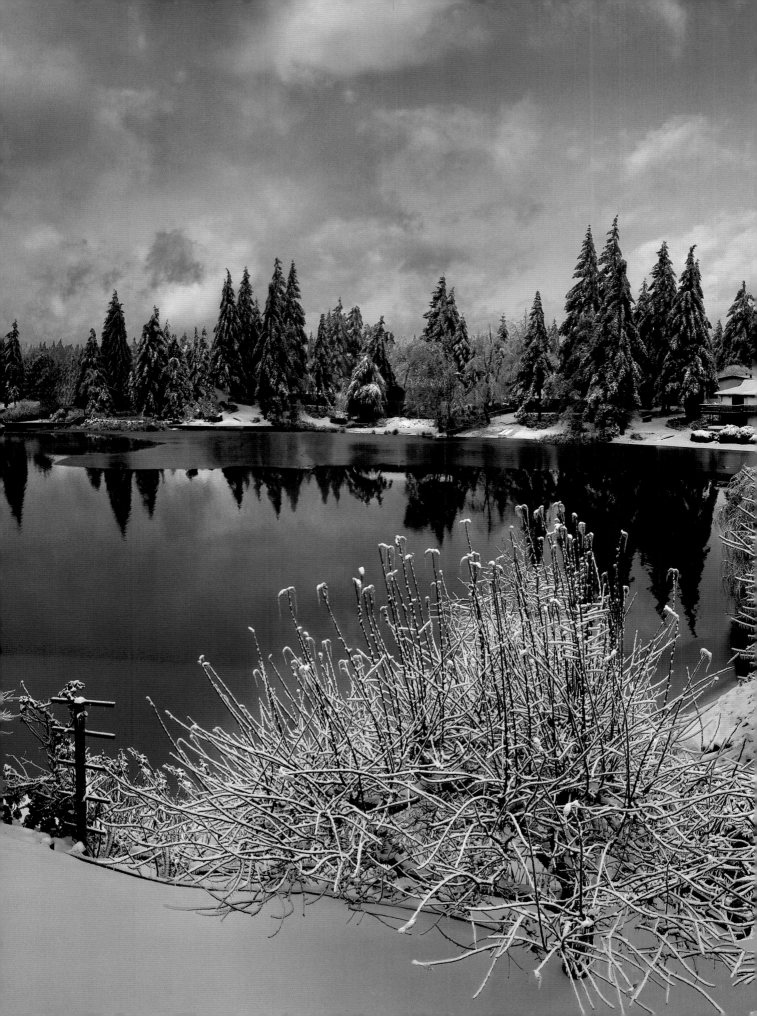

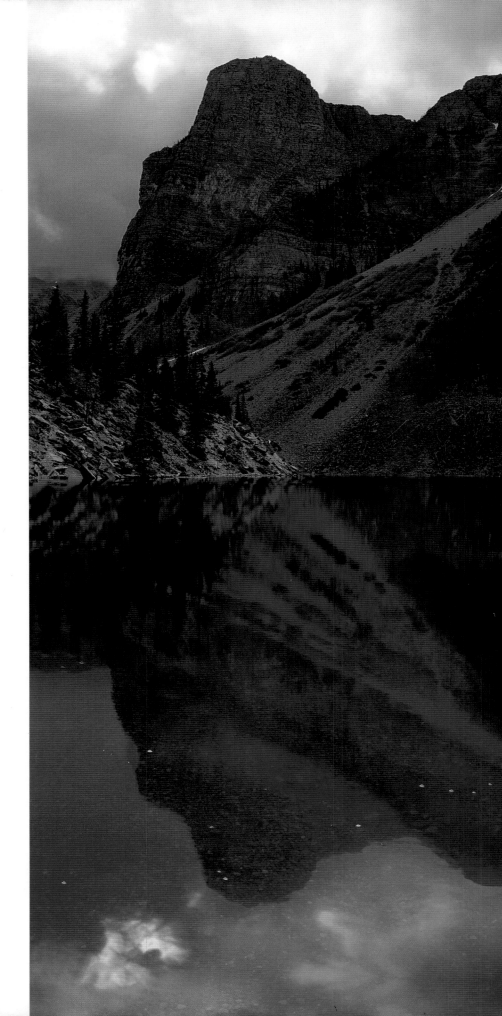

Previous page: Twin Lake, Federal
Way near Seattle, Washington
State, USA.

Lake Morine, Banff, Rocky
Mountains, Canada.

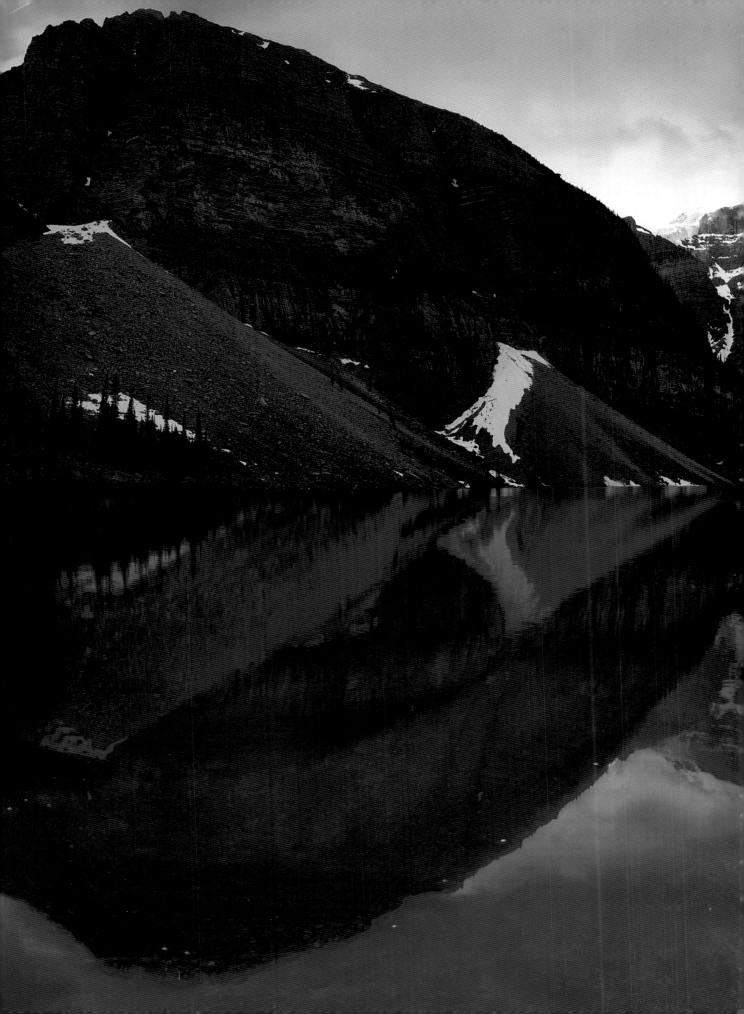

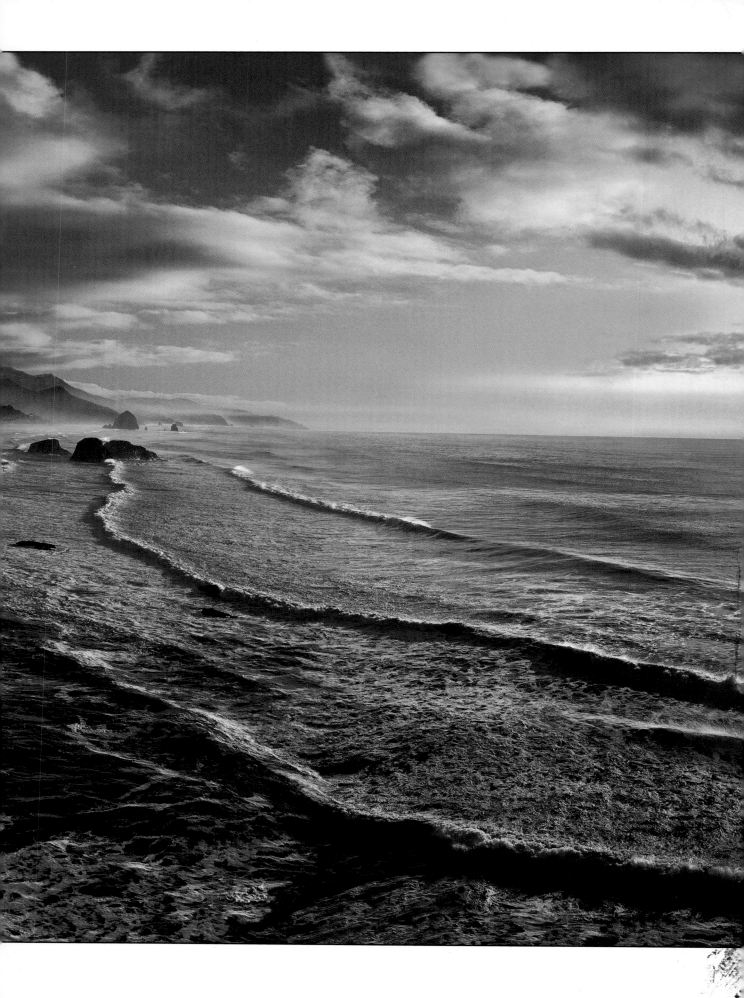

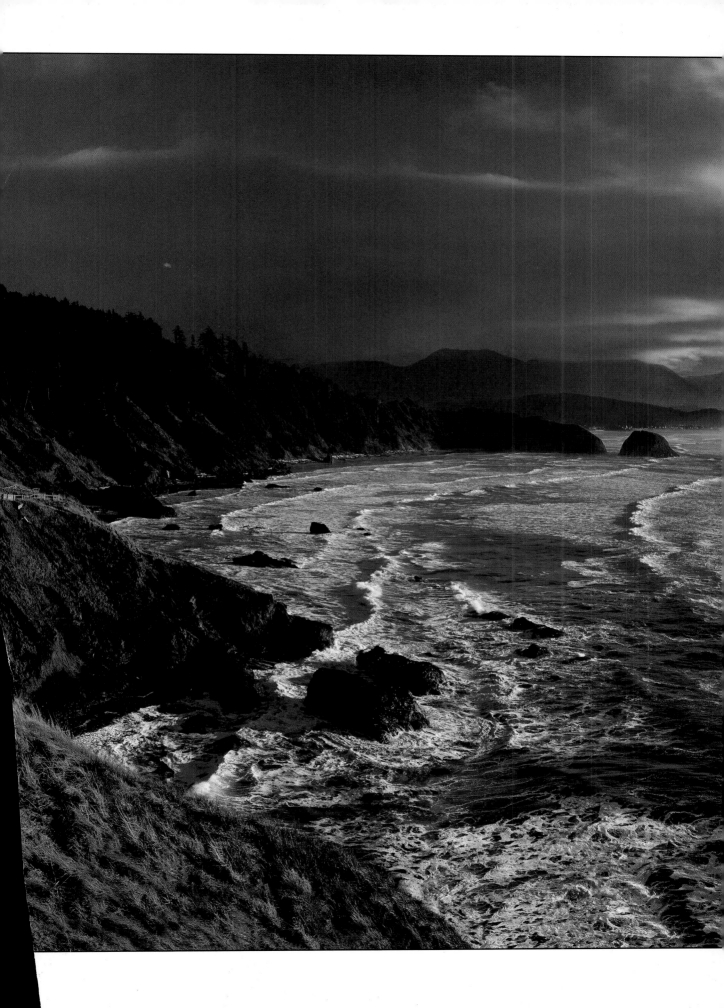

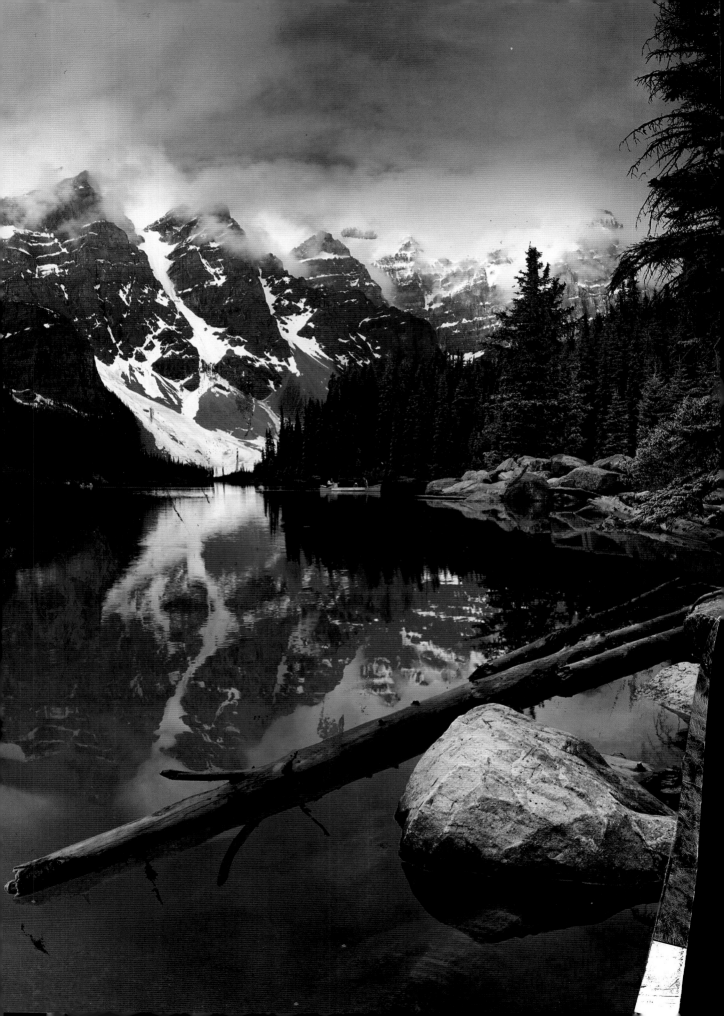

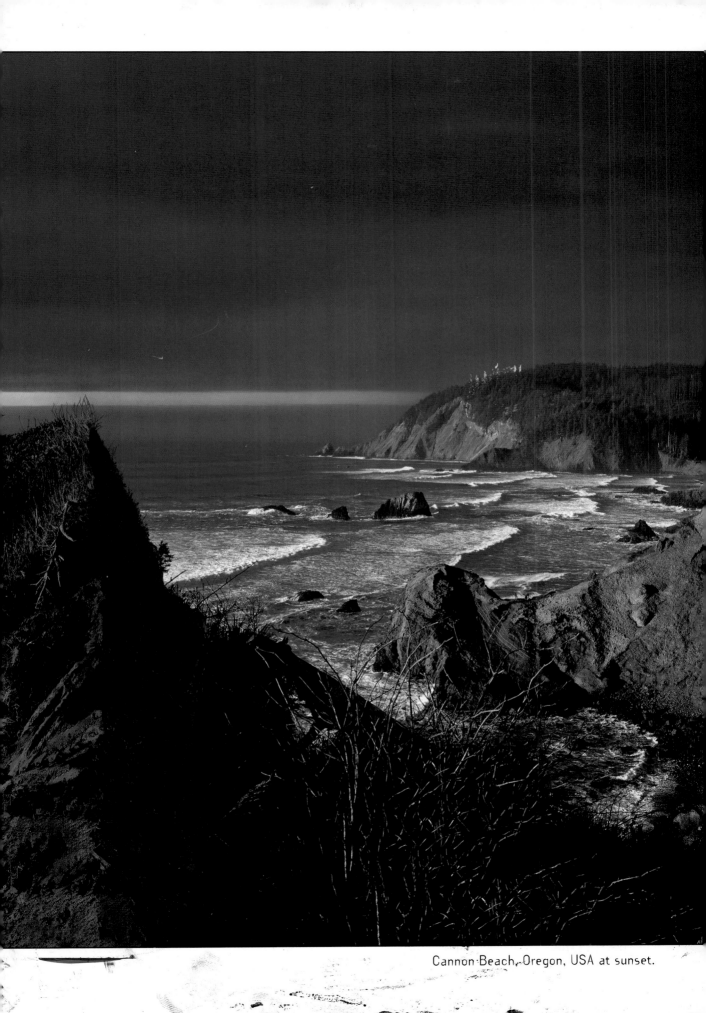
Cannon Beach, Oregon, USA at sunset.

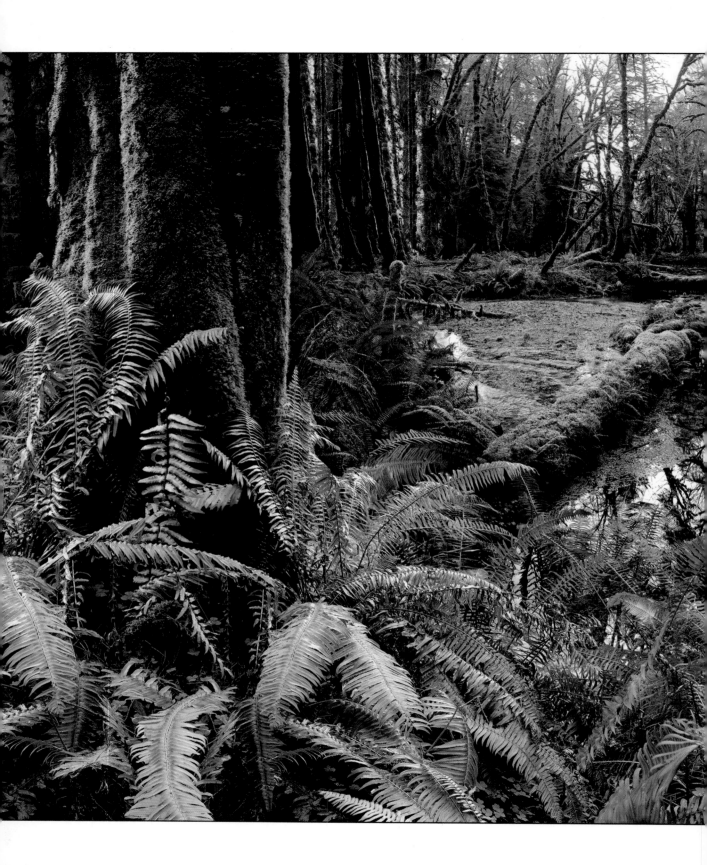

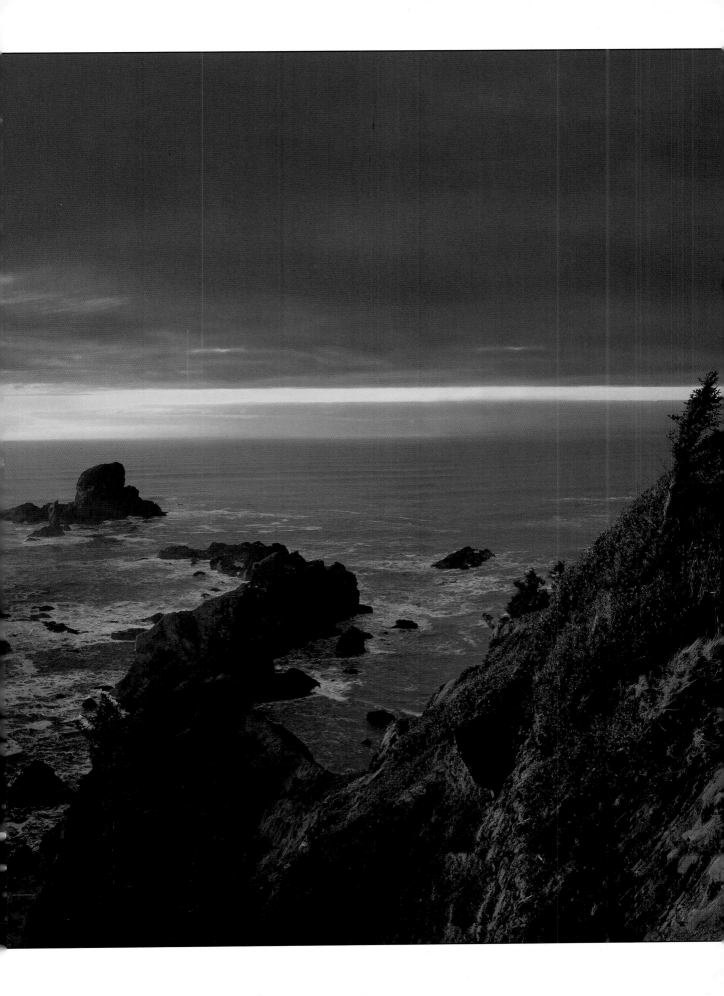

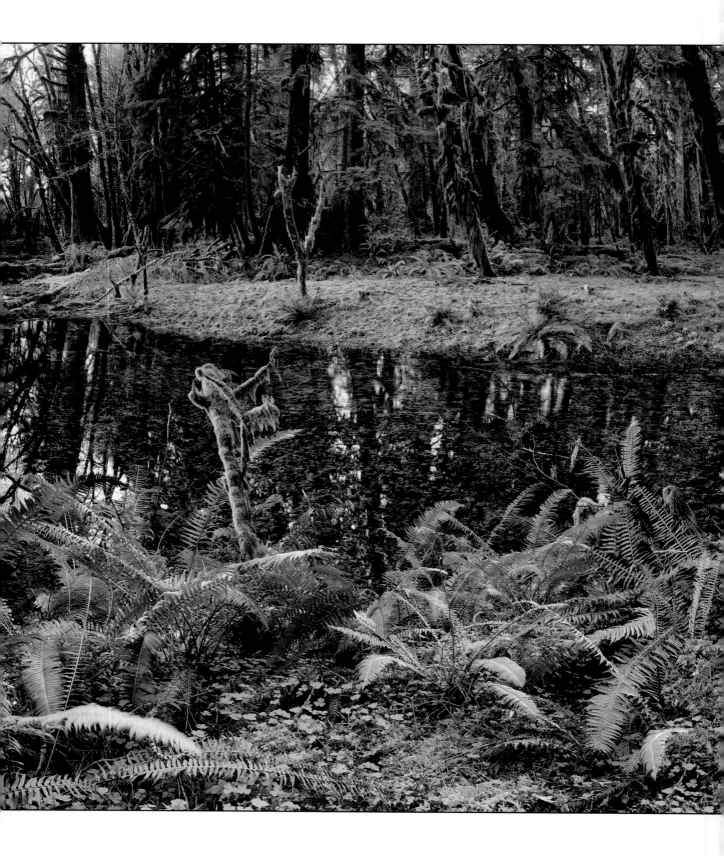

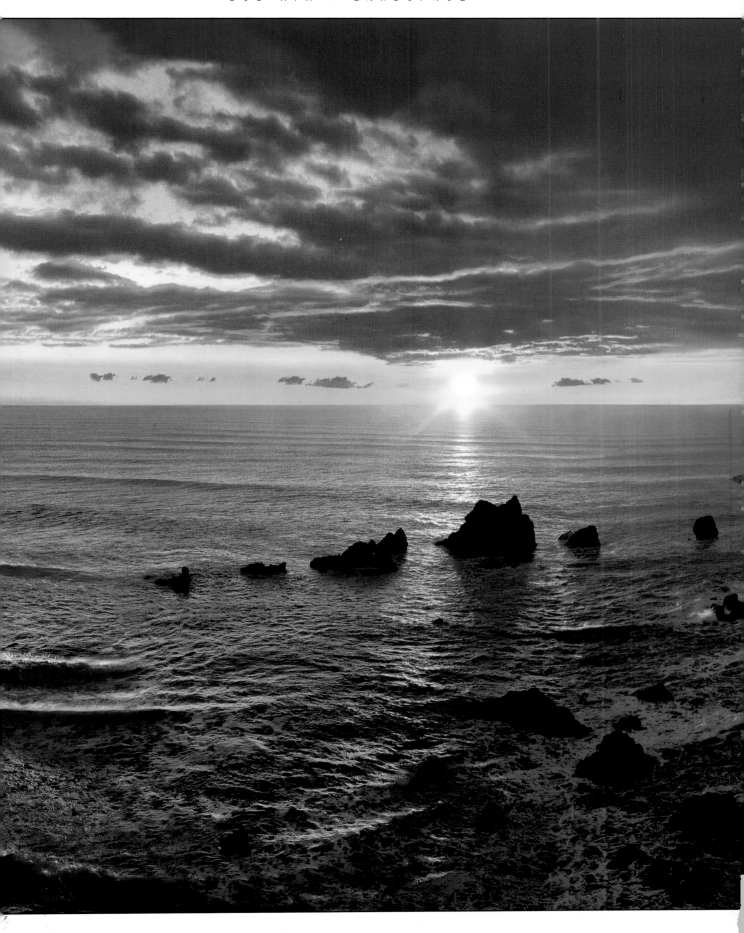

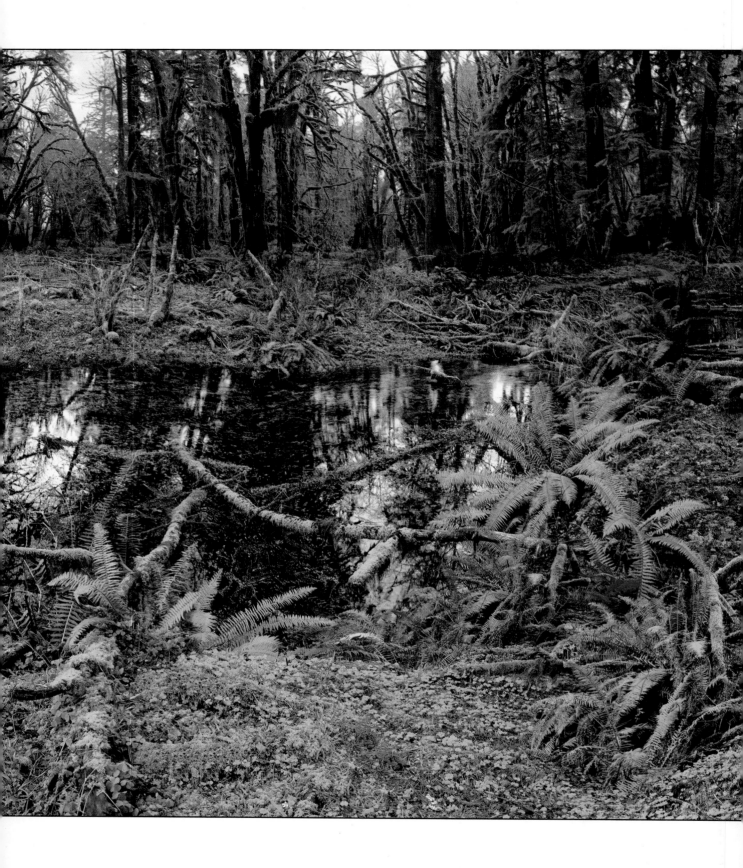

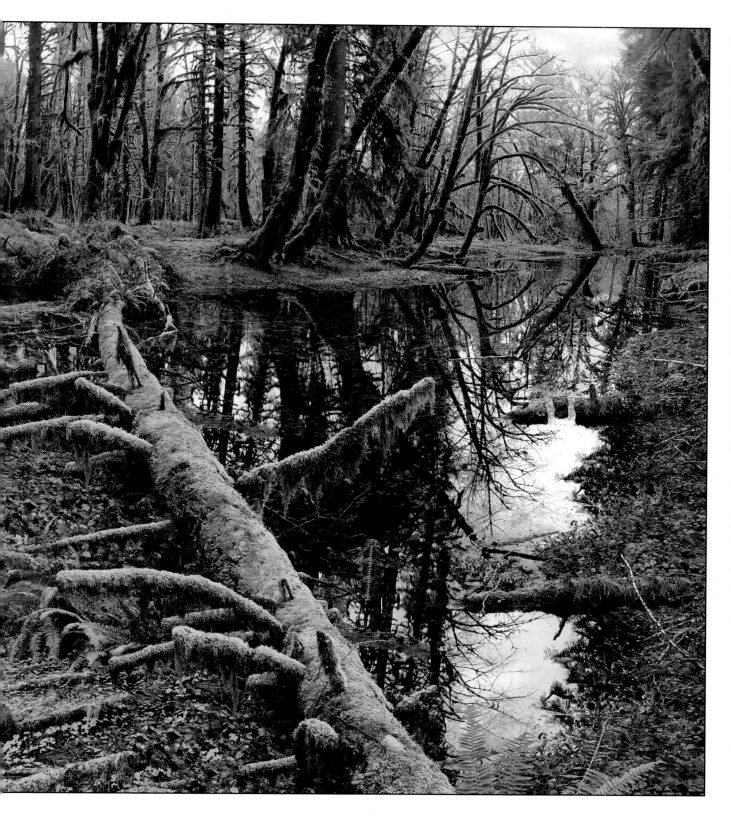

Rainforest, Washington State, USA.

PHOTOCOMPOSER
IMAGES BY THOMAS HERBRICH

Thomas Herbrich was born in Dusseldorf in 1955 and trained as a photographer in a still life studio. *"In a way the pictures that I create now are 'stills', the only difference being that I don't arrange objects on the table but blend different photographs into a new picture. I haven't always worked this way"* says Thomas. In his early days he used conventional photography for advertising. His, as he describes it, *"visual enlightenment"* came when he saw Stanley Kubrick's cult movie '2001: A Space Odyssey'. *"The overwhelming beauty and mysterious allure of this movie really threw me off balance, I believe it has influenced every single picture I have done since that day."*

For a while his goal in life was to create special effects for movies, in fact he is the creator of the 'space effects' for Roland Emmerich's first film. However Thomas Herbrich realized fairly soon that for a photographer it is far easier to imprint your own style on an individual photography project than in the huge film industry. He opened his studio in Dusseldorf in 1983, where in partnership with his brother Markus, a model maker they create up to 20 images a year. *"We are running a factory of creativity, offering our clients more than just a photographic product, we try to visualize their dreams of what their product could be! If the final image satisfies my clients, fine, if it satisfies me as well, perfect"*

Many people believe all our work is done digitally. But on the contrary most of it is pure handicraft and classical photographic tricks.

Only when absolutely necessary do we use the wonderful digital tools, but the computer never will replace the intellectual and creative power of its user.

If you want to see his gallery visit: www.herbrich.com

Tractor driving through the sea
We assembled the bulldozer from various photographs of tractors and dozers that we had specially photographed. The furrow left in the sea by the driver took some tricky image editing. The sea floor is mud flats and we produced the tracks with a toy car in a sandpit. This image consists of almost 30 individual photos.

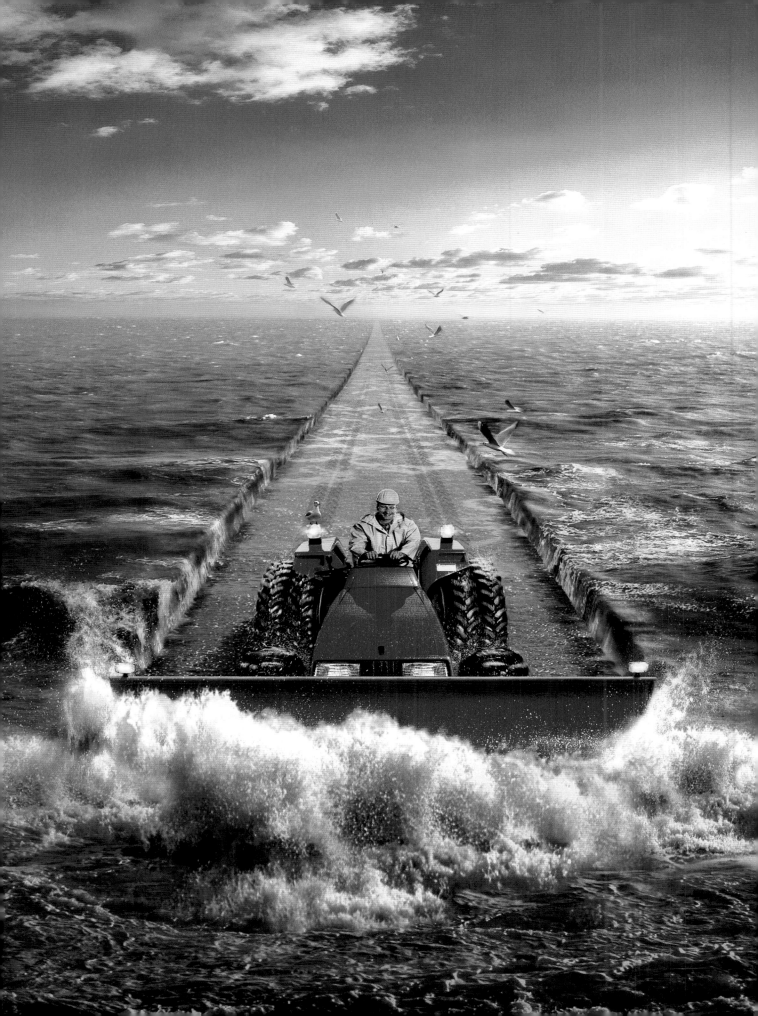

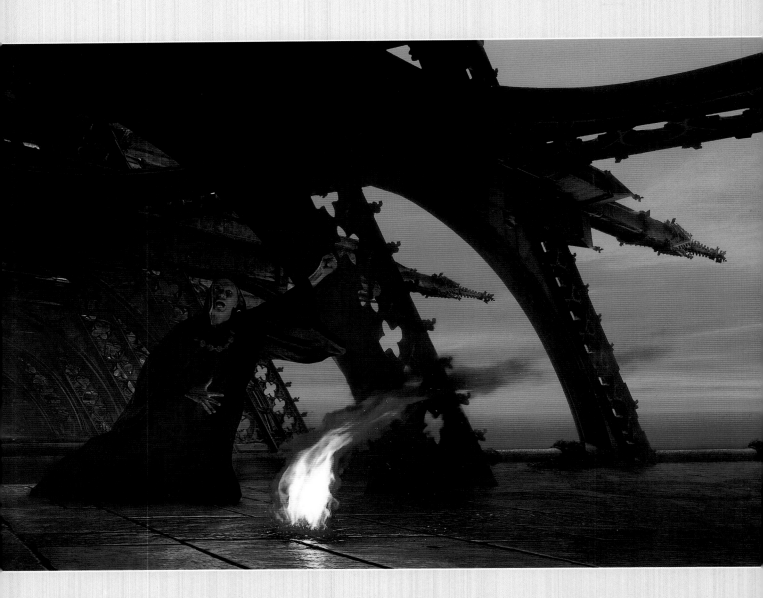

The magician
This was the first picture I generated with the help of a computer. The model for the magician is a friend of mine, the architectural structure in the background was not specially built, but is a partial view of Cologne Cathedral which I turned through 90 degrees. The ground came from my photo library, as did the flames and the sky. All of which goes to show that you don't always have to build a big set to create an extraordinary scene.

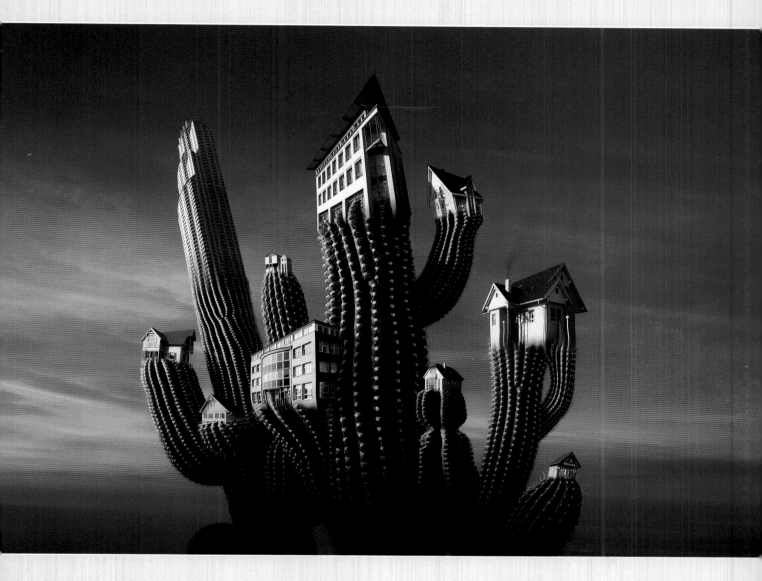

Cactus house
This motif was a contract job for
Expo 2000. What was required was
a humorous vision of house-building in
the future. We photographed the cacti
in the Grugapark gardens in Essen –
using the bluescreen technique, as that
allowed us to isolate the spines. More
difficult was photographing the houses,
not only because there are always trees
or cars in front of them, but above all
the owners think you're preparing
a break-in.

Next page:
Measuring rods
Normally, you need thousands of
measuring rods to create such a large
field. We only bought a thousand,
which we cut in half, thus doubling
their number. They were photographed
several times (this had to be done
following a well thought out plan) and
assembled. The big bird and the sky
came from my photo library while the
small birds were simply painted into
the picture. (If you're in the market for
very short measuring rods, you know
who to call.)

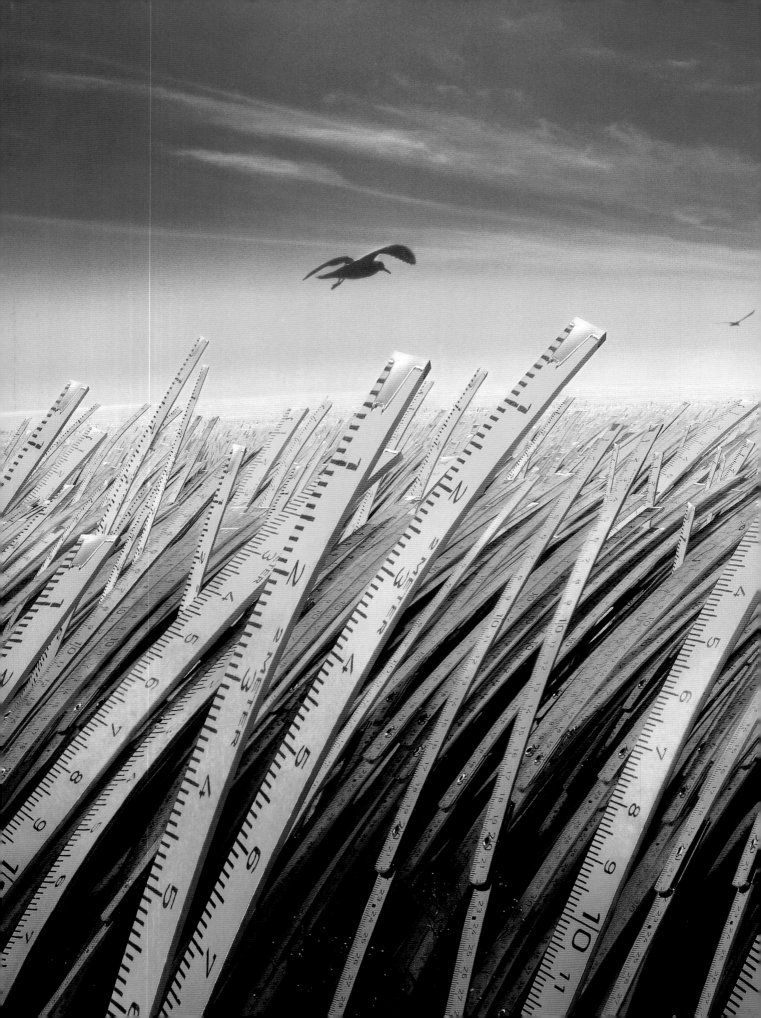

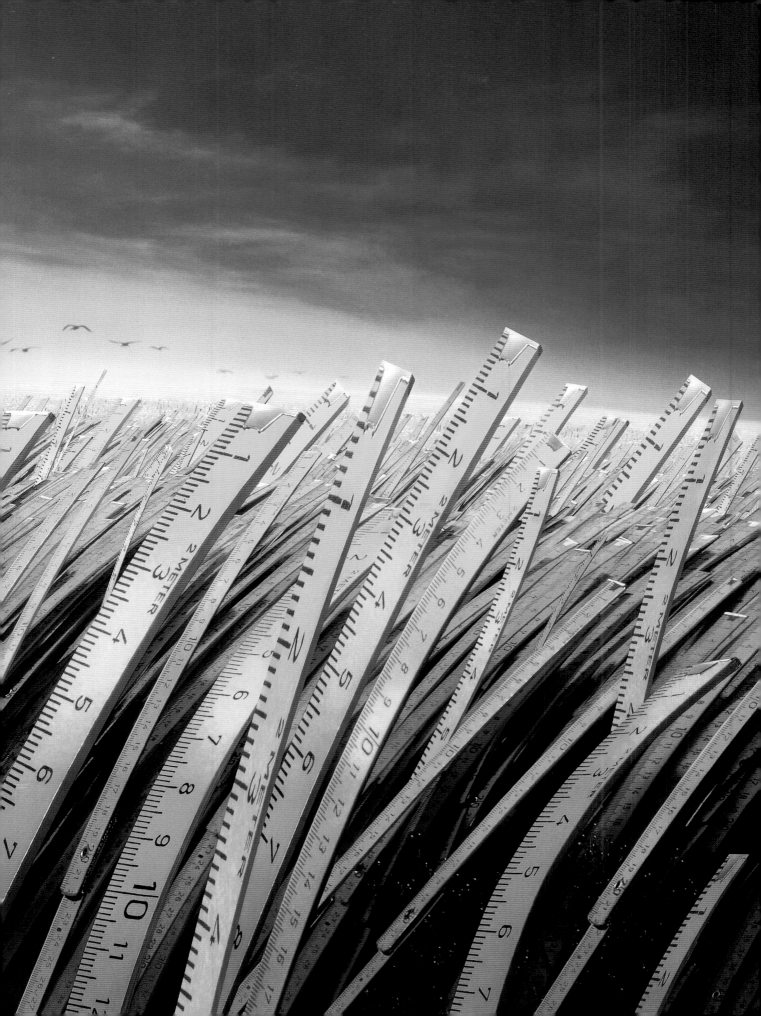

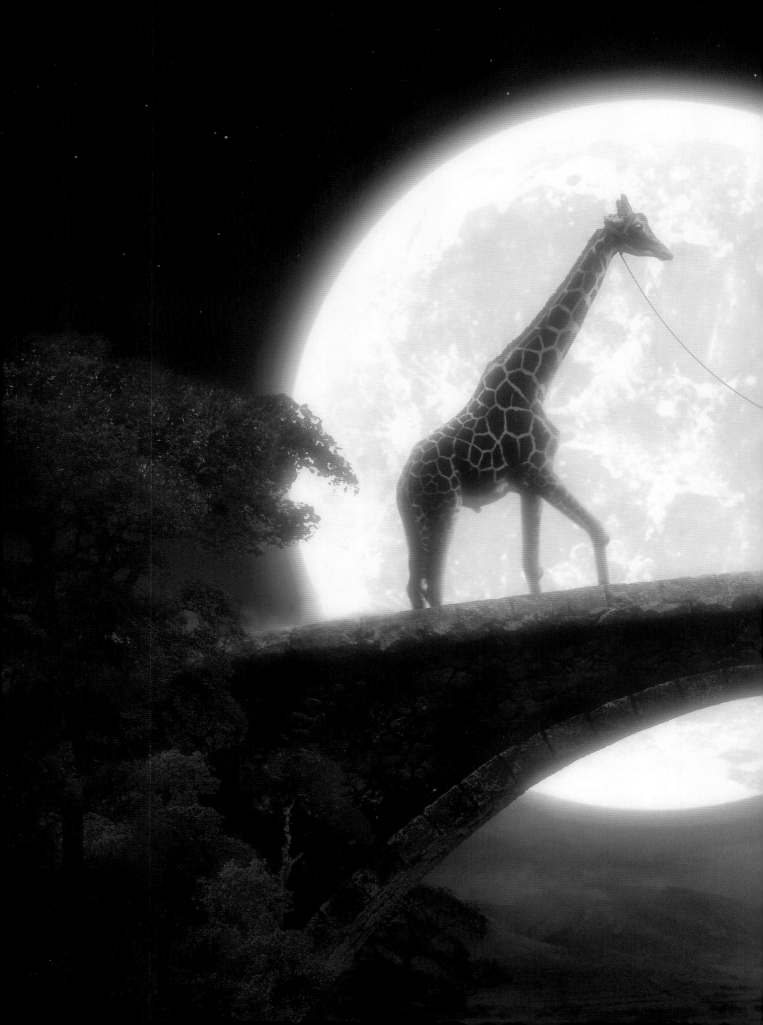

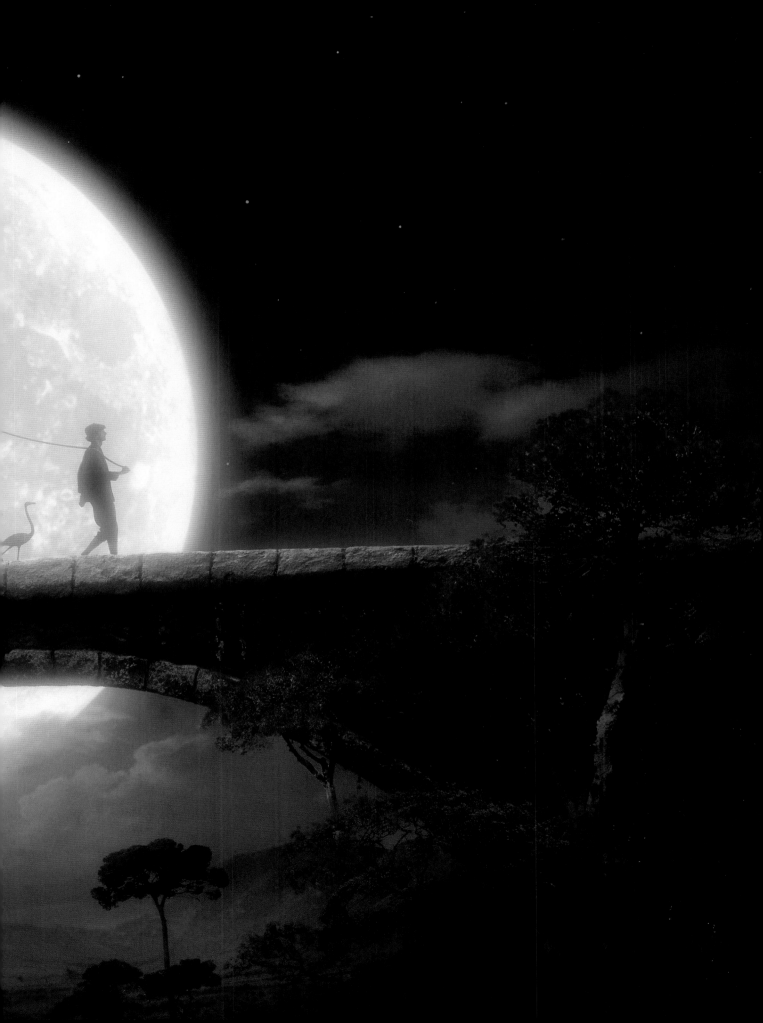

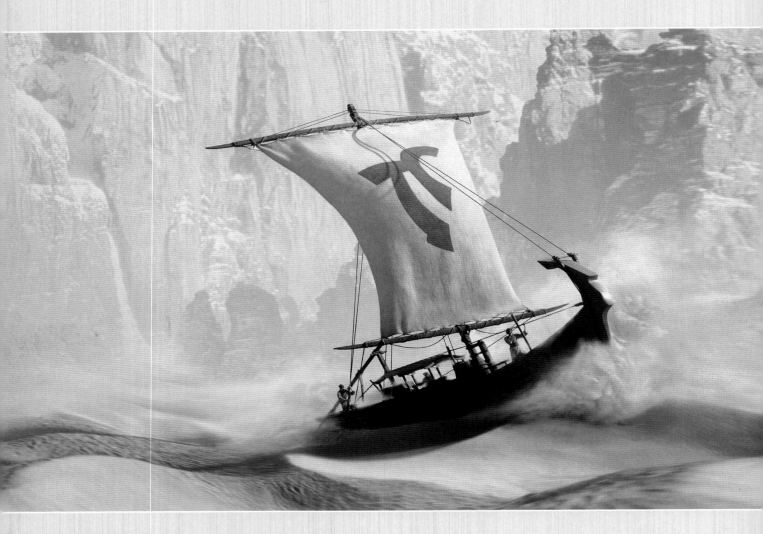

Ship of the desert

Again, the principle I'm playing with here is 'It cannot be – but it looks real!' The ship is a model about 60 cm long, while the desert sand is a perspective model measuring roughly 4 square metres. It was very difficult to get the ship to sail realistically through the sea of sand. It always looked as though it had somehow been stranded... It didn't quite work until I 'moved' the sand during image editing.

We made the clouds of dust on the beach while on holiday. The mountains in the background were originally a snowy region in the Alps – recolouring turned them into mountains of sand. The people on board are Nils and Markus from my studio. The clothes were simply stapled together from cloth. I spent about a month working on this image – it wasn't a contract job, so I could happily take my time.

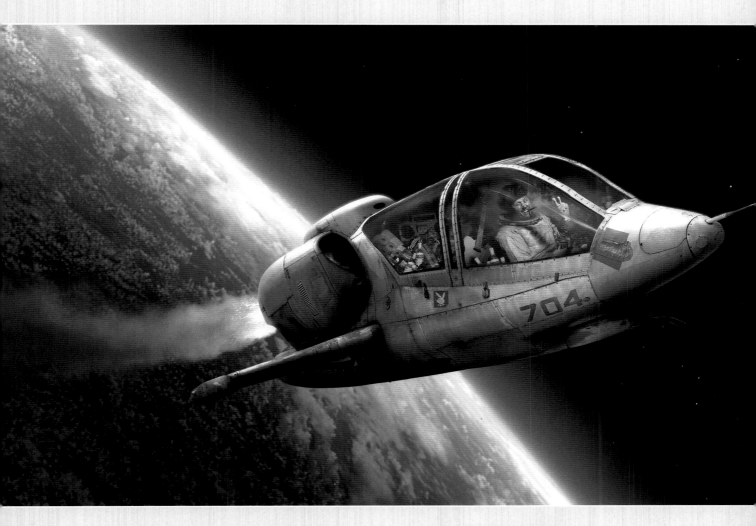

Russian Space Ship:
I always try to create scenes that contain an element of surprise. We are familiar with the world of spaceflight as a hi-tech, clean and controlled affair – I wanted to design a radical and humorous opposite. Why shouldn't it be a run-down Russian spaceship manned by a drunken pilot – and the man's even smoking! Look at the details. For example, there's a Playboy sticker, padlocks to secure the cockpit, and the pilot, schnapps and toilet paper in hand, looks like he is on the way to a wild space party. The spaceship was originally an old helicopter that I took photographs in a New York museum.

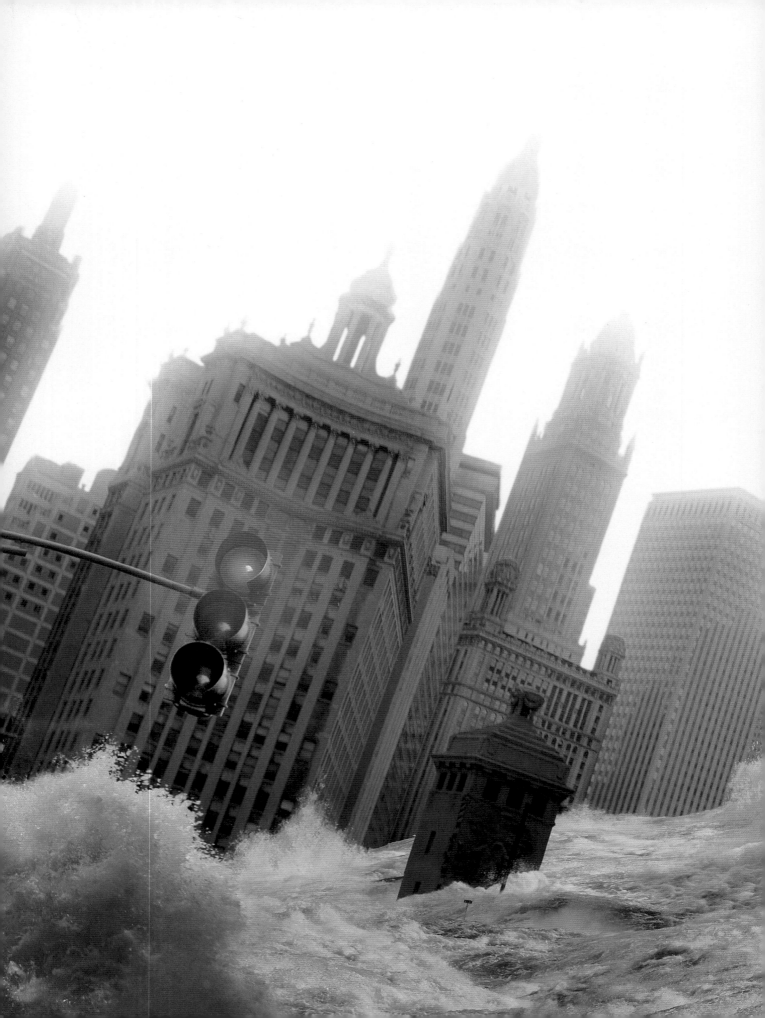

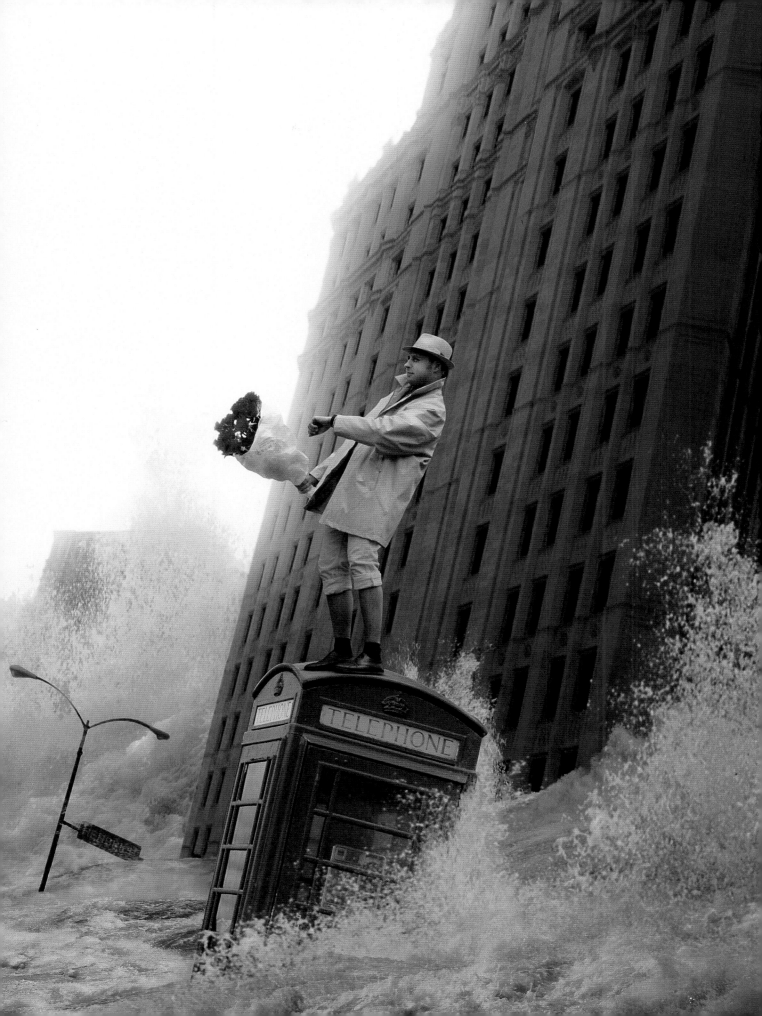

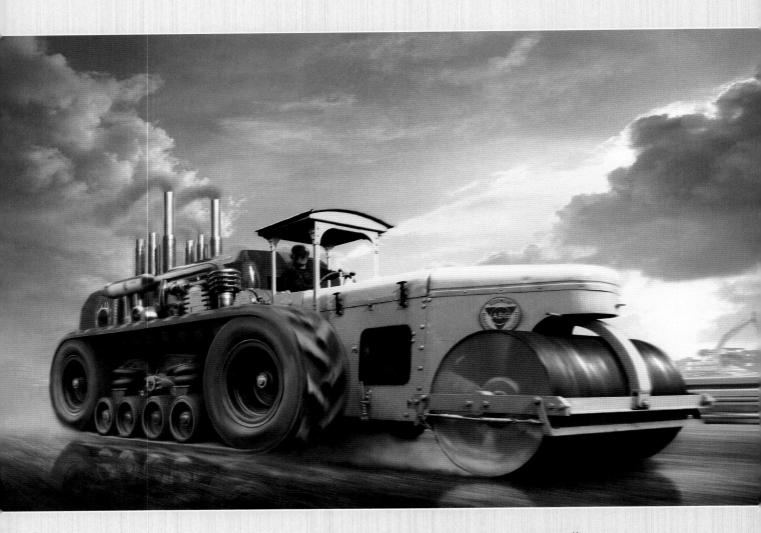

Previous Page:
Flood / Chicago
This is a combination of two scenes:
a street scene in Chicago and the
Rhine falls at Schaffhausen. There
are also several additional photos of
fountains and surf. All these photos
were taken from my own archive.
The photograph was composed within
a day, while the finishing work took
another one and a half days.

Steamroller
I photographed the yellow vehicle
in a museum of road construction
machinery – it is made up of three
photographs. The chain drive is from
an excavator. We built the red
superstructure with the exhaust pipes
as a model. I subsequently added
some 'speed' to the motif, while the
reflection in the wet asphalt and the
swirling water are also purely the
result of image editing. This gave the
old-fashioned road roller a modern
'booster drive'.

Next Page:
Ricefield
We were commissioned to create a picture
on the subject of 'growing markets in Asia'.
We had a background shot of a rice field,
which I had to alter radically. The radiant
plants in the foreground are 35 custom-built
lamps for this purpose. In order to make them
seem a much larger number, they were
photographed with mirrors standing on either
side of the row – this created the effect of
an endless row of lamps.

The horizon was composed of 4 different
pictures culled from my photo library.
This favourite picture of mine has already
been copied several times

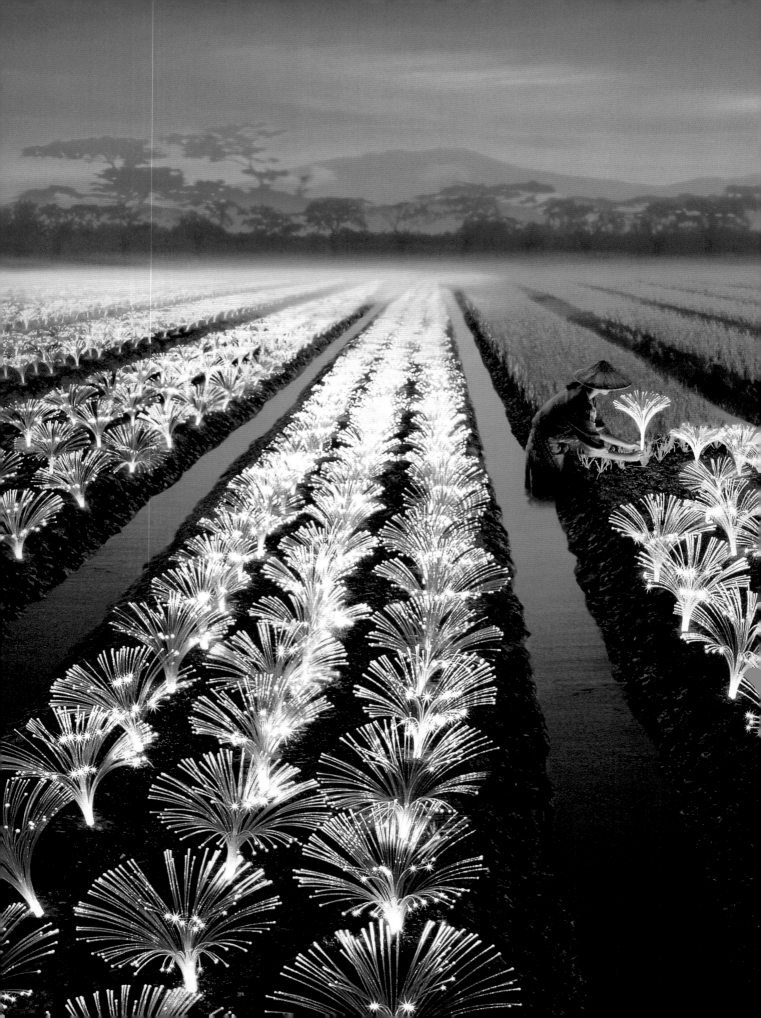

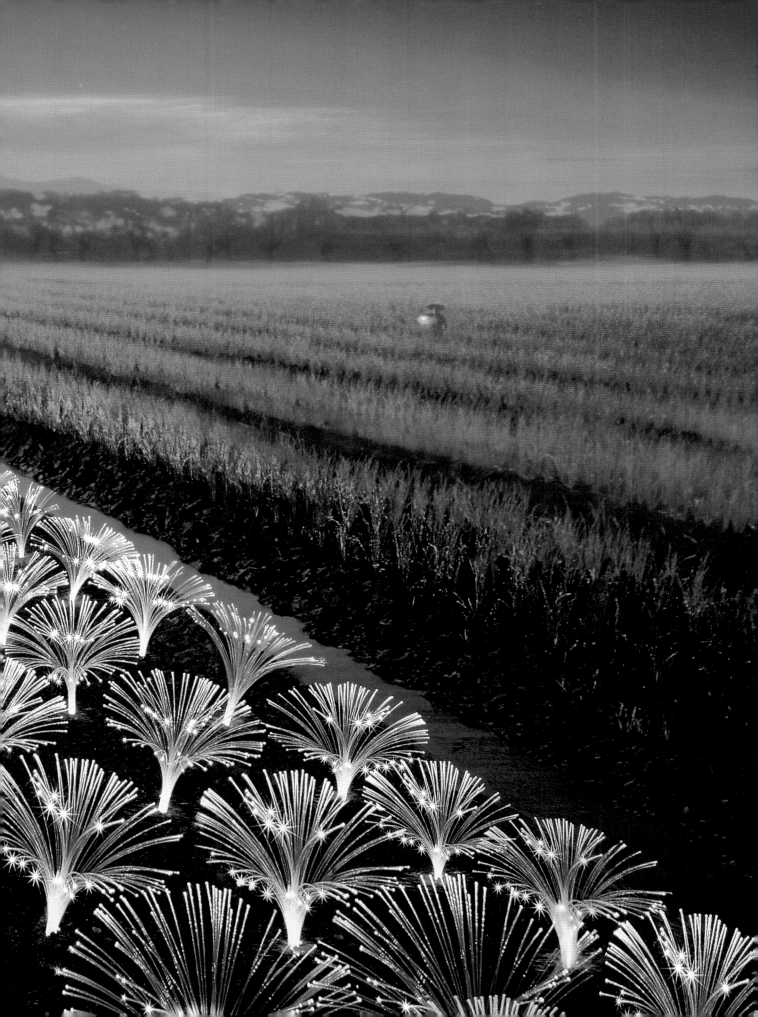

Sacred Stones

PHOTOGRAPHS BY
CAROLINE DAVIES

Caroline Davies was born in England near Oxford and grew up in Australia. She has lived in California for the past twenty two years from where she embarks on photographic expeditions to the parts of the world which inspire her. On her travels Caroline records and studies the alliances within our world through the ancient remnants of architecture that retains the mysteries of civilisations long gone. Her fine art images are exhibited in the United States and are used extensively in editorial publications. She is also represented in private collections around the world.

This portfolio is taken from her photographic essay 'Our Spirit Through Architecture: The Legacy of Great Britain'. A project that spanned many months and involved travelling almost 14,000 miles around the British Isles.

In the field although everything is planned and organised, Caroline is capable of working in the most challenging of situations. Often these difficult circumstances contribute to the creation of her extraordinary images. There is also the element of change in the natural elements that she is dealing with; the season, the weather, the quality of light.

Another different aspect of Caroline's work is seen in her printing techniques. Her individual interpretation through the use of various papers and processes allow for experimentation and greater spontaneity, giving an added vitality to her images.

Caroline draws you into the magical realms of dawn and dusk, of ritual and the afterworld. She conveys information in a form that penetrates through to our subconscious. There is a kind of blurring about the edges of reality, presenting tangibility and solid reality on one hand and the evidence of mystical essences of the unseen on the other.

Everything matters that is remotely connected with her feelings, giving her work an immense depth. It is this extra sensitivity that links Caroline with the surrounding environmental energy. She reveals with her images that nature and the ancient mysteries of man have an emotional life of their own.

Men-an-Tol, Cornwall

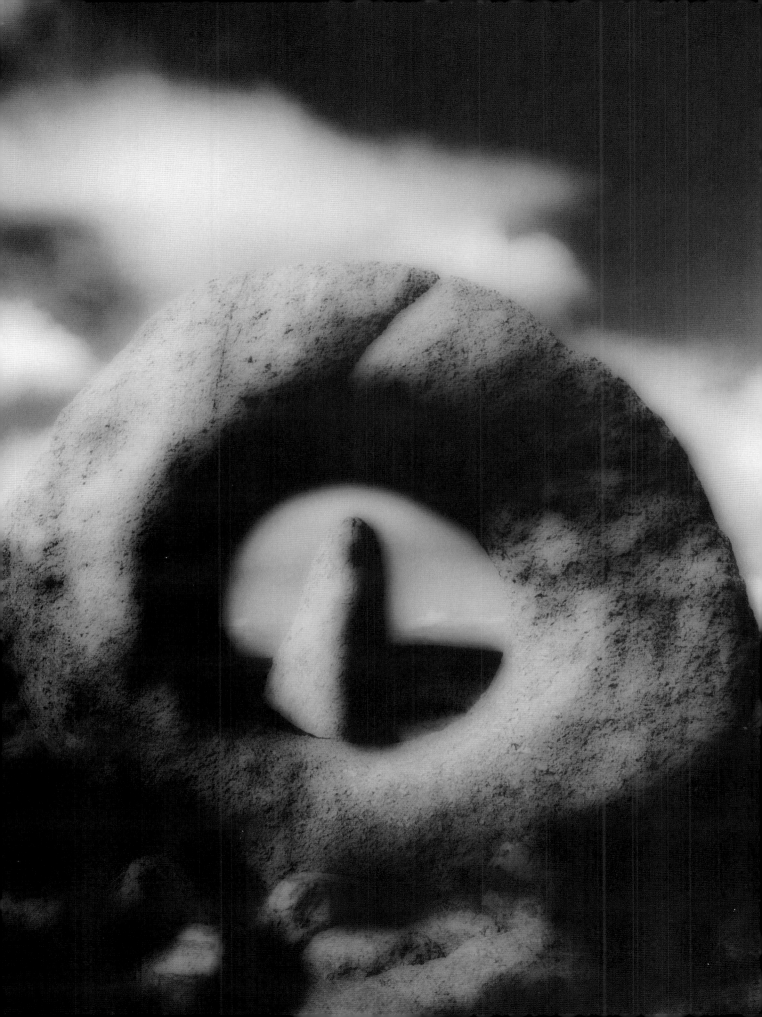

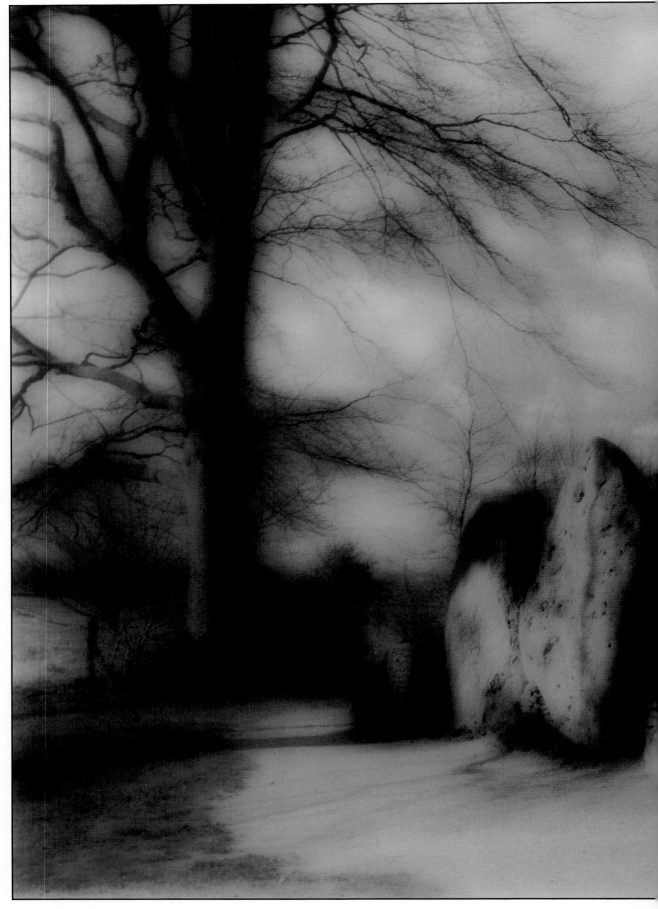

Wayland's Smithy, Berkshire

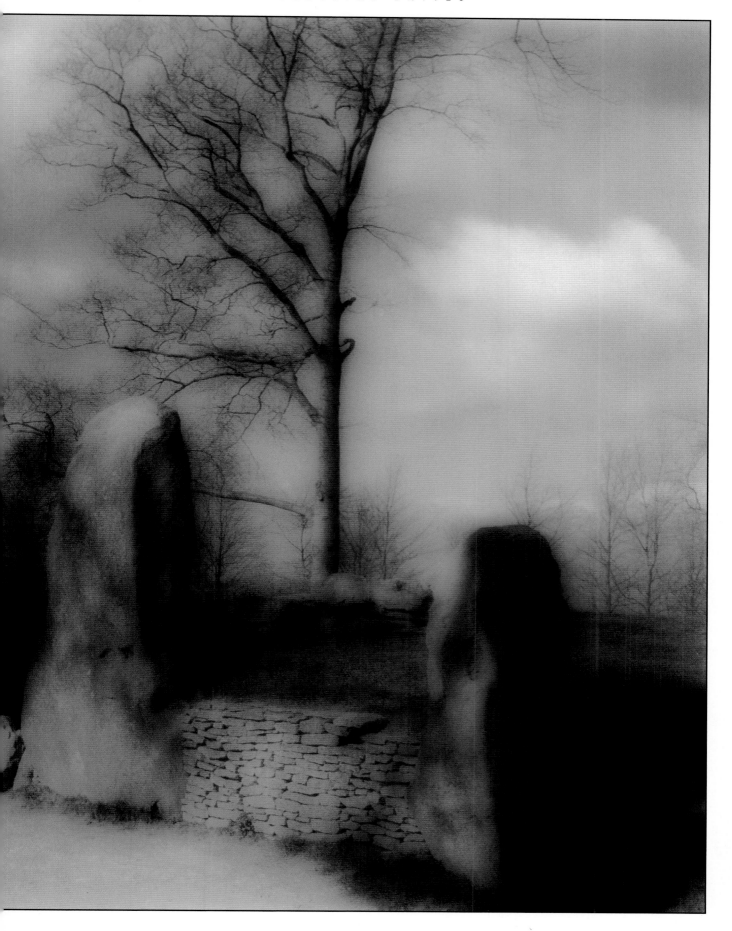

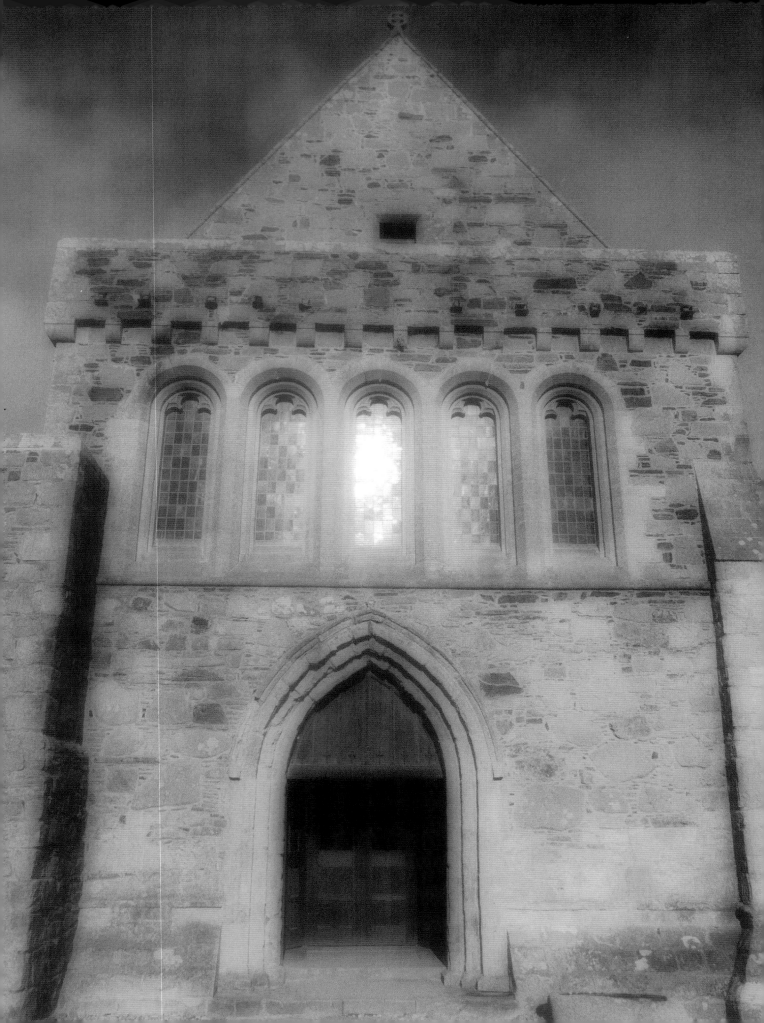

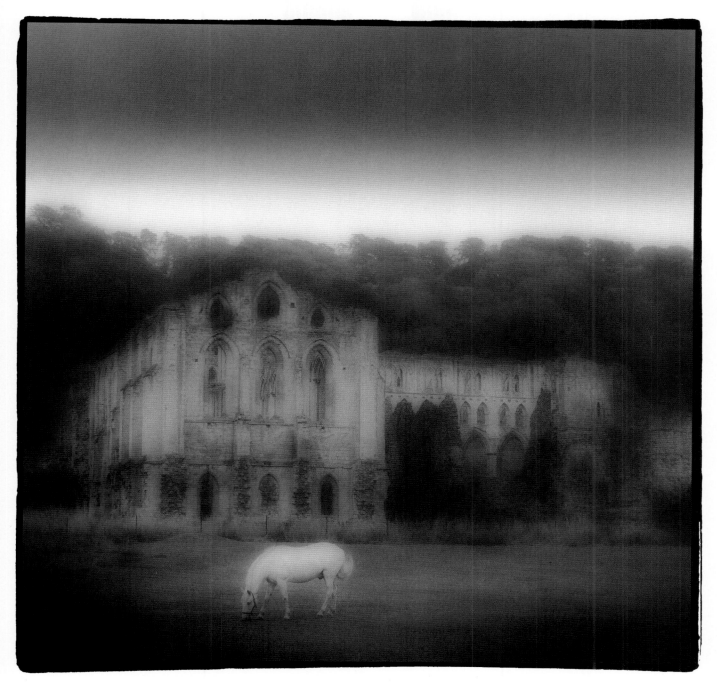

Rievaulx Abbey, Yorkshire

Chapel, Iona, Inner Hebrides

Overleaf: The Quoit, Cornwall

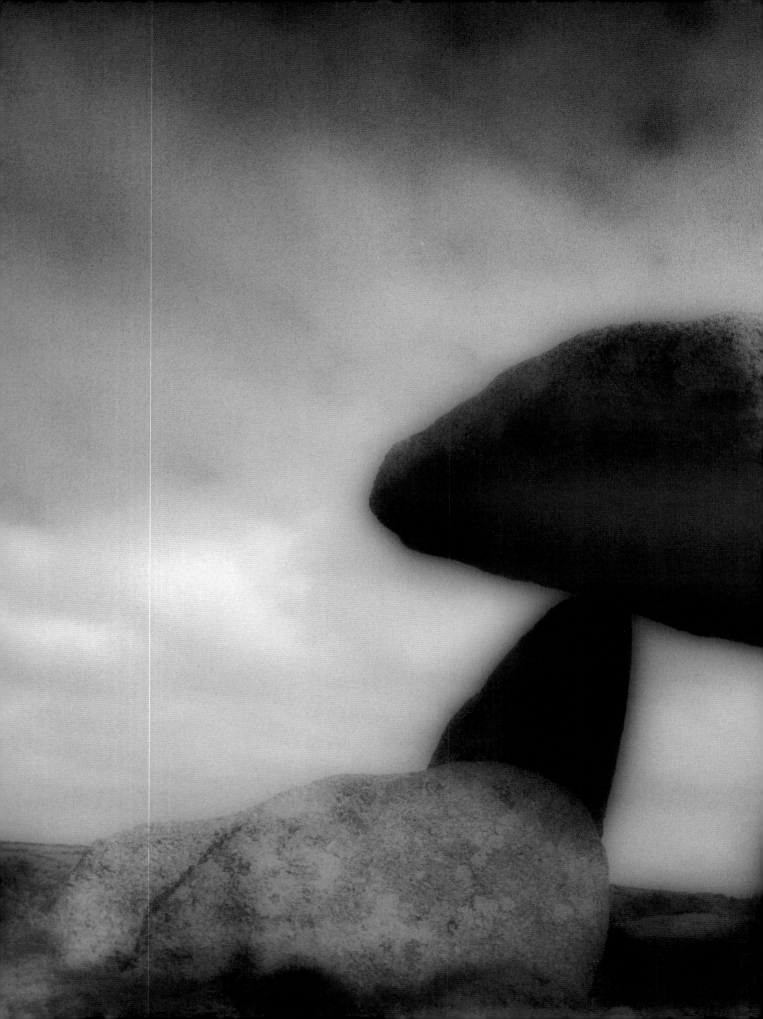

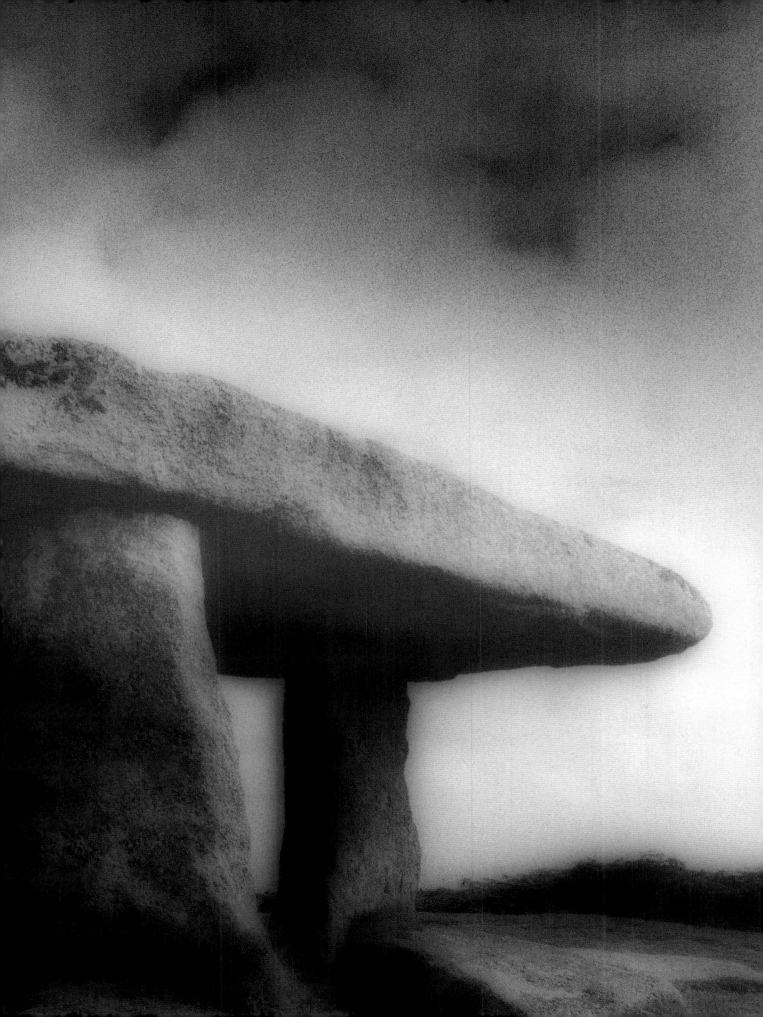

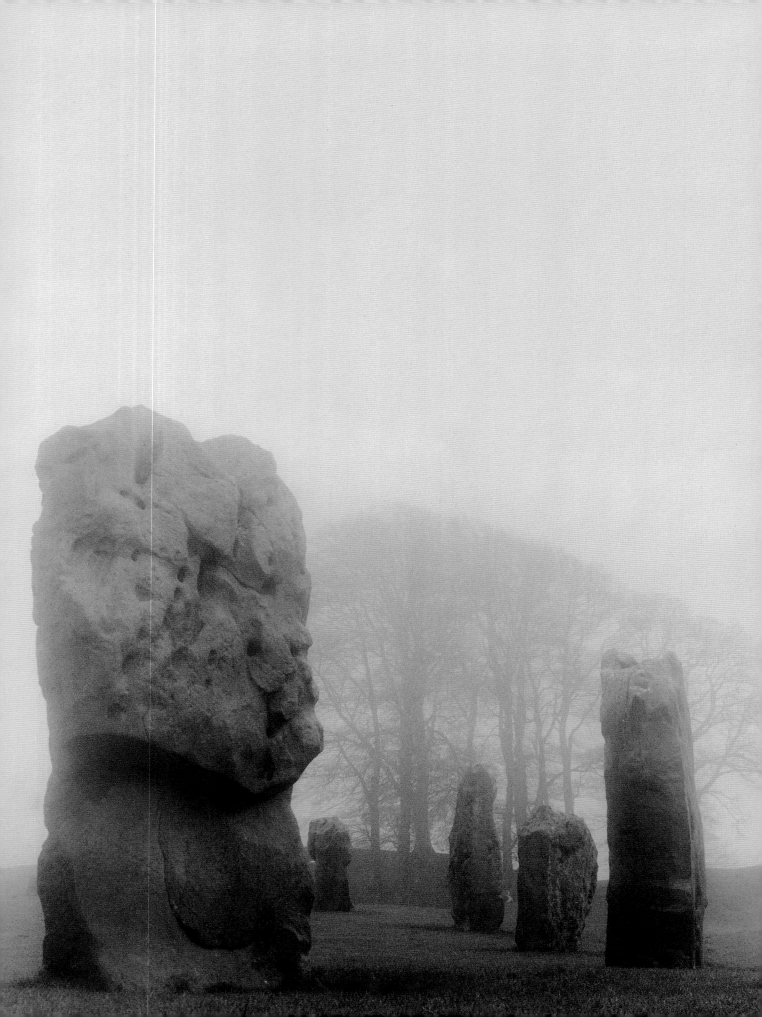

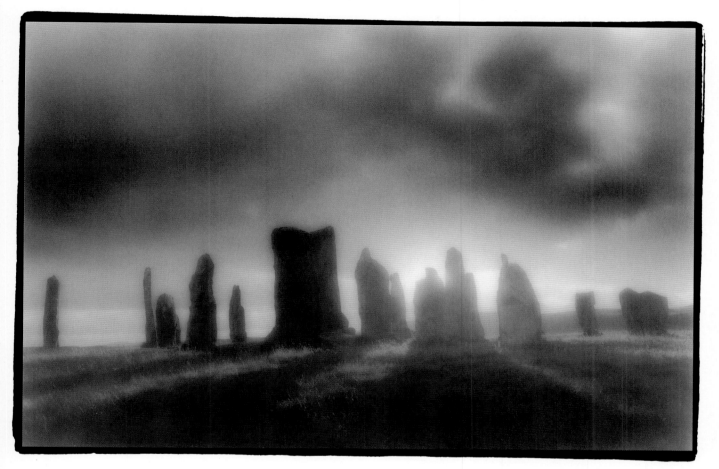

Callanish, Isle of Lewis

Avebury, Wiltshire Overleaf: Stonehenge, Wiltshire

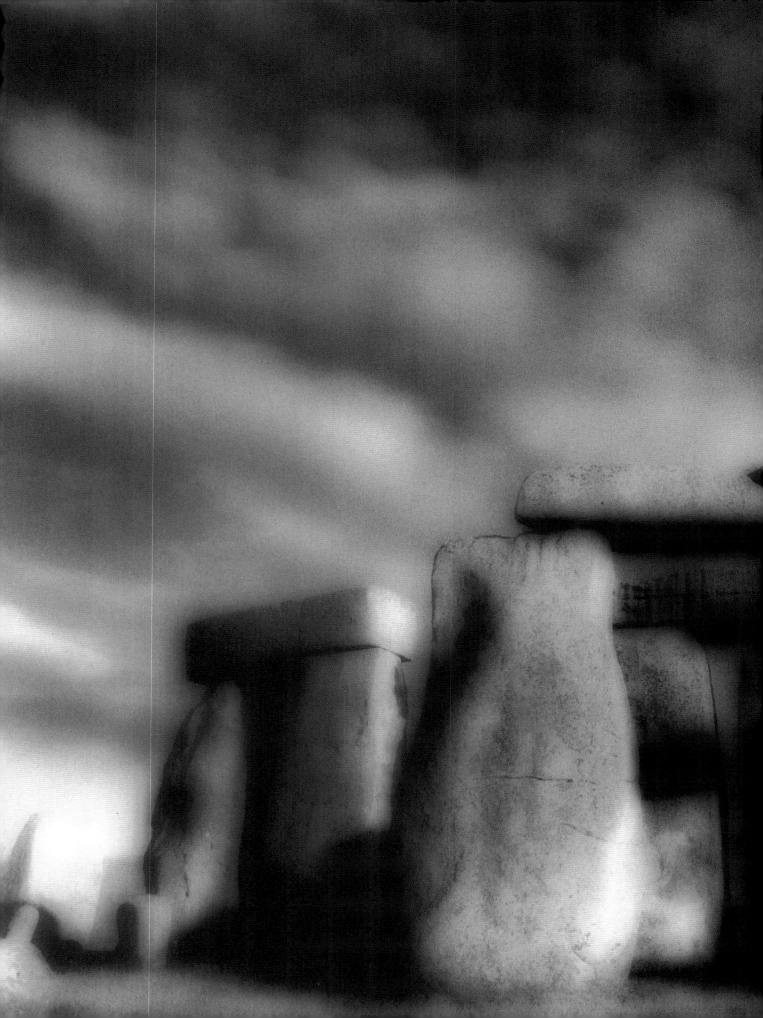

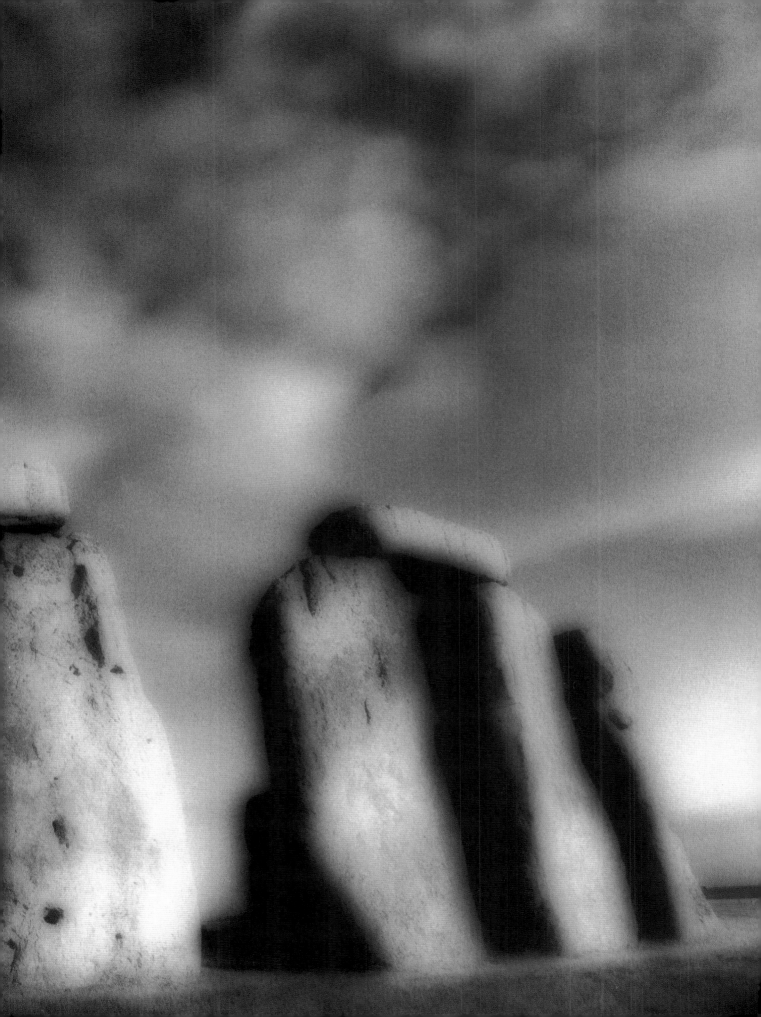

Head Hunters

PORTRAITS FROM PAPUA NEW GUINEA

Rod Macmillan

Rod Macmillan was born in England in 1947, and has lived for most of his life in East Anglia. He was introduced to photography and to travel by his parents who took him on extended overland journeys to Europe's least known corners. At seventeen, and travelling alone, he ventured into Africa for the first time. Enthralled by the sights and sounds of unfamiliar cultures he resolved, quite consciously, to explore the planet.

Over the years Rod has planned a series of journeys that have taken him to a hundred countries and all seven continents. His global curiosity and passion for photography have driven his search for extraordinary but honest images of the world. However, this quest has inevitably left its mark on the photographer. He is now acutely aware of the good fortune of the West, but convinced that material wealth and sophistication have been acquired at considerable cost. In particular he is concerned by the relentless erosion of cultural identity and the loss of traditional lifestyles.

His most memorable encounters have been with tribal people in remote area. In the last few years his search for traditional communities has taken him to most of the countries of Southeast Asia and South

America, as well as Tibet, Namibia and Papua New Guinea. He is a Fellow of both the Royal Photographic Society and the Royal Geographical Society, and has a number of exhibitions to his credit.

In creating this portfolio Rod has tried to capture, through the faces of ordinary people, the harsh yet attractive reality of life in the Highlands of Papua New Guinea. The subjects were not positioned, manipulated or paid to create pictures – they were just there at the time. Indeed, with this style of photography in mind, part of the art of approaching people is to do so in a manner that minimises disturbance. Their adornments are not a product of tourism, but preparation for singsing – a traditional combination of feasting and dance. The work is therefore candid insofar as it is totally honest, but not in the fly-on-the-wall sense. Rod calls this type of work real-world portraiture because it portrays people as they really are in an engaged manner.

A stunning variety of endangered tribal identities is revealed by his portfolio. However, despite superficial differences, a common thread emerges – the essential humanity and dignity of tribal people.

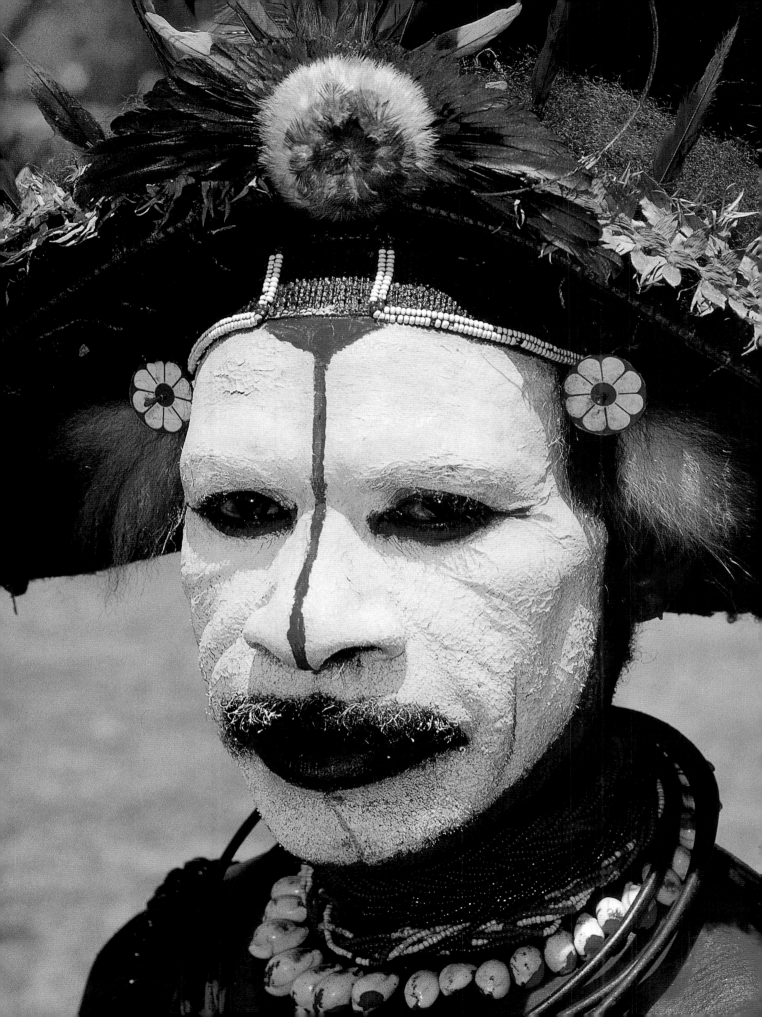

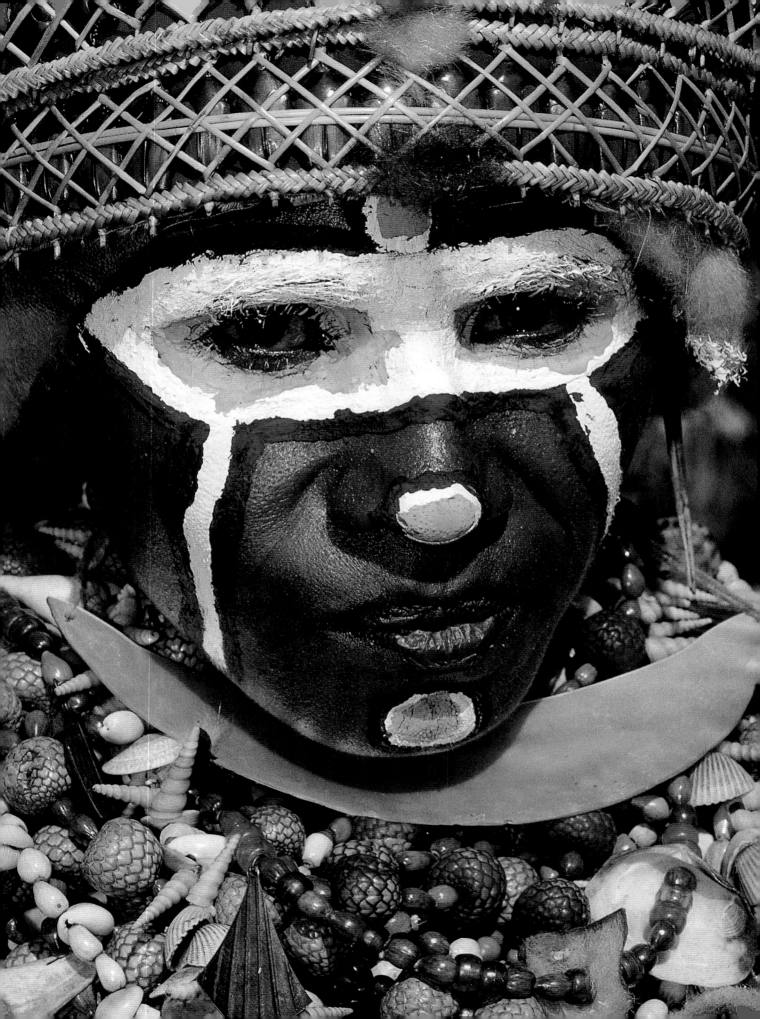

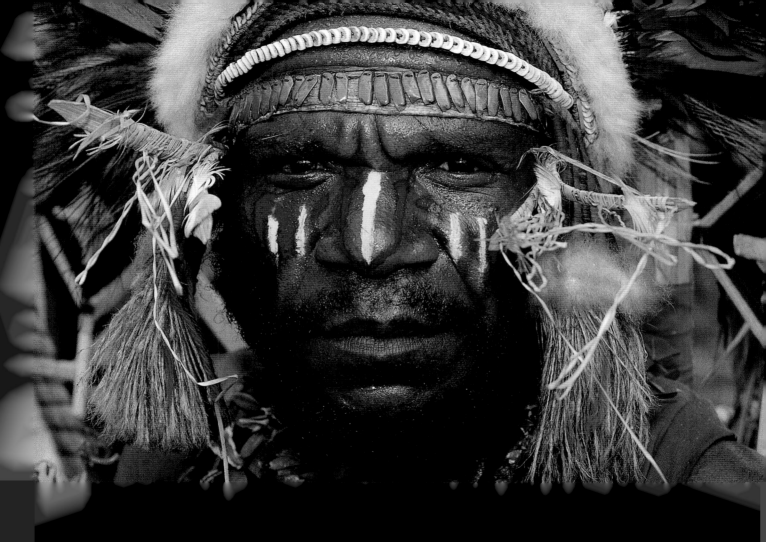

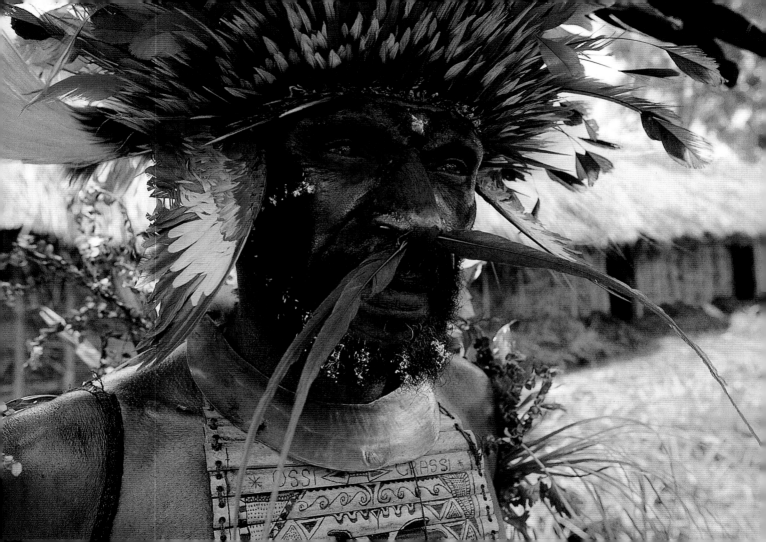

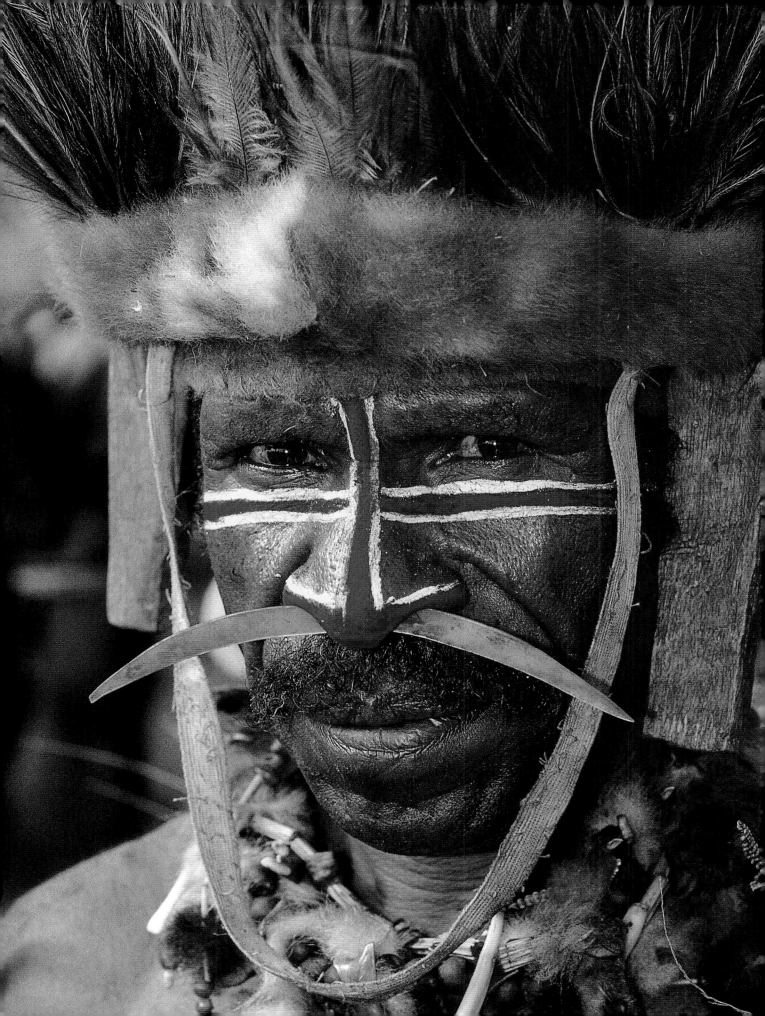

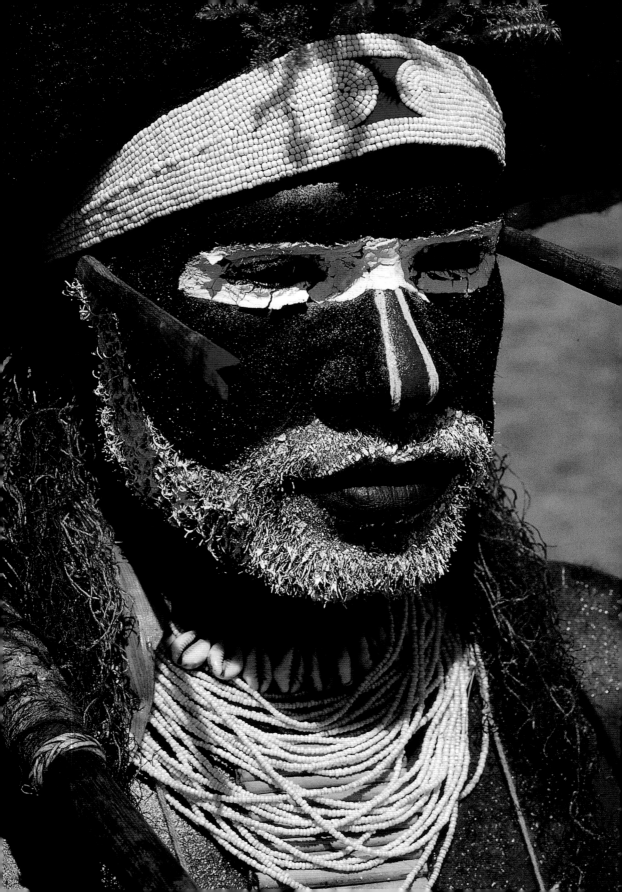

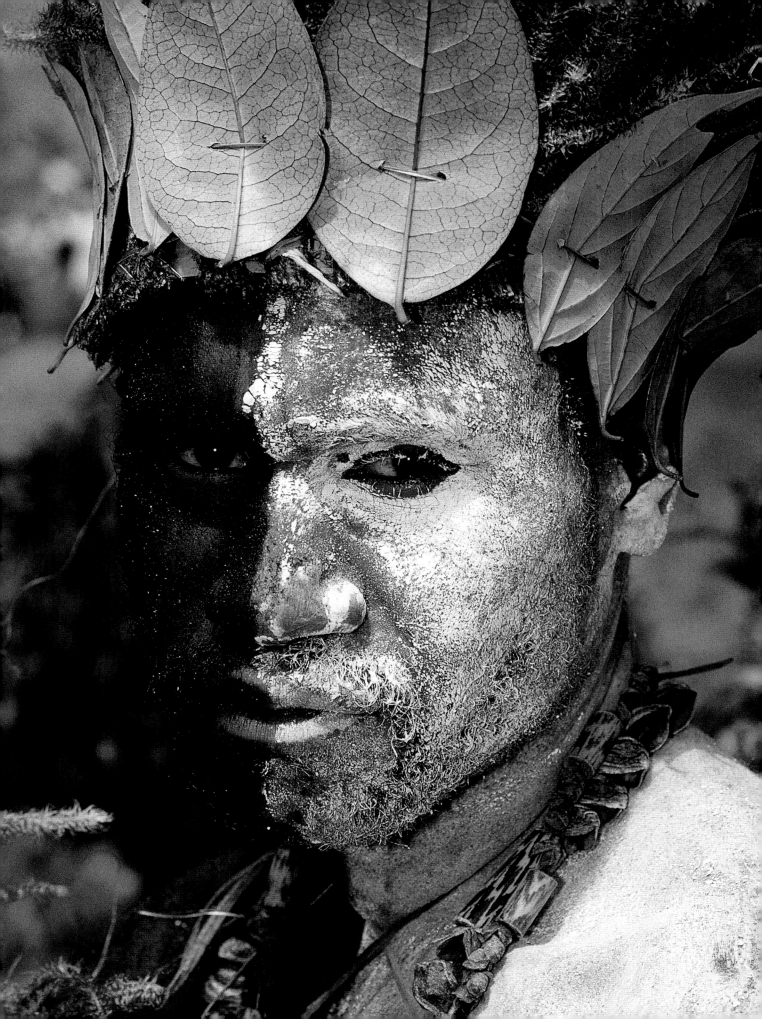

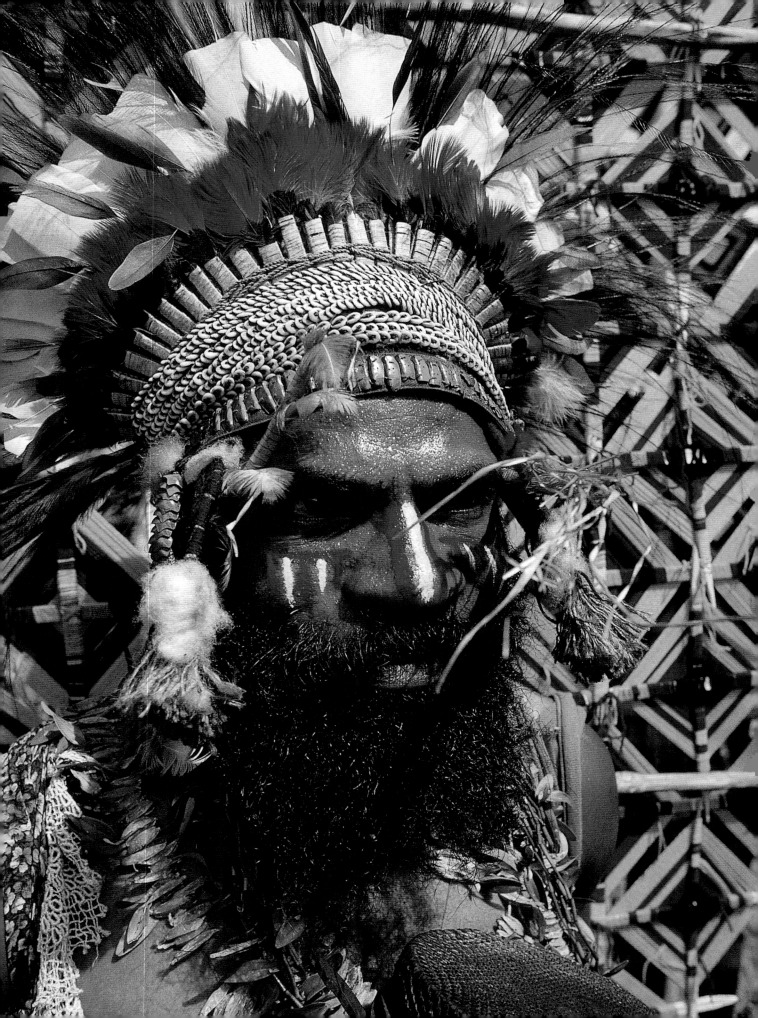

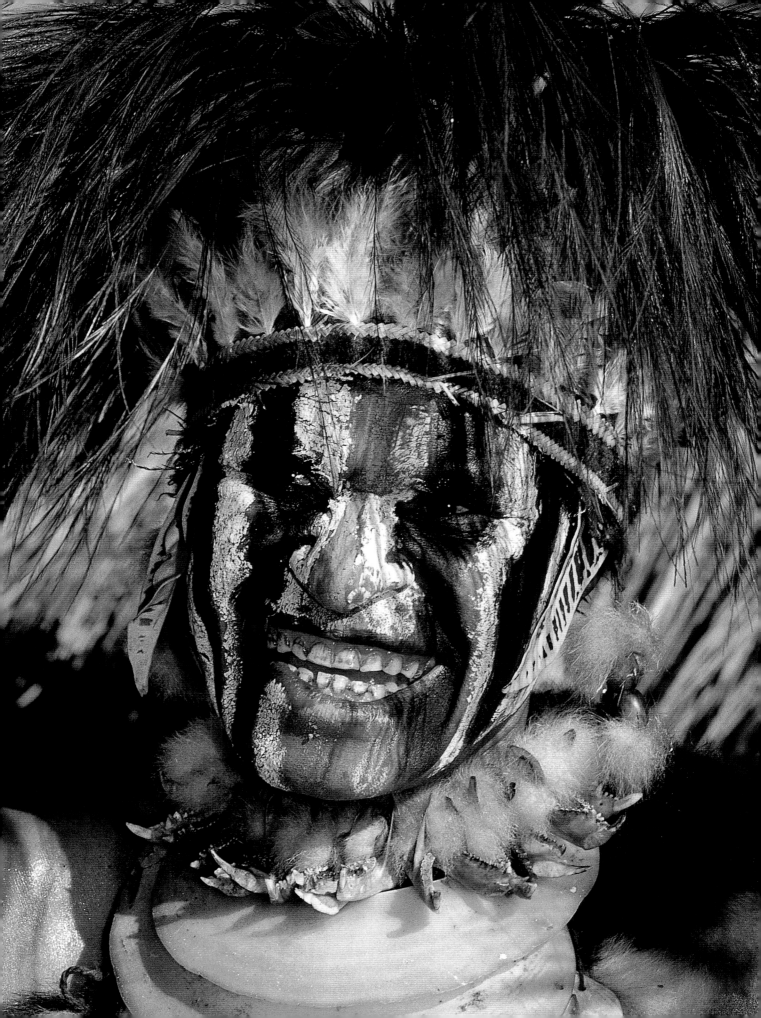

IN PRAISE OF
TREES
Noël Kingsley

Noël Kingsley started photography in the late 1960s. Since then his enthusiasm for the subtlety and expressive mood of monochrome photography has continued unabated, with his main subjects being trees and informal portraiture.

Using Hasselblad equipment, Noël gives great attention to technical detail and seeks to create fine art prints in the traditional manner. He believes that the making of a fine monochrome print is reliant on creating a high quality negative with sharp details in both shadows and highlights. His methods include making very accurate exposure of the film and he favours dilute Dixactol developer as a means of producing luminous, glowing prints.

He started photographing trees in 1995 almost to the exclusion of other subjects. Noël's approach is to show them as they are in their environment, be it park or country. They are not necessarily trees of extraordinary beauty, but simply by a delicate ray of early morning light, they become vibrant and alive.

Most of the trees represented here are to be found within a few miles of London. The experience of calm and connection with nature that one can feel whilst being among trees has been an inspiration to Noël.

"Through my work I want to draw attention towards their individual character and beauty, and to reveal some of the spirit of these beings, how they radiate energy, quietly and powerfully, permeating their surroundings with their enduring quality and stillness."

Noël has had several solo exhibitions in London, and work accepted for major International Exhibitions. Organisations commissioning his work include the Woodland Trust in the UK for whom he has produced special limited edition prints. He is an Associate of the Royal Photographic Society.

To see more of his work visit www.noelkingsley.com

To contact Noël Kingsley email to info@noelkingsley.com

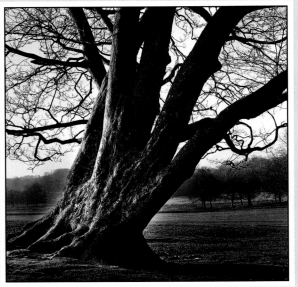

Hand '98

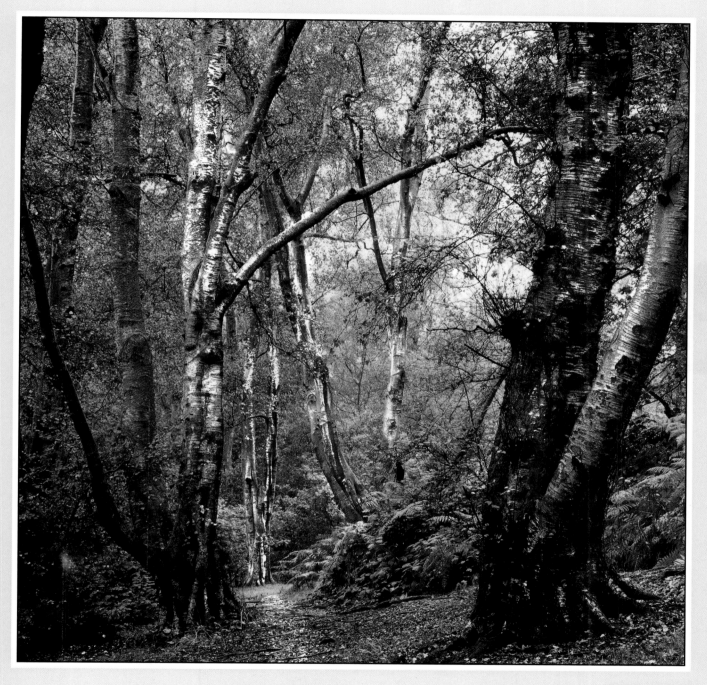

Birchwood '99

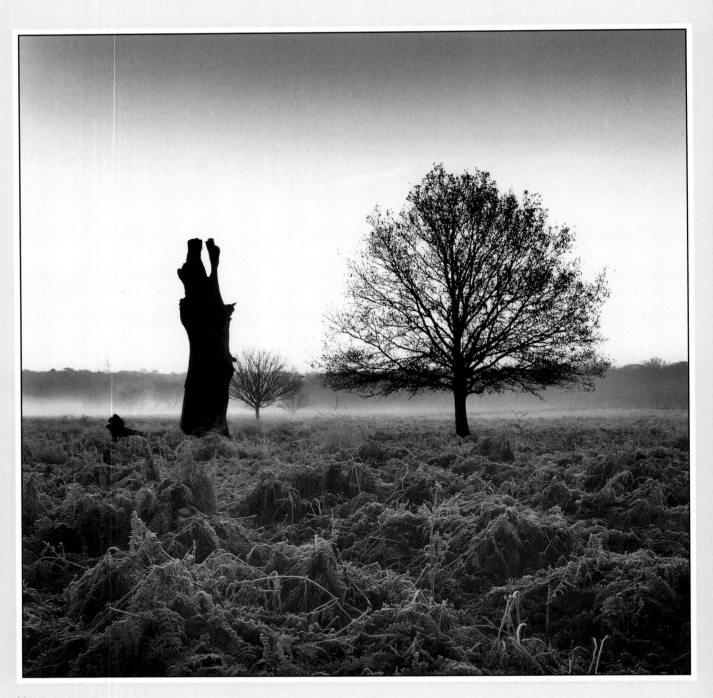

Monument #2

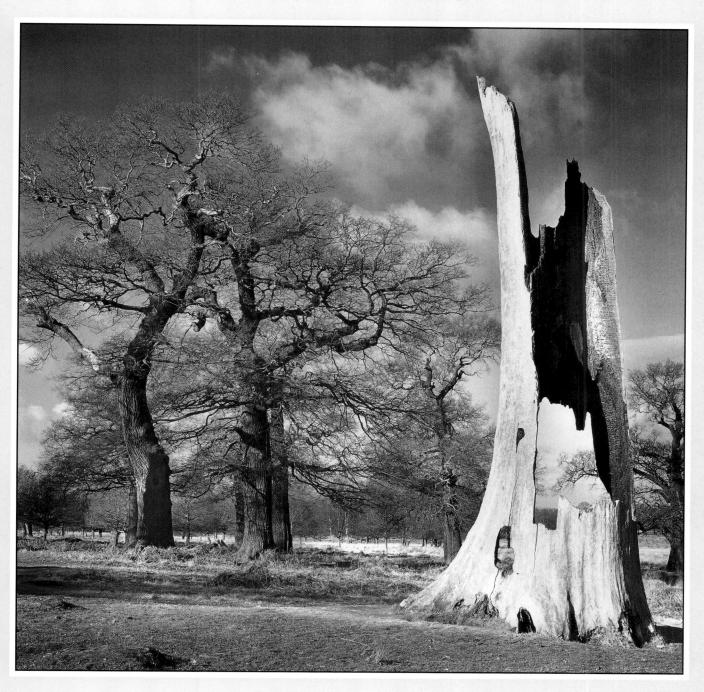

Monument #1

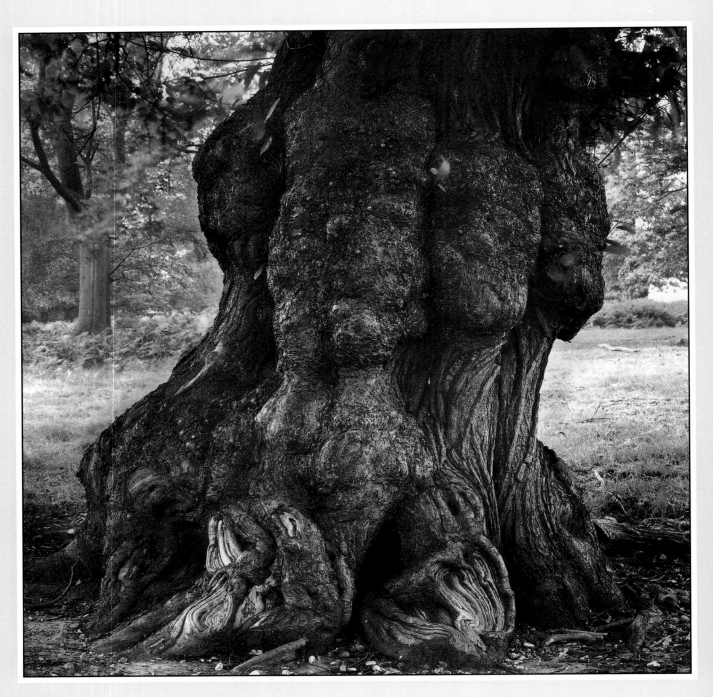

Chestnut #1

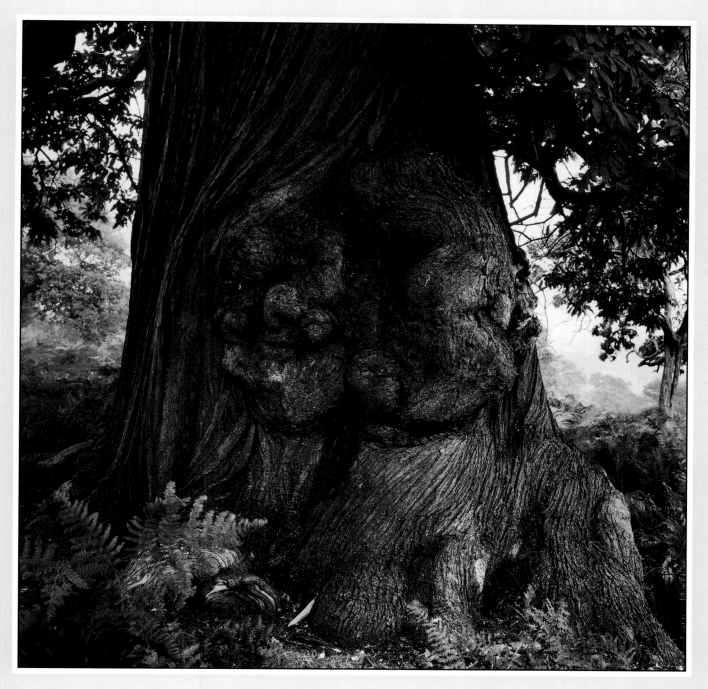

Chestnut #5

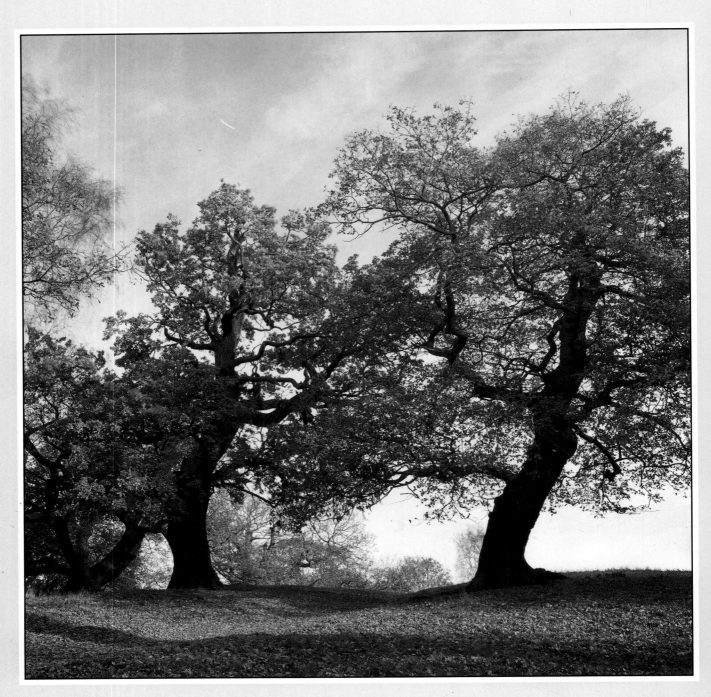

Oaks in silhouette

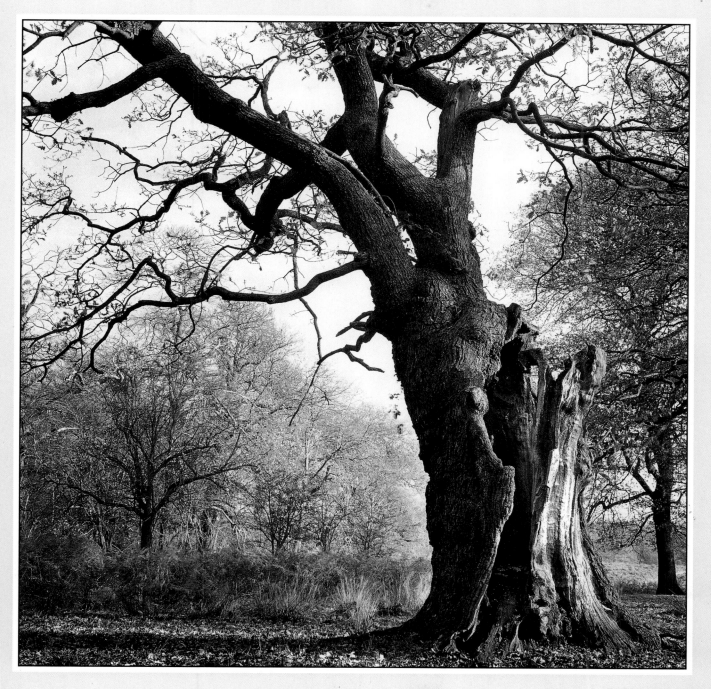

Broken Oak #2

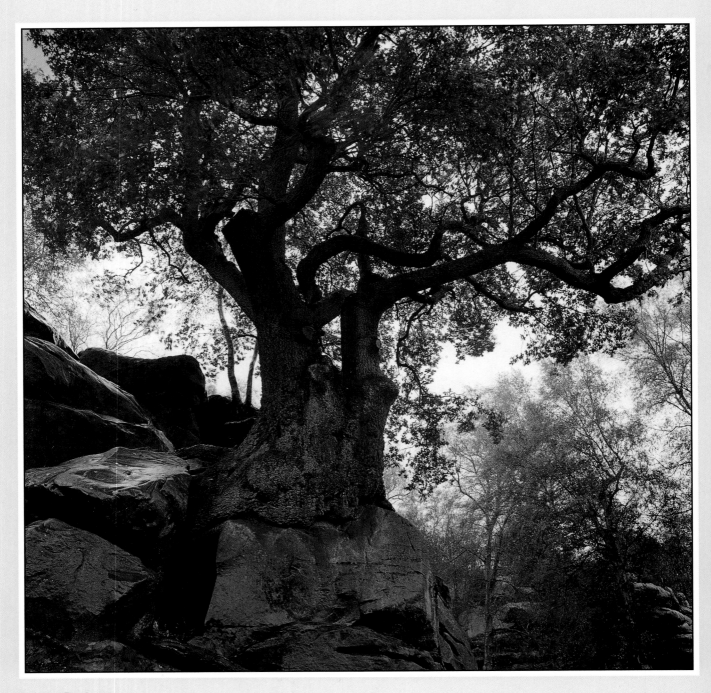

Oak on Rocks #1

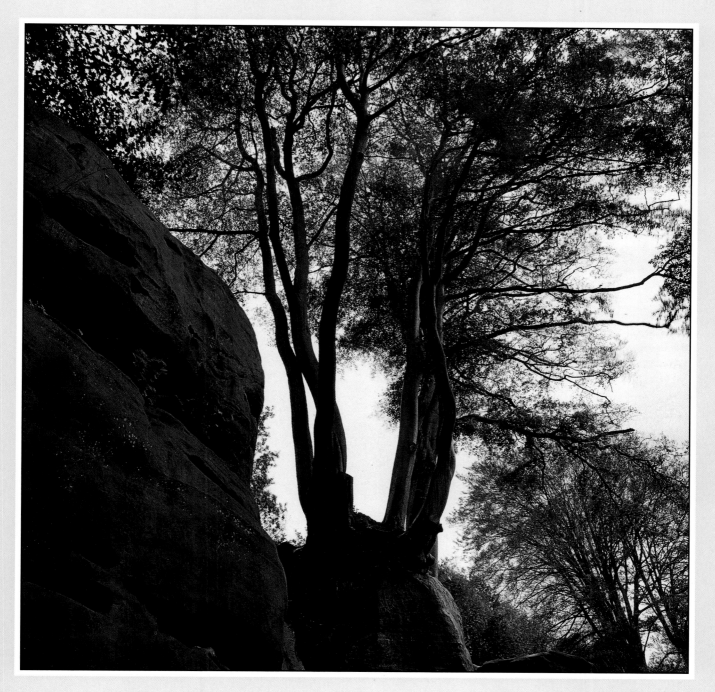

Beech on Rocks

The Photographers

Charles H. Miller
USA
Outrageous face, Studio

Nikon 8008 Nikkor 105mm
Kodachrome 64

84

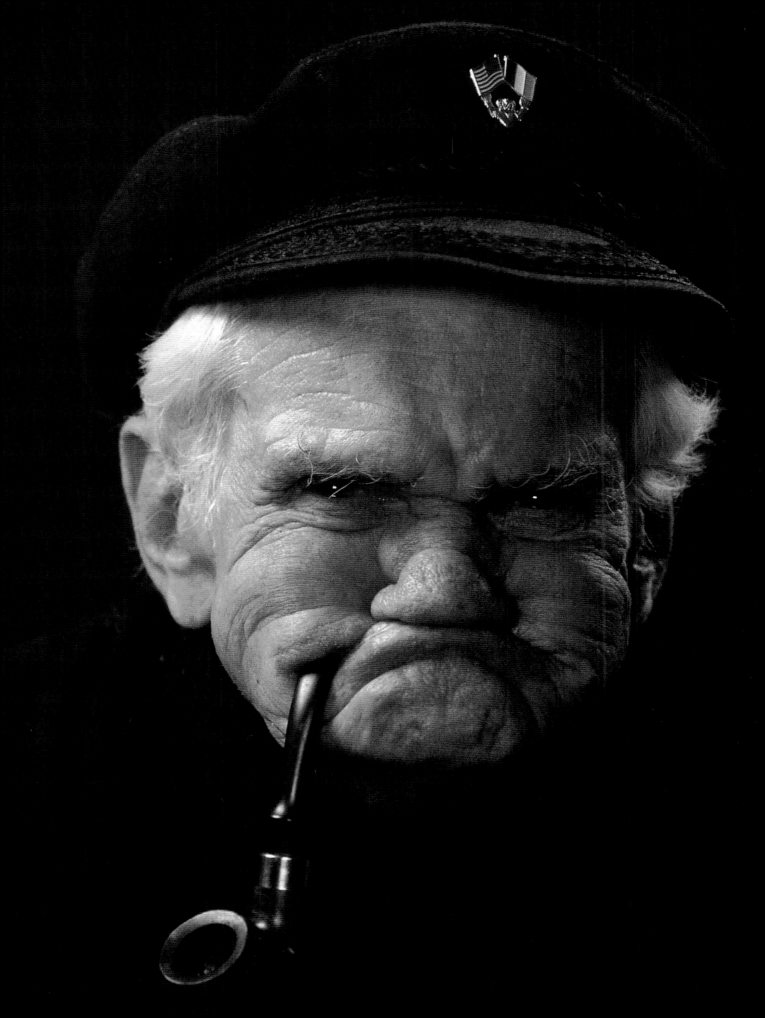

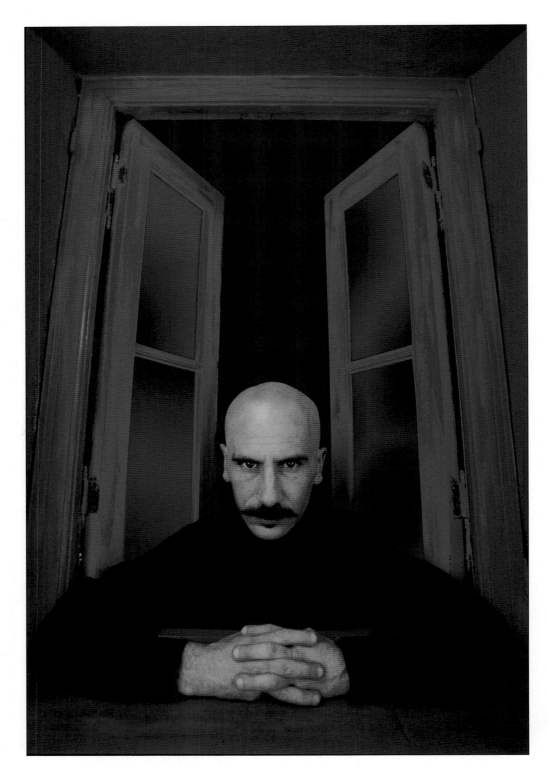

Jorge Hermida
ARGENTINA
Buenos Aires, Argentina

Nikon F90X Nikkor AF20mm
Fujichrome Sensia

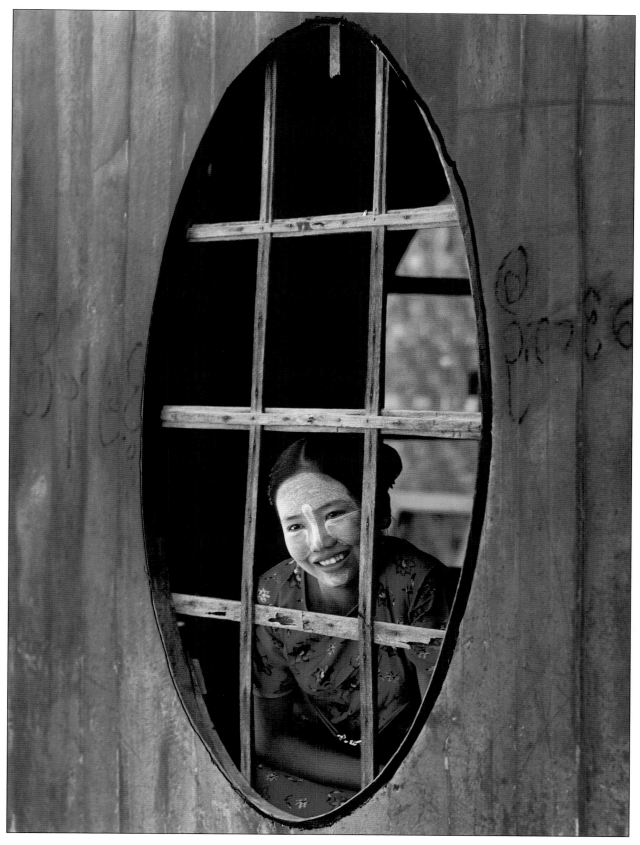

Yee Chung Lam
HONG KONG
A happy Burmese girl

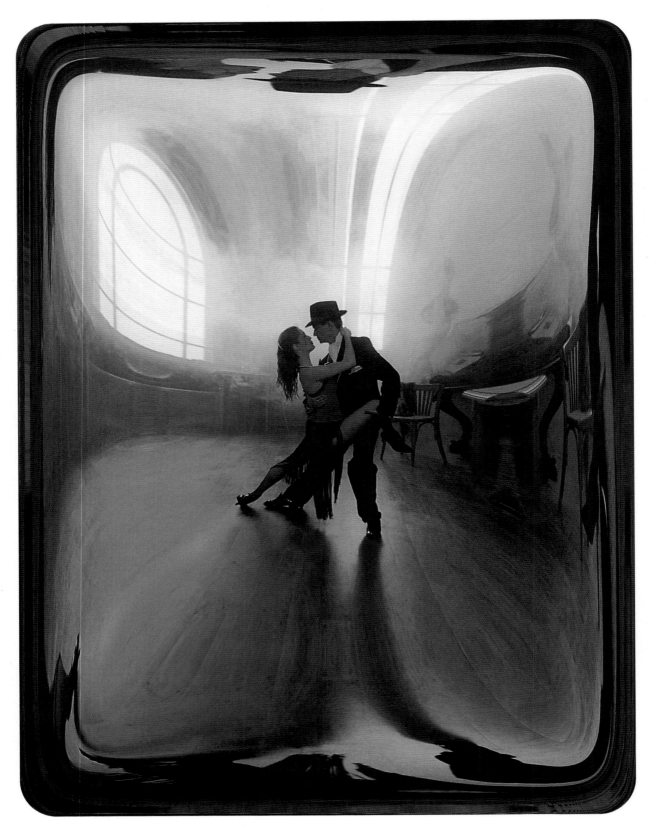

Francisco Pace
ARGENTINA
Buenos Aires, Argentina

Nikon F2AS 105mm
Fujichrome 160 ISO

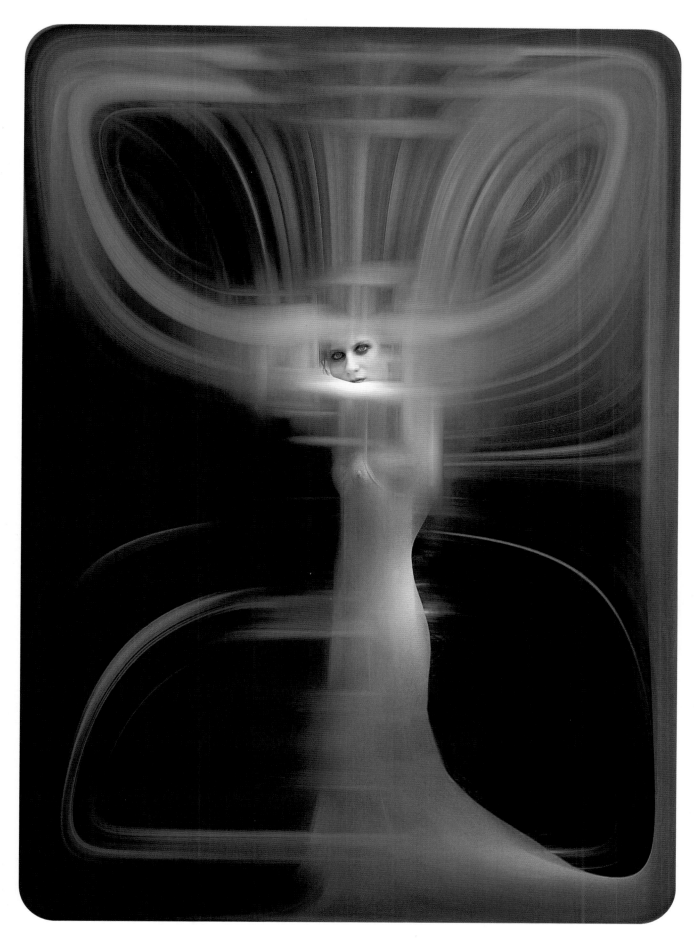

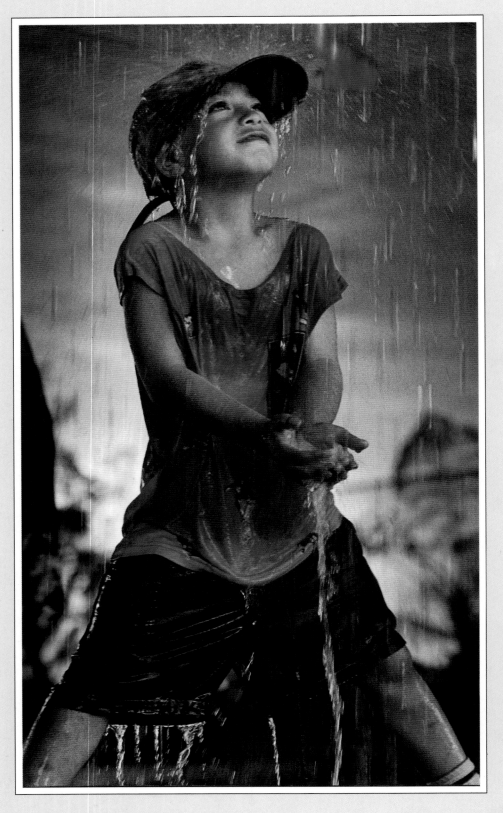

Kien Long Khuu
AUSTRALIA
Darling Harbour, Sydney, Australia

Canon EOS5 Canon EF 70-200mm Kodak 400

Long Thanh
VIETNAM
April shower

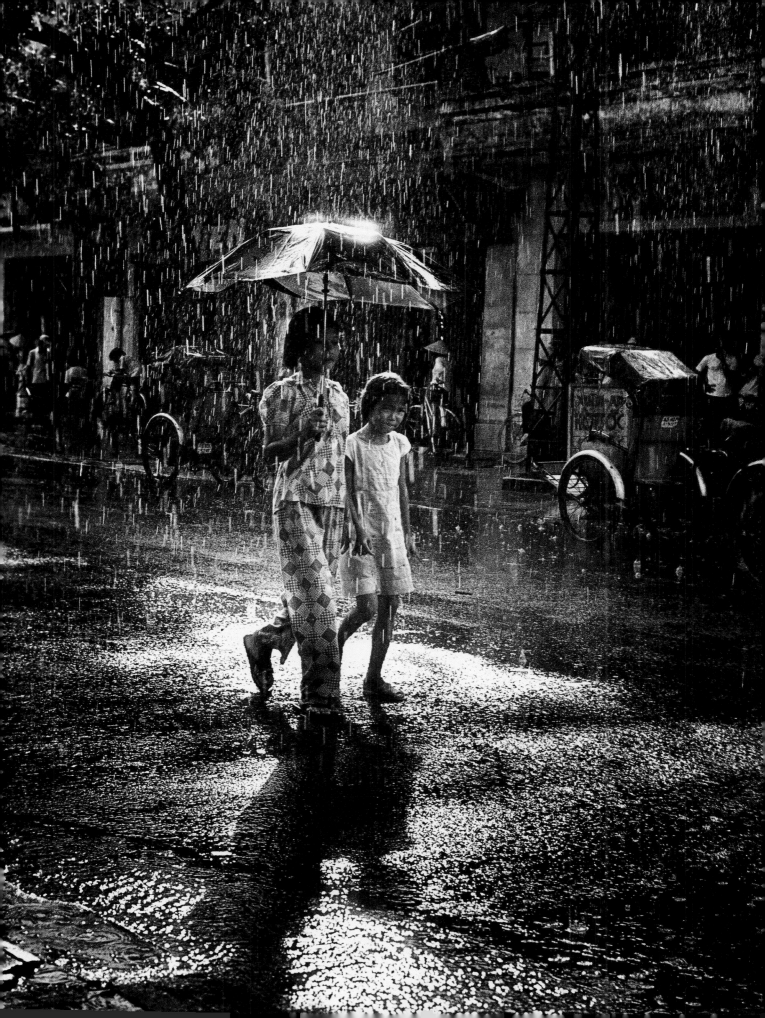

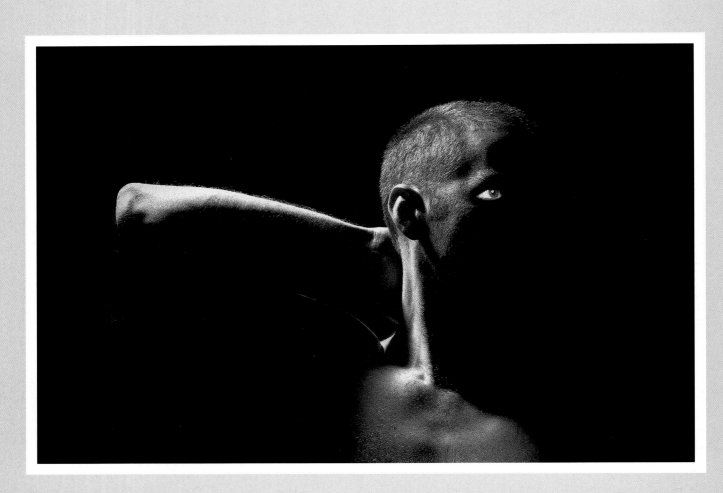

Elisabeth Steffen
SWITZERLAND

Studio

Minolta 700SI Minolta Macro 100mm
Ilford Delta 100

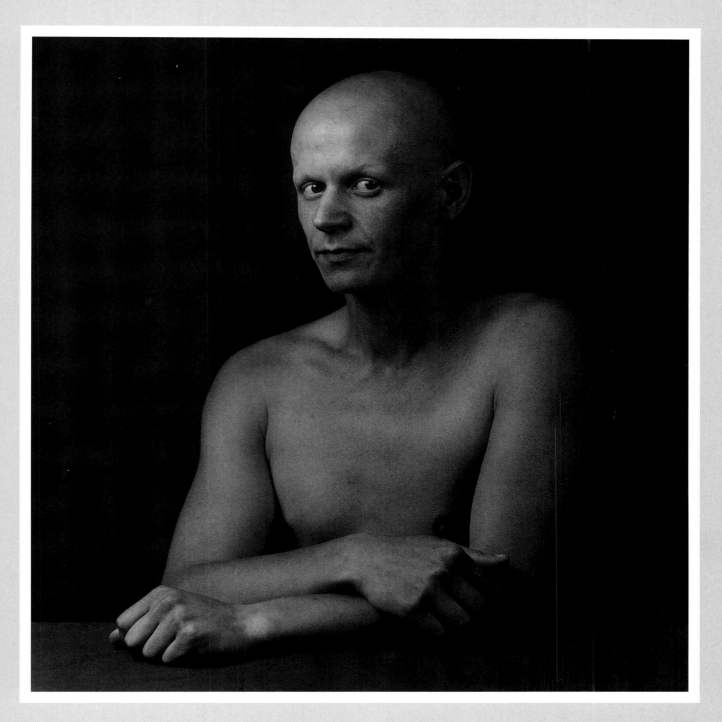

Gines Asensio
SPAIN
Studio

Hasselblad 500CM Zeiss
Sonnar 180mm Ilford FP4

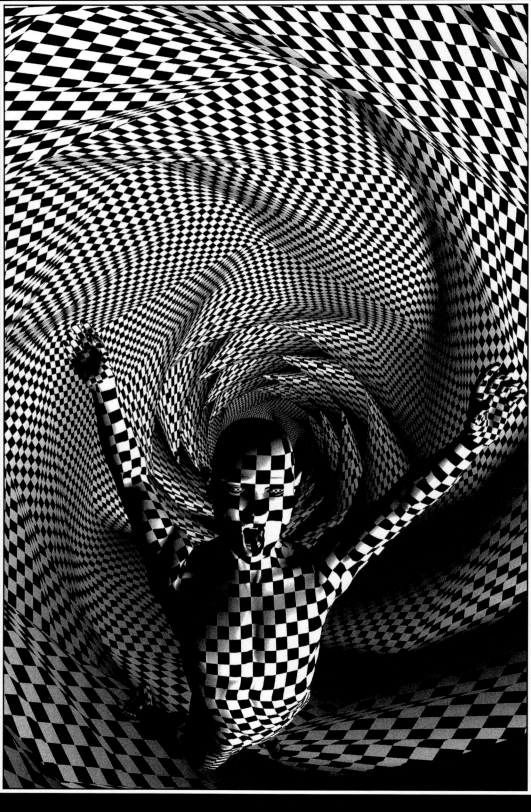

Erwin Rybin
AUSTRIA

Vienna, Austria, Studio

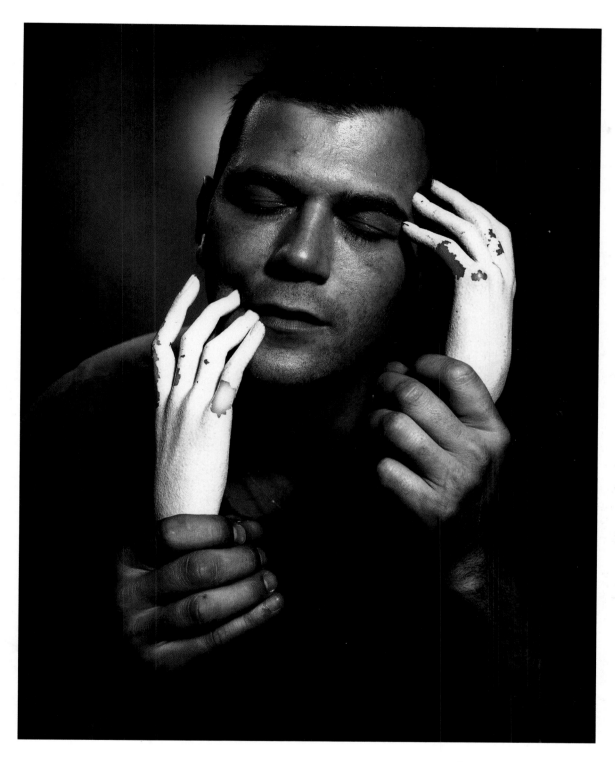

Antonio Arabesco
SPAIN

Studio

Pentax 645 Pentax 55mm
Agfa Scala 200

Tommy Seiter
AUSTRIA

Studio

Canon EOS50 Canon 28-105mm
Kodak T Max 400

97

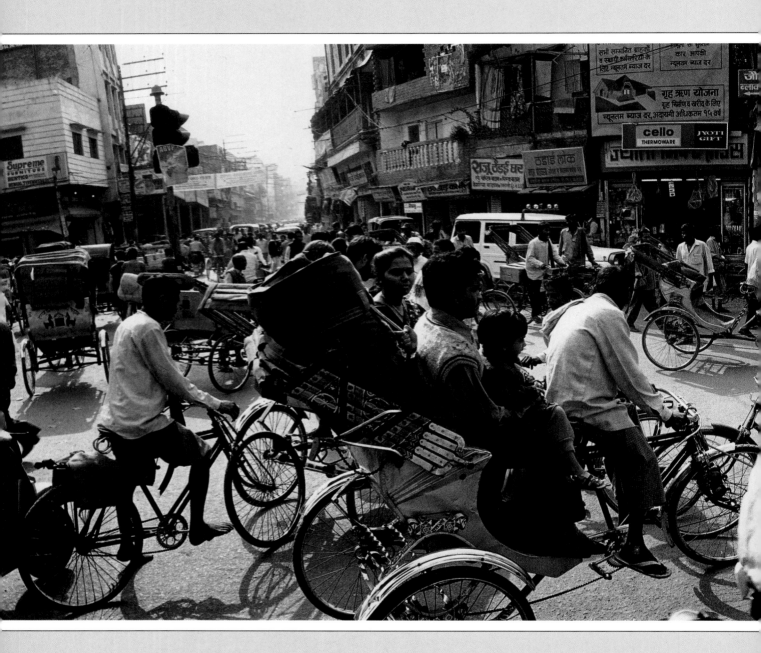

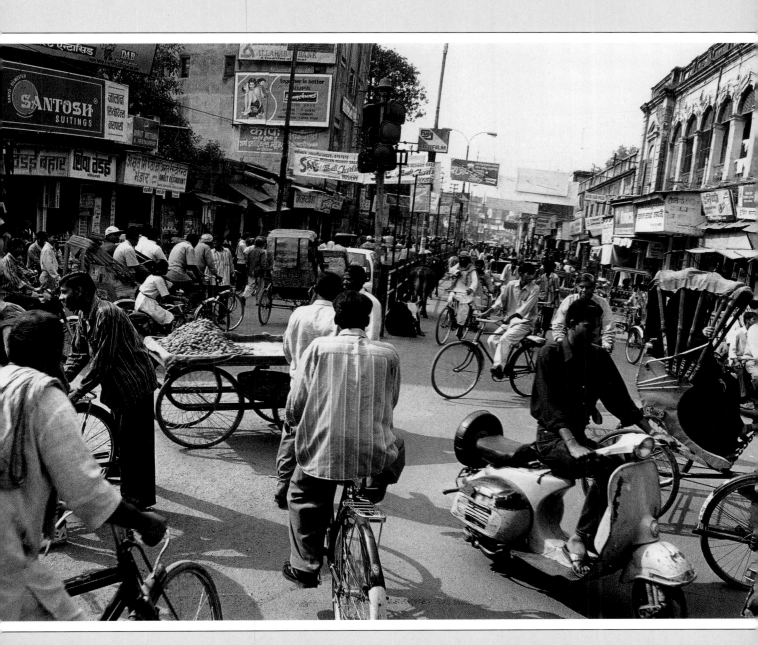

Helio Hickl
SWITZERLAND
Waranasi, India
Noblex 135 29mm Ilford HP5

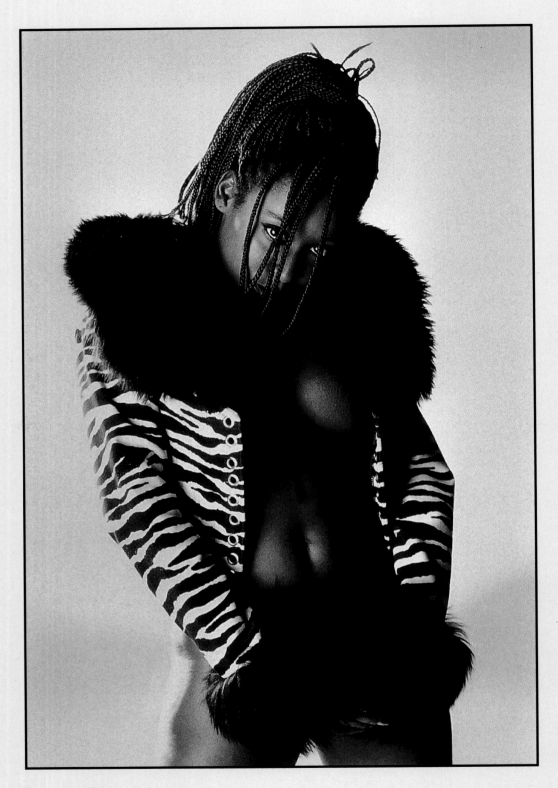

Andreas Papez
GERMANY
Studio shots

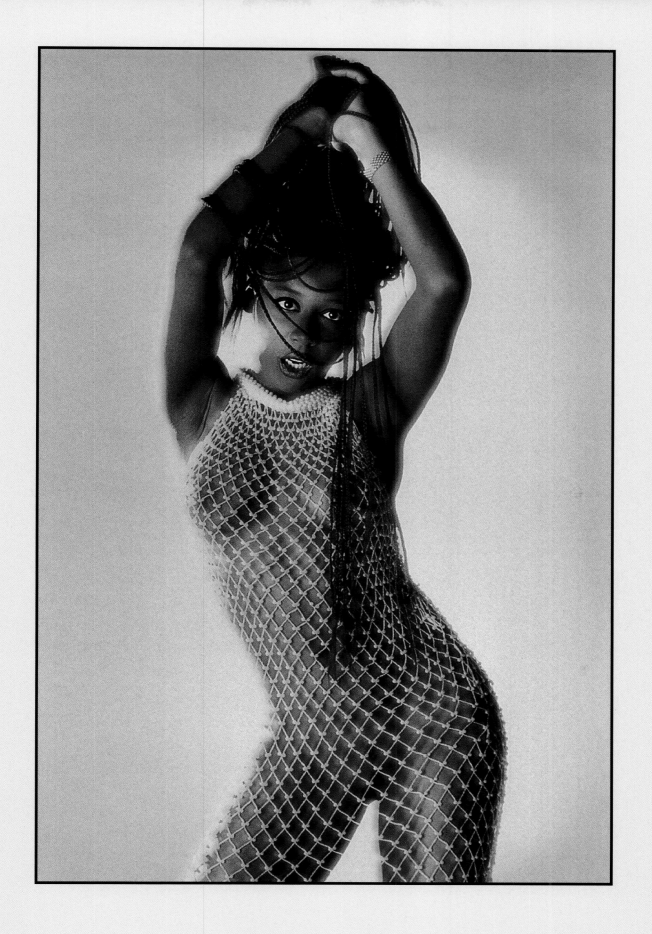

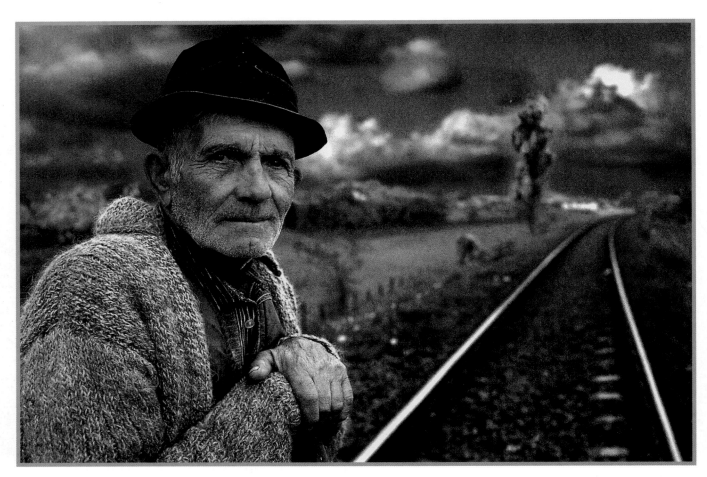

Giulio Montini
ITALY
Maramures, Romania

Minolta 700SI Minolta 35mm
Fujichrome Velvia

Wolfgang Stark
GERMANY
Meerfeld, Eifel, Germany

Canon T70 Tamron 60-300mm
Kodak plus X Pan

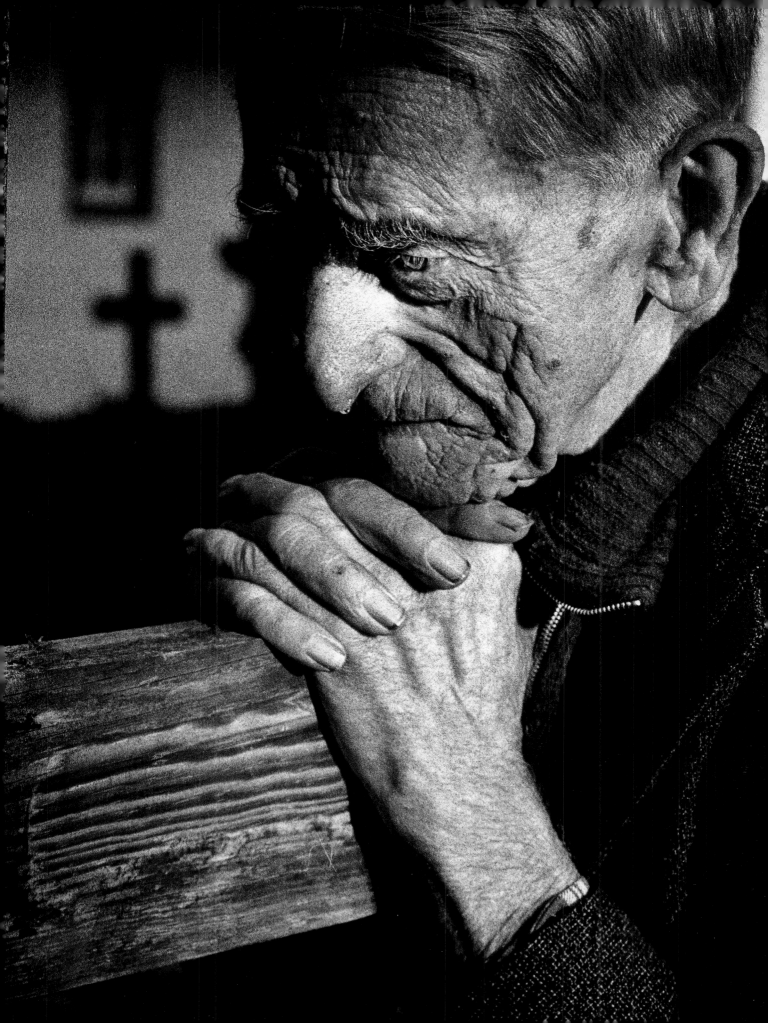

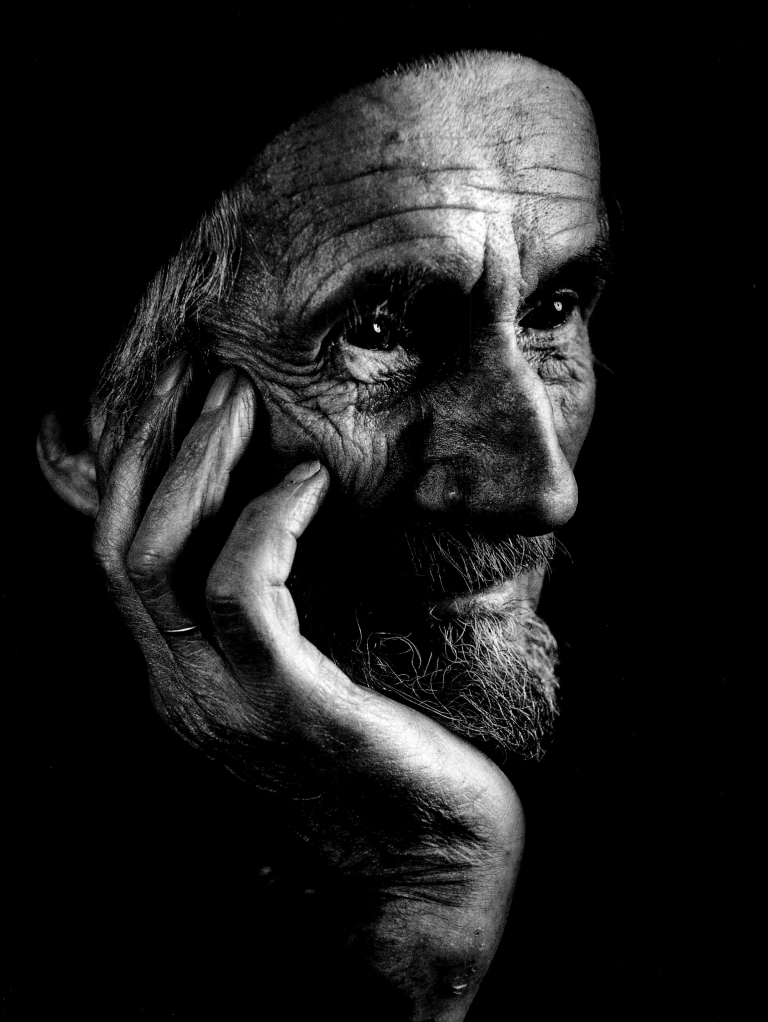

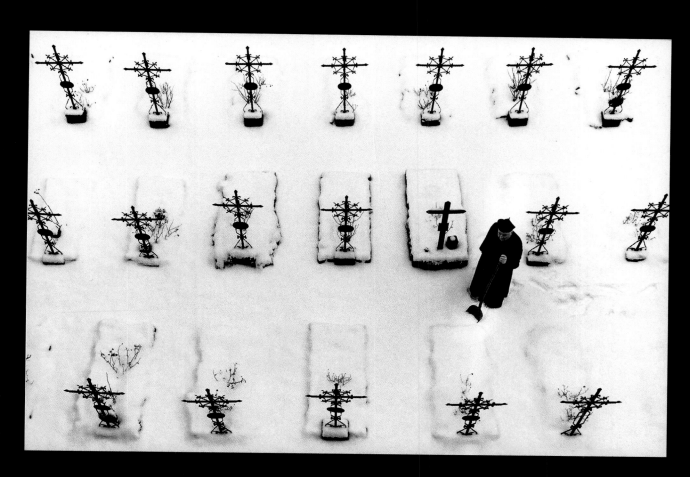

Wolfgang Oberascher
AUSTRIA

St. Florian, Austria

Canon EOS100 Tokina 70-200mm
Ilford Delta 100

Manfred Haidorfer
GERMANY

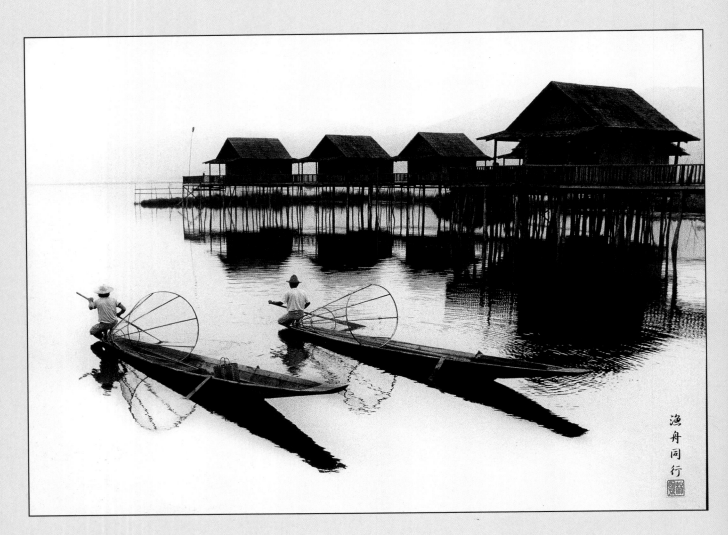

Lim Kok Huat
SINGAPORE

Inle Lake, Myanmar

Nikon F5 Nikon 80-200mm
Kodak Tmax 400

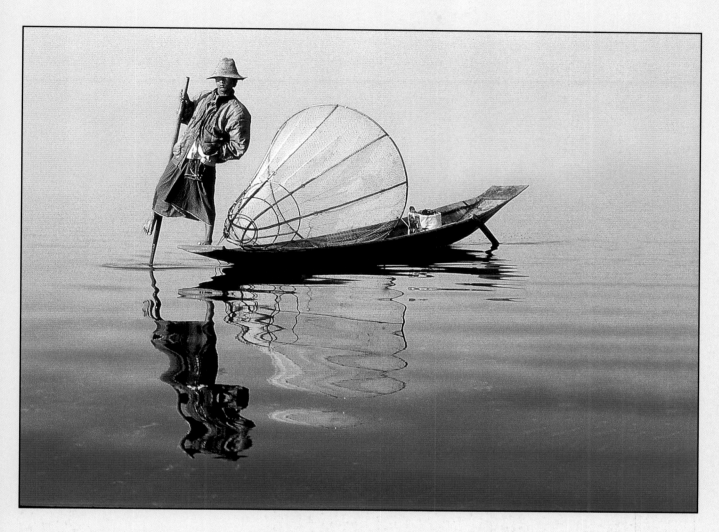

Willy Spegelaere
BELGIUM
Inle Lake, Myanmar
Nikon F70 Sigma 70-200mm
Fujichrome Sensia

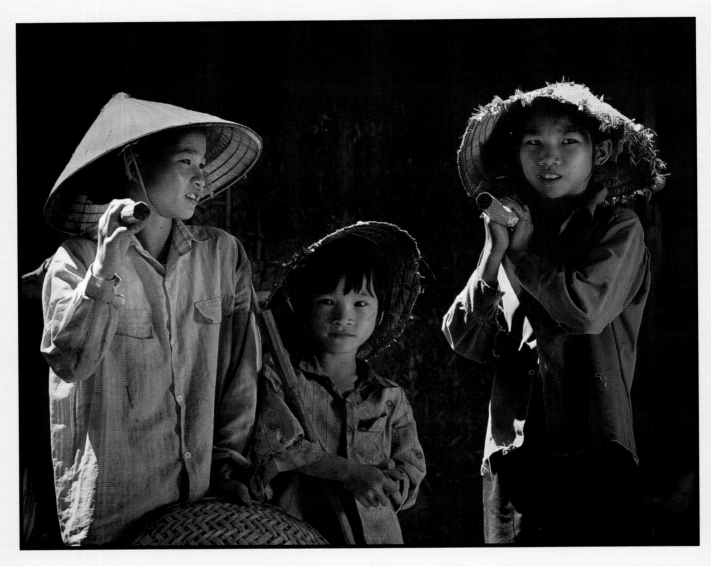

Lee Kee Hiang
SINGAPORE

Hanoi, Vietnam

Hasselblad 503CW Hasselblad 120mm Marco
Kodak Gold-GA

Nguyen Ba-Nhan
VIETNAM

Near Dalat City, Vietnam

Nikon FE Nikkor 50mm Fujichrome 400

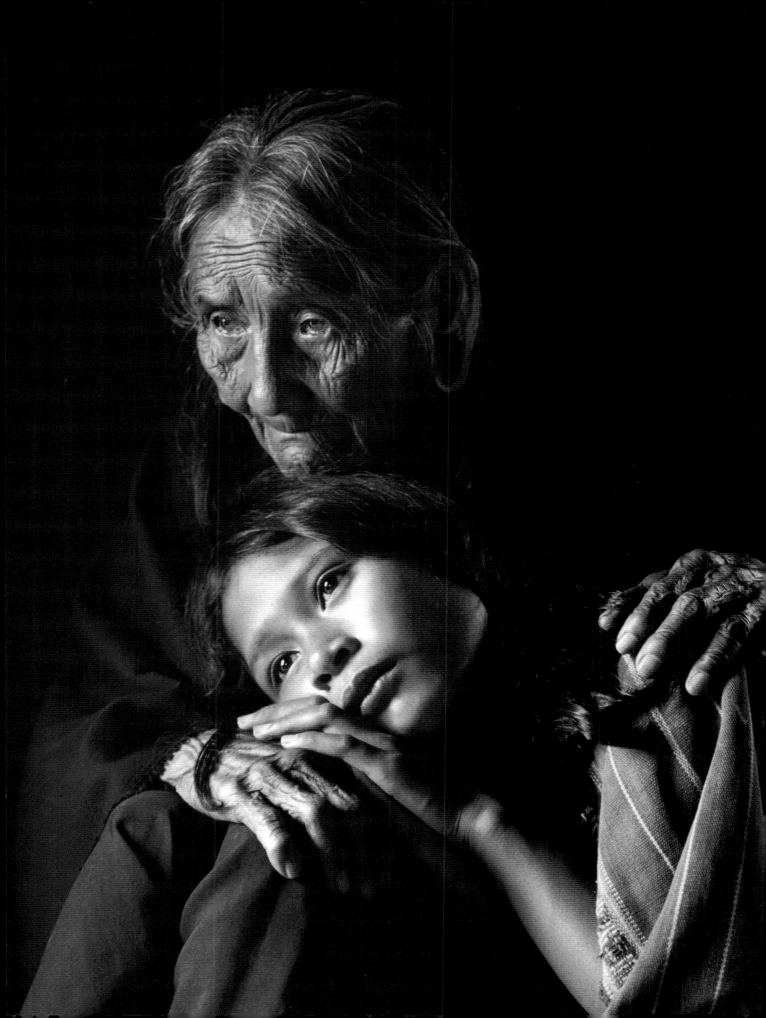

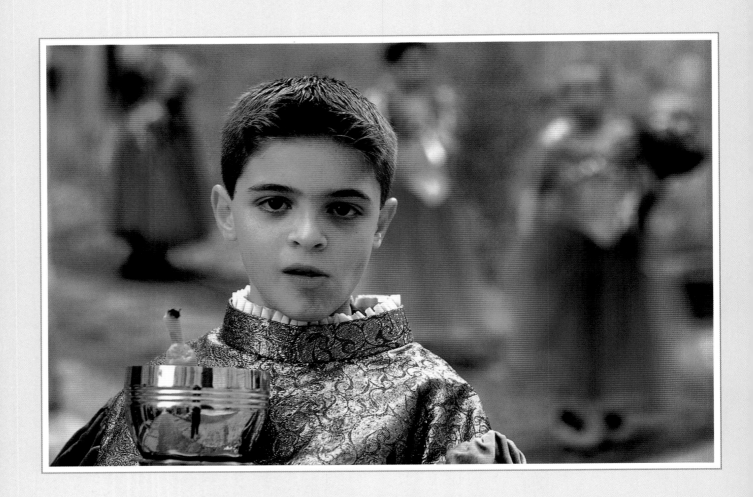

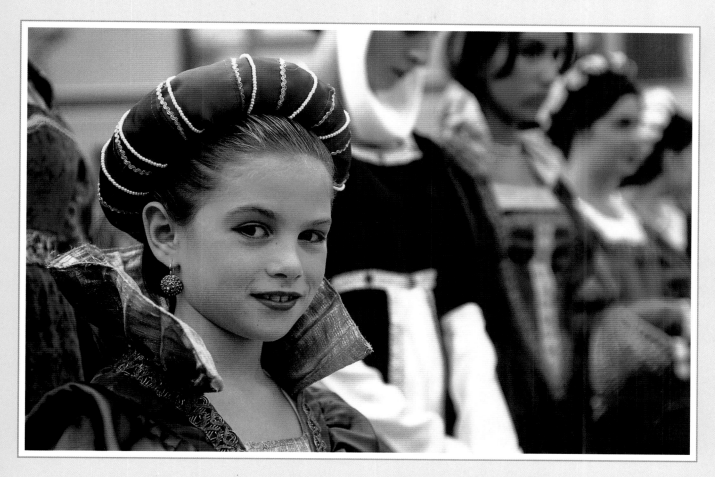

Enzo Gabriele Leanza
ITALY
Festival in Mussomeli, Sicily
Nikon F70 Nikkor AF-D 85mm Fujichrome Velvia

Elena Martynyuk
UKRAINE

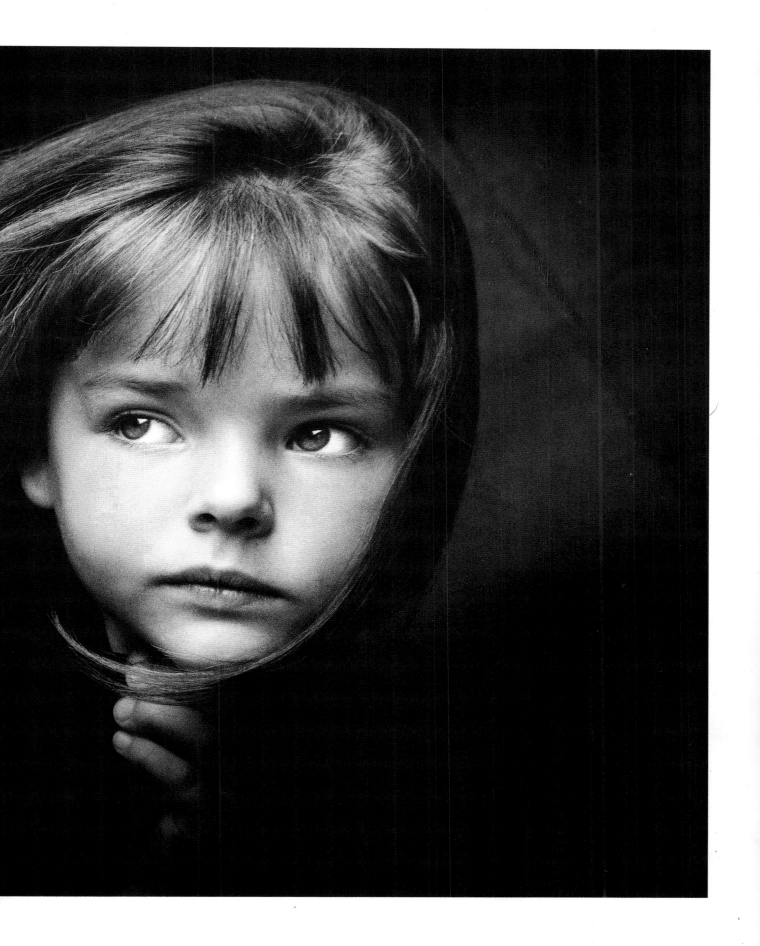

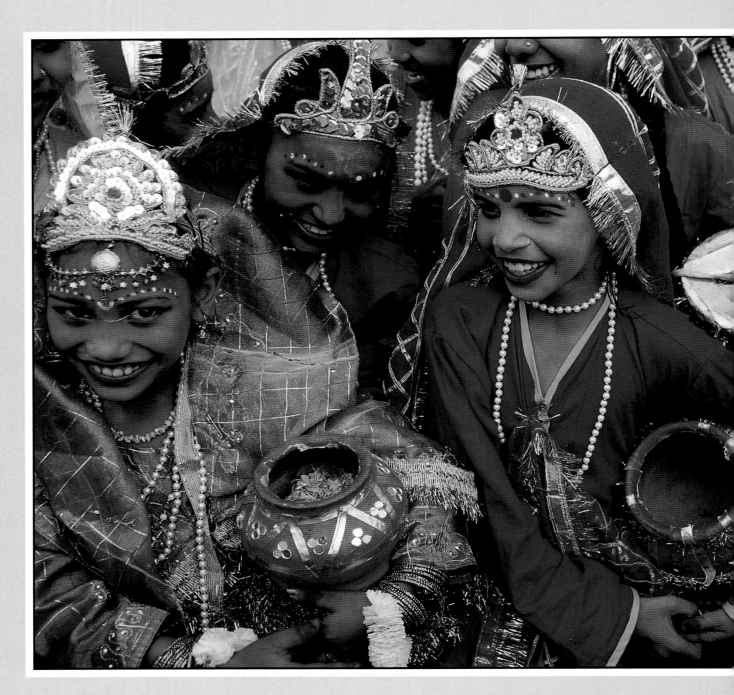

S. Paul
INDIA

Delhi, India

Nikon F601 Nikkor 28-85mm
Fujichrome Sensia 100

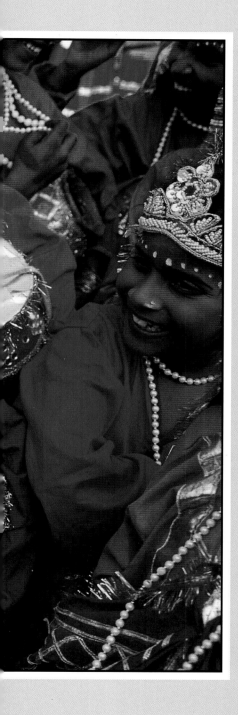

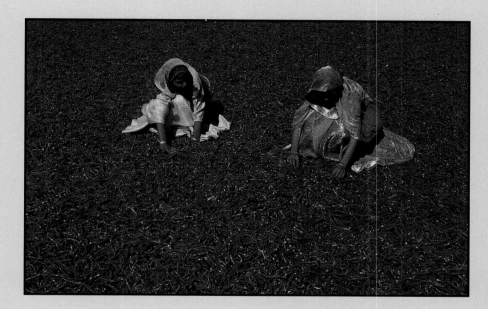

Shivji
INDIA
A village near Jodhpur
Nikon FM2N Nikkor 50mm f/1.8
Fujichrome Velvia

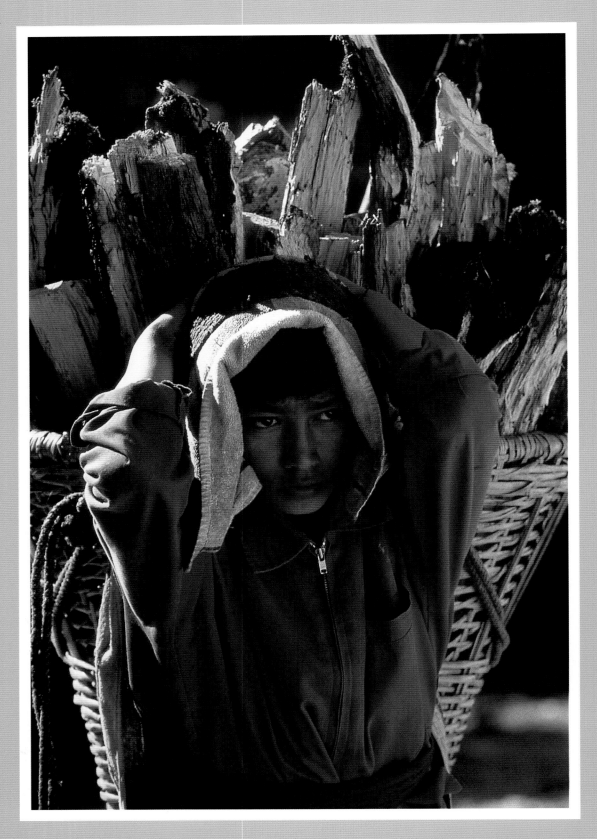

Yip Weng Chow
SINGAPORE

Heavy load, Nepal

Nikon F90X Nikon 105mm Micro
Kodak EPP

Tahsin Aydogmus
TURKEY

Harran-Saliurfa, Turkey

Leica M6 Elmarit-M ASPH 21mm
Kodak E100VS

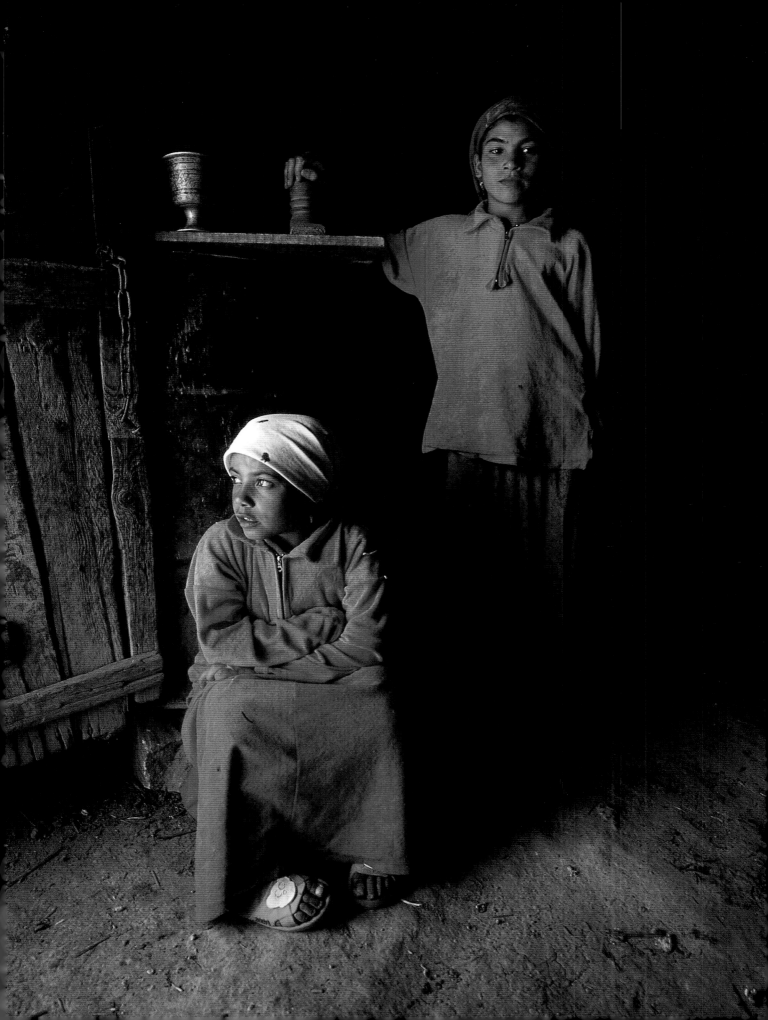

Tran The Long
VIETNAM
Nam Dinh Province, Vietnam

Nikon FM2 Nikkor 35-105mm
Kodak Gold 200

118

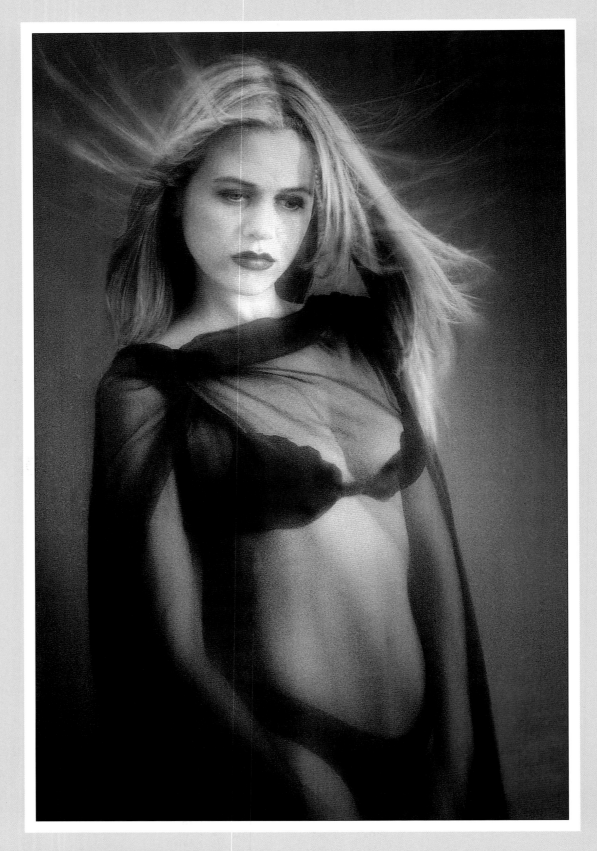

Maria Rosa D'Elia Demetilla
ARGENTINA

Buenos Aires, Argentina

Nikon F90 Nikkor 28-85mm Kodak PJ 400

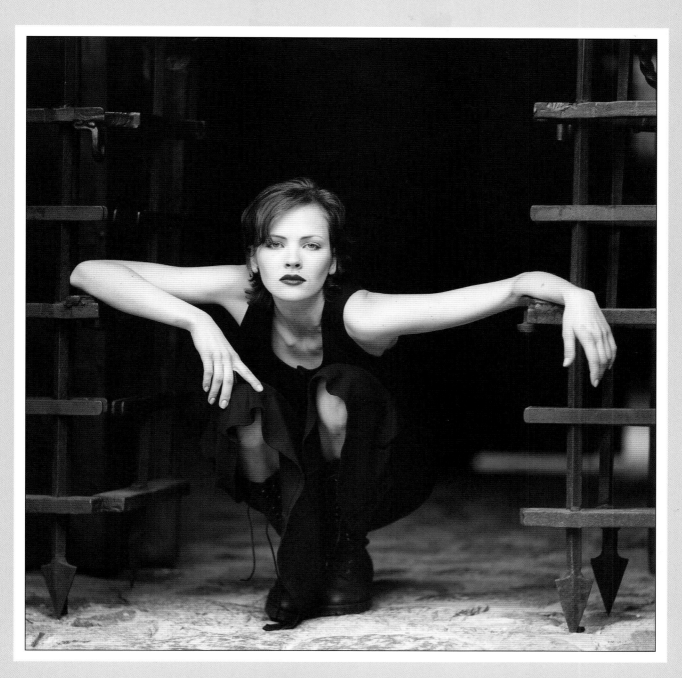

Romas Cekanavicius
LITHUANIA
Portrait of the castle ghost
Pentacon Six 6x6 Sonnar 180/2.8 Kodak 100

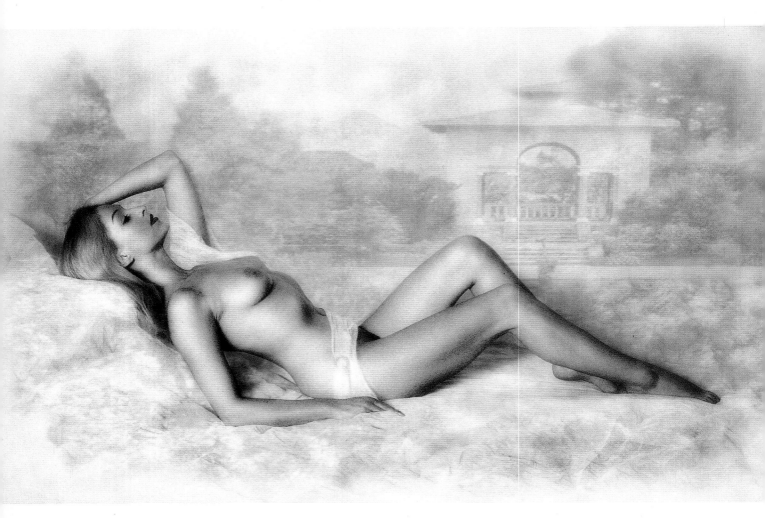

Carole McGillen
UNITED KINGDOM

'Alfrescos dream'

Elena Martynyuk
UKRAINE

'Sapho'

122

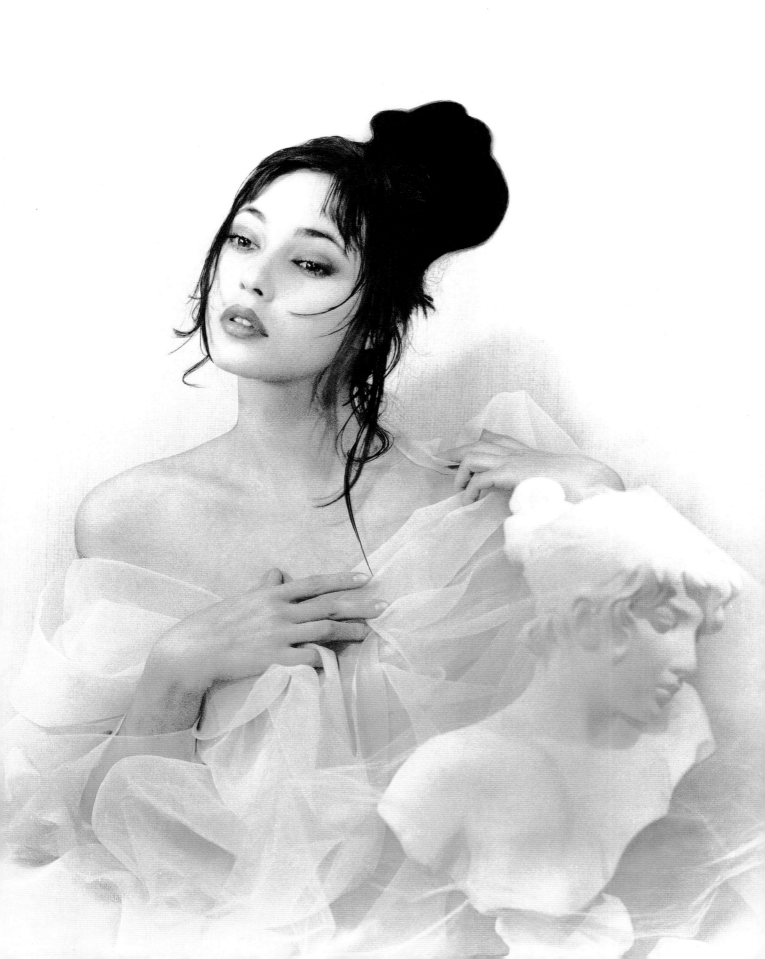

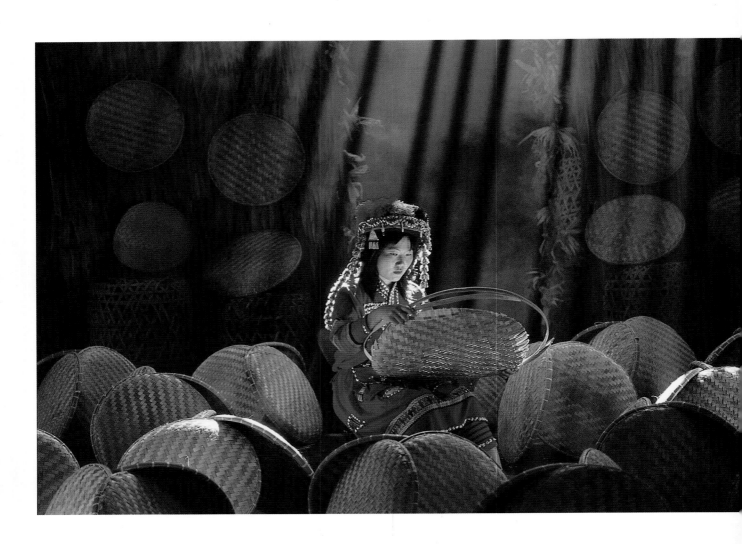

Goh Poh Leong
SINGAPORE

Native rattan worker

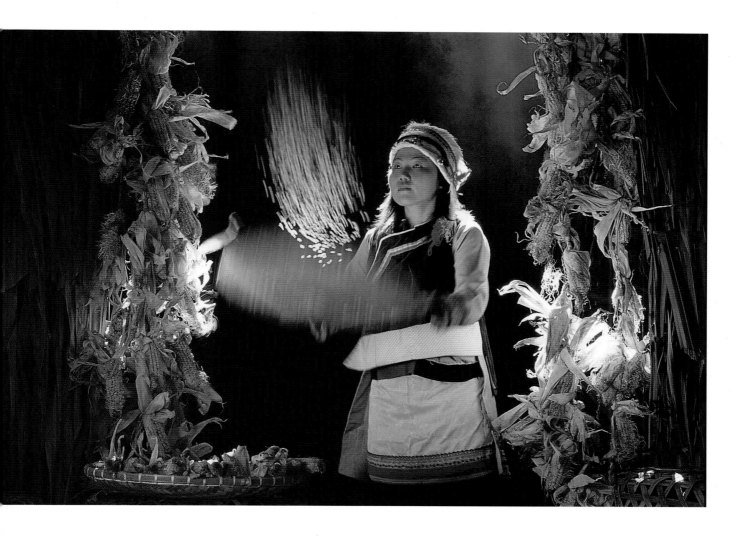

Kok Ngian Hock
SINGAPORE

Kampang girl,
Yunan Village, China

Nikon F90X Nikkor Zoom 80-200mm
Kodak

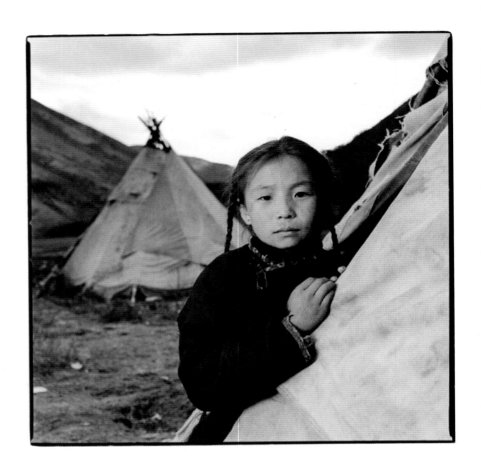

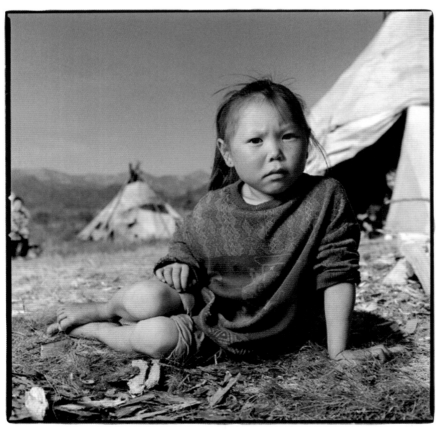

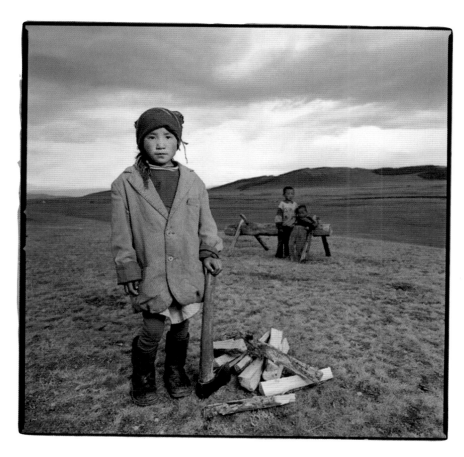

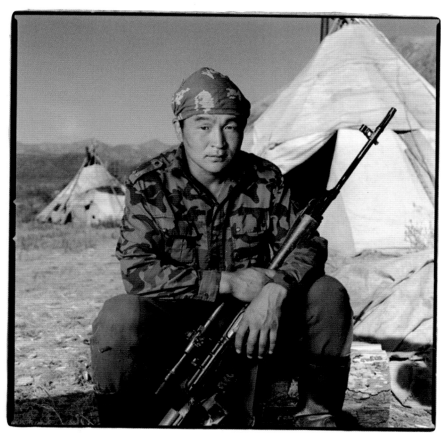

S. Jon Marion
USA

Mongolia

Hasselblad 503CX Zeiss 50mm
Kodak TRI-X Pan

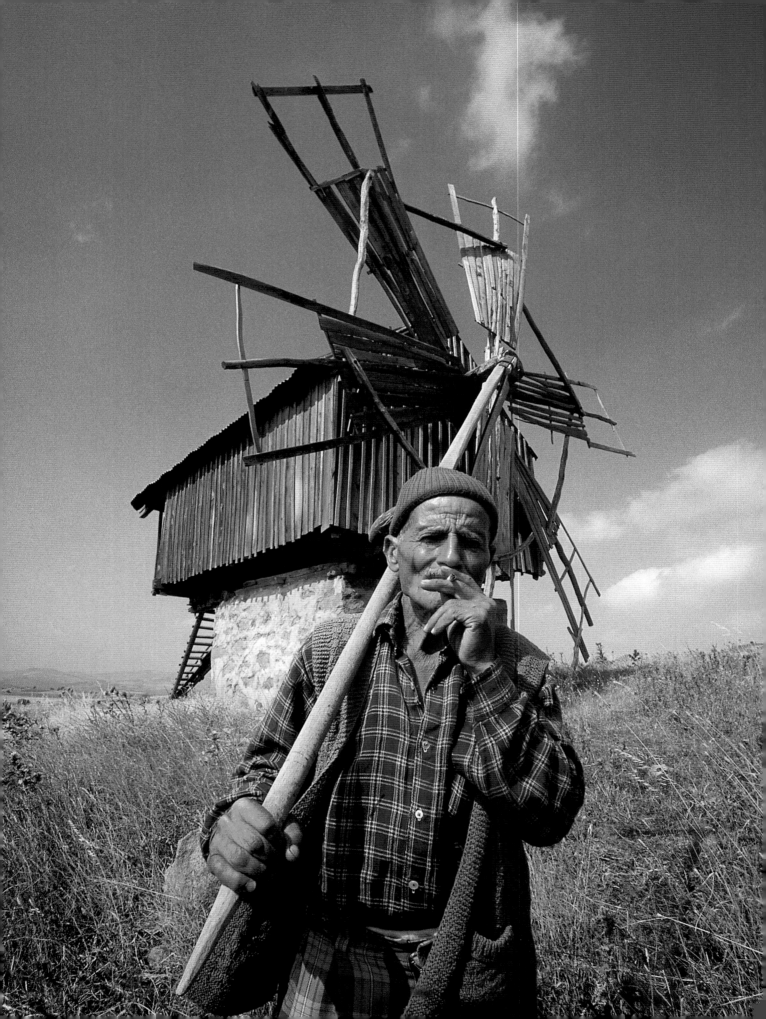

Lars Endre Orseth
NORWAY
Sculpture in sunlight

Özer Kanburoglu
TURKEY
Eskisehir, Turkey

Canon A1 Canon 17mm
Fujichrome Sensia 100

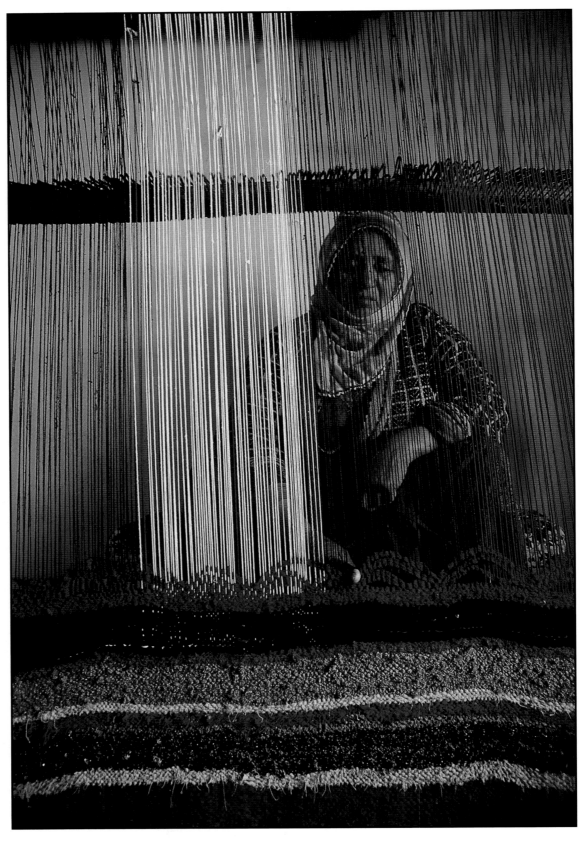

Tahsin Aydogmus
TURKEY
Bogazköy Hattusa Corum, Turkey
Leica R6-2 Elmarit-R 19mm Kodak E100VS

Tahsin Aydogmus
TURKEY
Iskilip Corum, Turkey
Leica R6-2 Elmarit-R 19mm Kodak E100VS

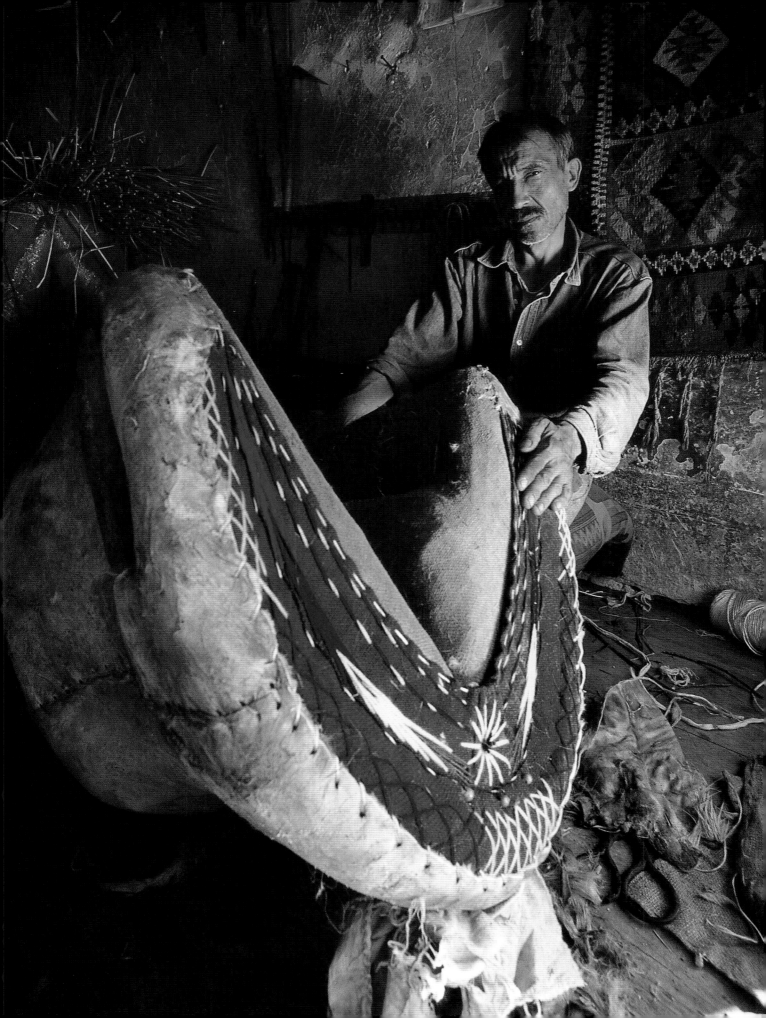

Petra Papenhoff
GERMANY

Antsirabe, Madagascar

Nikon F3 Nikon 100mm
Kodak Elite 100

Karl-Heinz Papenhoff
GERMANY
Antsirabe, Madagascar

Nikon F4 105mm Kodak Elite 100

Zbigniew Jodlowski
GERMANY
Dannenberg, Germany
Minolta Dynax 7XI Sigma 28-70mm
Fujichrome Velvia

Roland Guth
GERMANY
Satriani
Minolta Dynax 800SI Minolta 100mm
Fujichrome Sensia 400

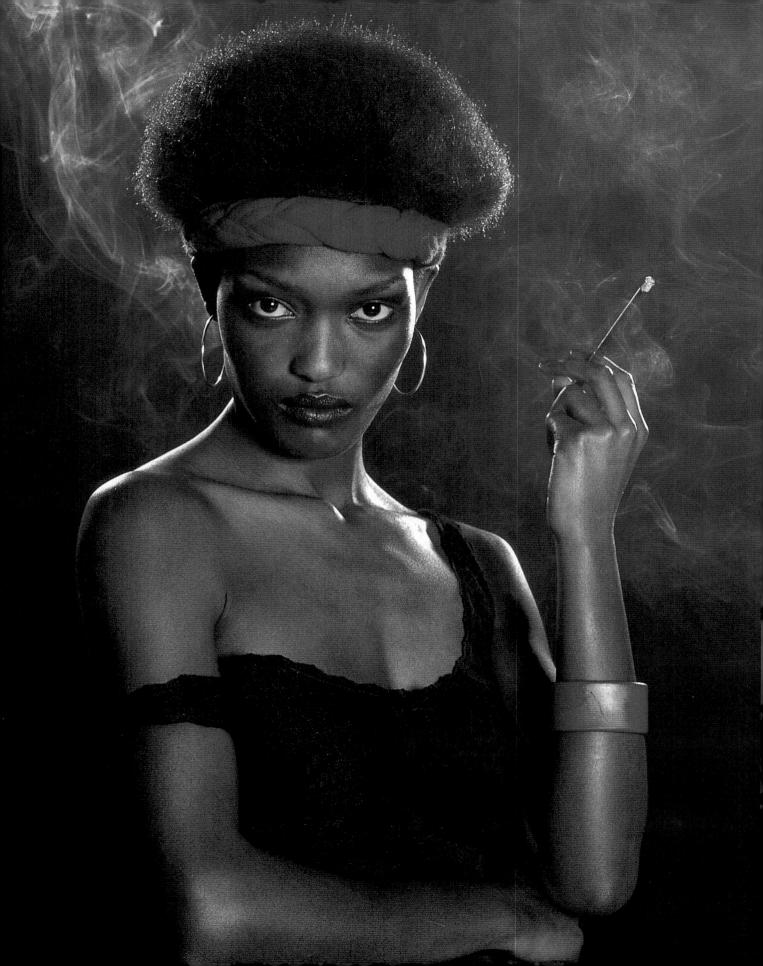

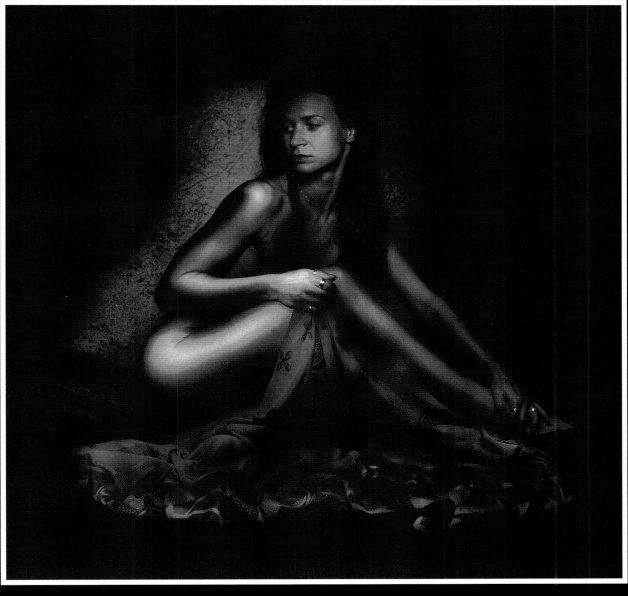

Jörg Gründler
GERMANY

Sandra, Studio

Modified Kiev 88 80mm
Fujichrome Provia 100

Eric Molitor
BELGIUM

Photostudio in Lint

Pentax LX Takumar 100mm Macro
Ektacrome 100

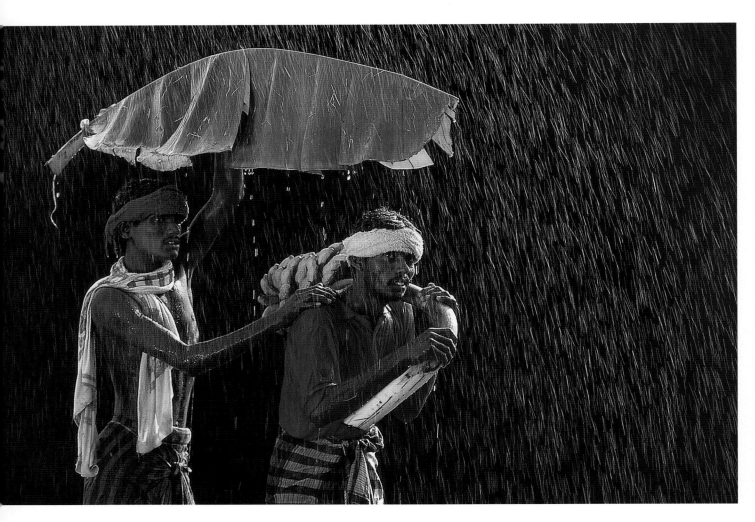

Ong Tiang Joo
SINGAPORE

Rainforest, Singapore

Nikon F4 Nikkor 80-200mm
Fujichrome Velvia

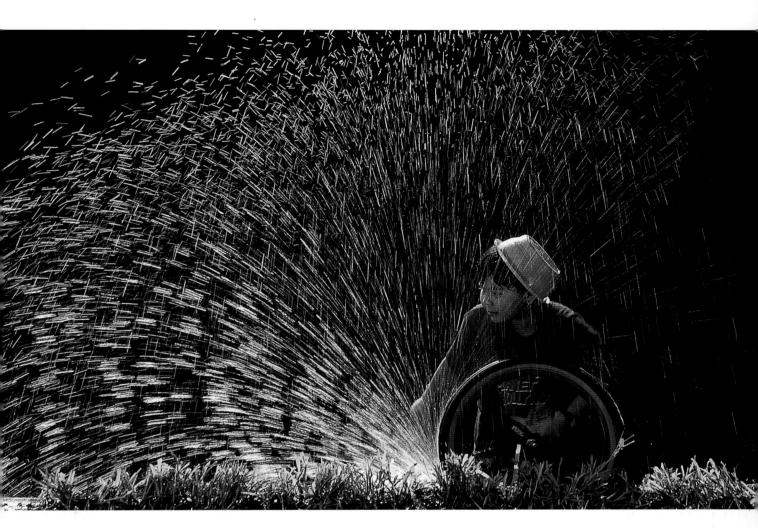

Chew Han-Luan Vincentius
SINGAPORE

Playing with water, Singapore

Leica R7 Leica Zoom 80-200mm Fujichrome Velvia

Raymond Widawski
BELGIUM

Brussels, Belgium

Minolta 800SI Minolta Zoom 24-85mm
Fujichrome Sensia

Luc Pappens
BELGIUM

Brugge, Belgium

Nikon F5 Nikkor 300mm Teleconverter 1.4
Fujichrome Sensia 100

Luc Pappens
BELGIUM

Mario de Clerck

Nikon F5 Nikkor 300mm Teleconverter 1.4
Fujichrome Sensia 100

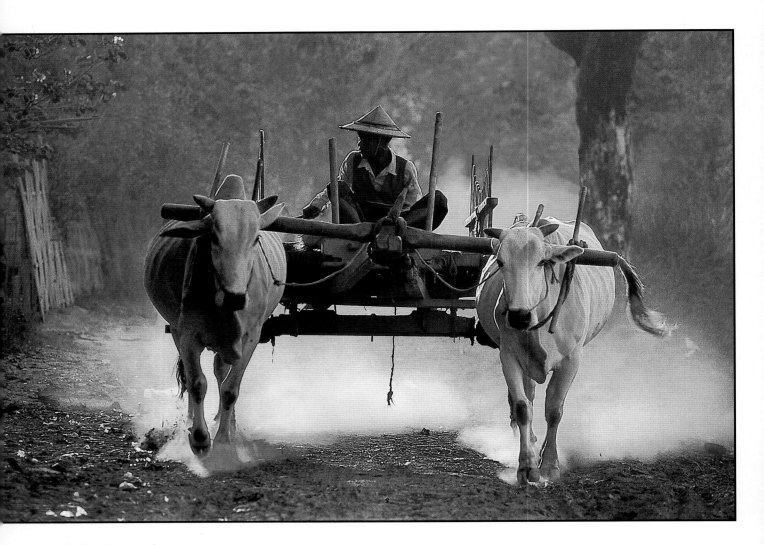

Willy Spegelaere
BELGIUM

Myanmar

Nikon F70 Sigma 70-200mm
Fujichrome Sensia

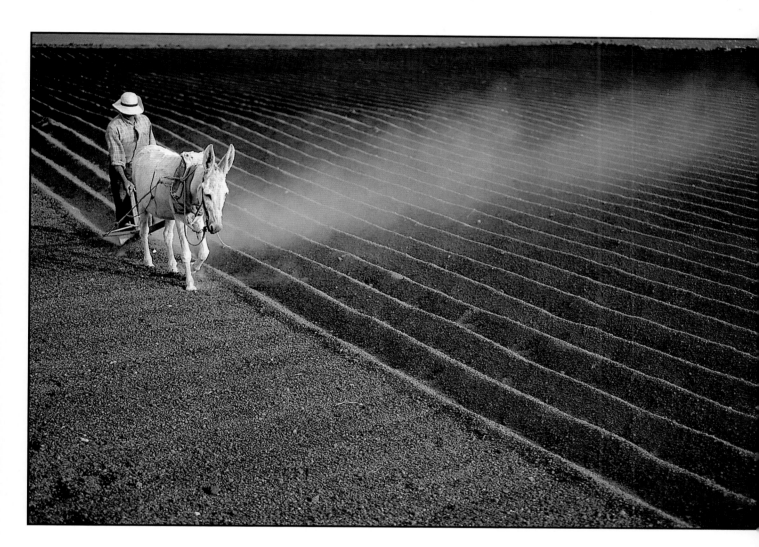

Aldo Basili
ITALY
The Canaries

Nikon F90X Nikon 80-200mm
Fujichrome Velvia

145

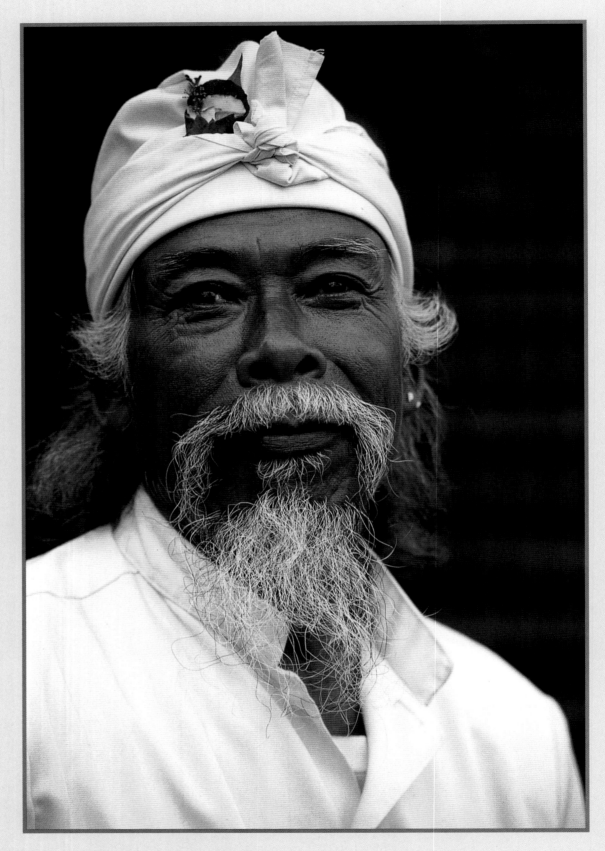

Alfons Ceunen
BELGIUM
'Indonesie'

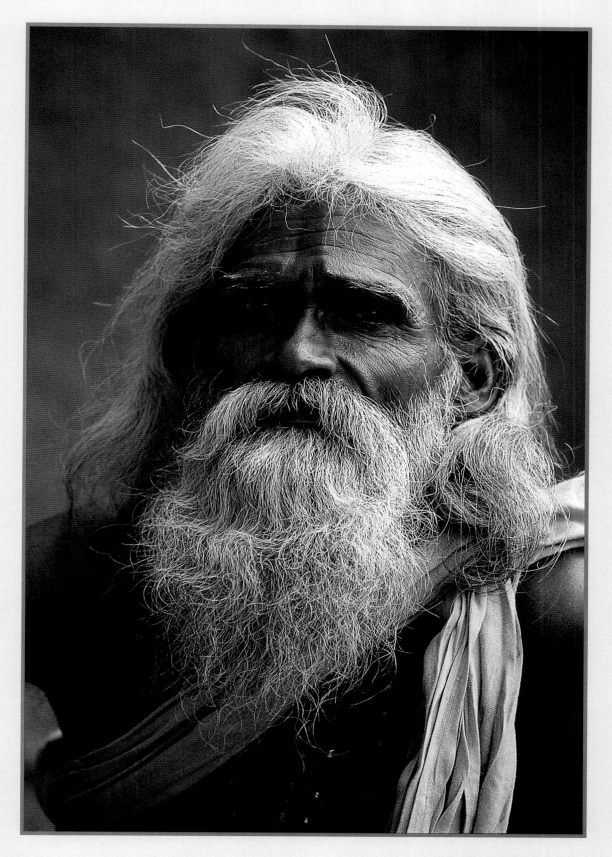

Erich Rohrauer
AUSTRIA
Asket III, Delhi, India
Minolta XE1 Minolta 70-210mm
Kodachrome 64

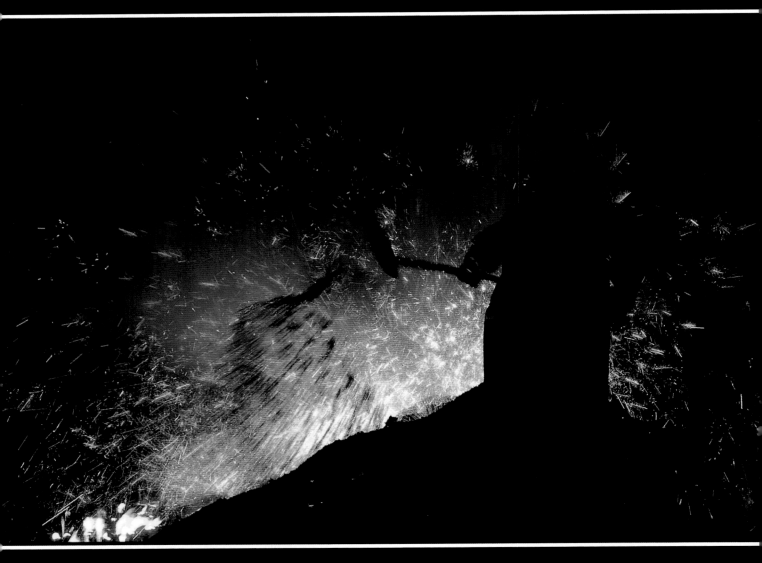

Viorel Munteanu
AUSTRIA
Vöest Industry, Linz, Austria
Pentax Z1 Pentax 28-80mm
Fujichrome Sensia 100

Etienne Camusat
BELGIUM
'Boat painter'

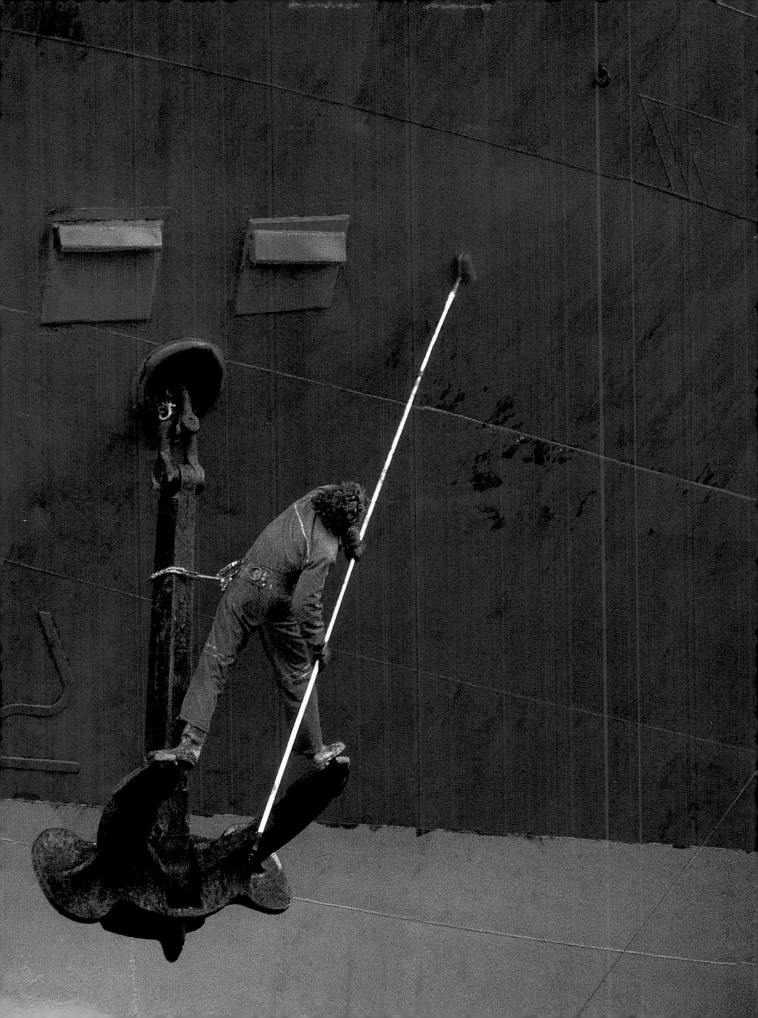

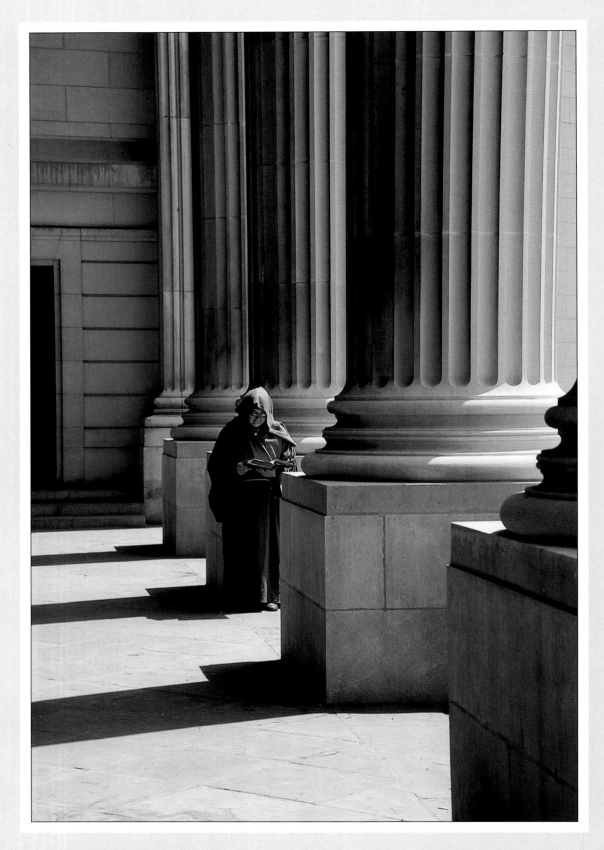

John P. Maloney
USA
A moment to reflect,
New Haven, USA

Nikon FE Nikkor 35-105mm
Kodachrome

150

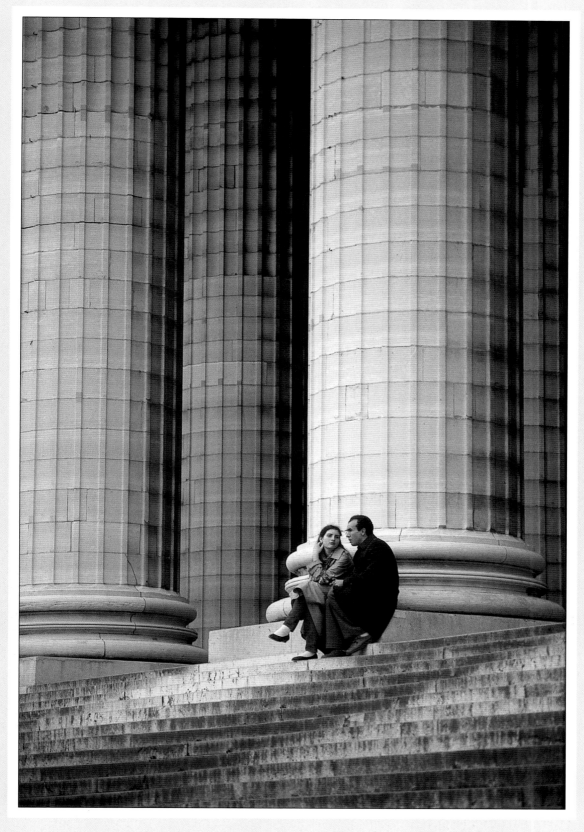

Rolf Lindel
GERMANY

Paris, France

Nikon FM2 Nikkor 135mm
Kodachrome

151

Maria Bein
AUSTRIA
Vienna, Austria

Canon EOS50E Canon 20-35mm
Kodak Elite Chrome

Thomas Ebelt
GERMANY
St. Pauli, Germany
Minolta Dynax Minolta 28-80mm
Fujichrome Velvia

Eric Bron
BELGIUM

Montpellier, France

Minolta Dynax 800SI Sigma 18-35mm
Kodak Highspeed Infrared

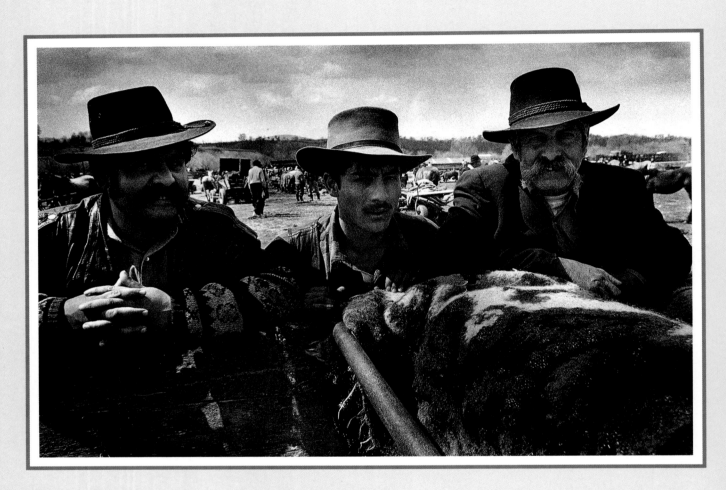

Omero Tinagli
ITALY
Maramures, Romania
Canon EOS1 Canon 24-85mm
Kodak TRI-X 400ASA

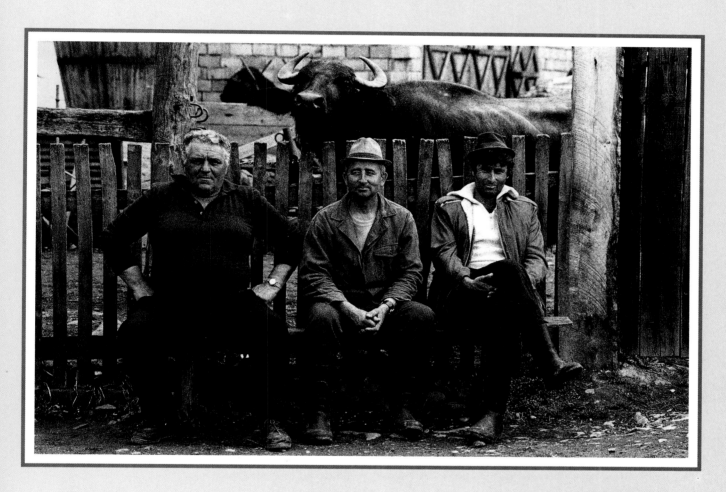

Giulio Montini
ITALY
Maramures, Romania
Minolta 700SI Minolta 28-135mm
Ilford Delta 400

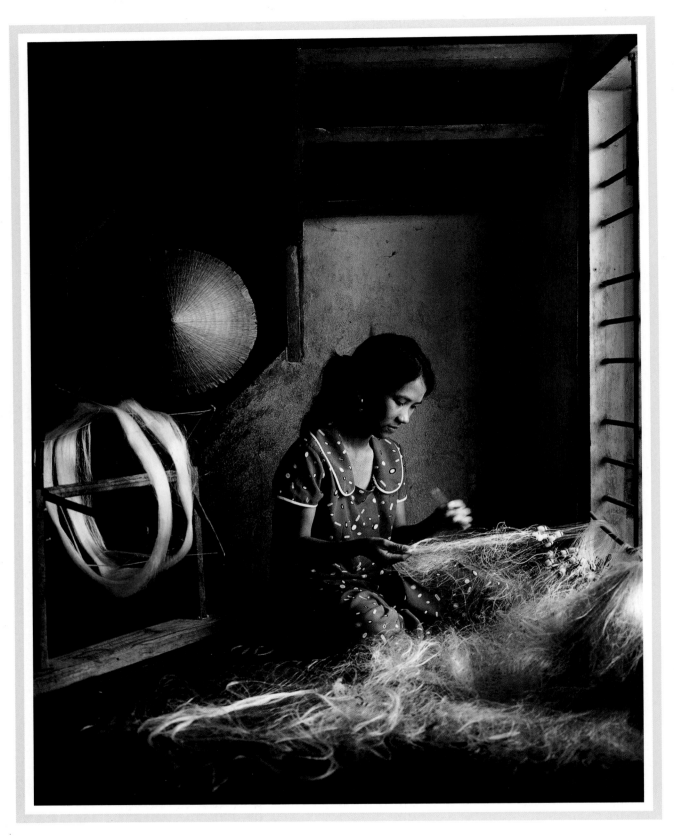

Lan Van Banh
VIETNAM

'Net mending'

Heng-Sun Kok
MACAO

Kon Lam Temple, Macao

Hasselblad 500CM Zeiss Planar 80mm
Kodak 100

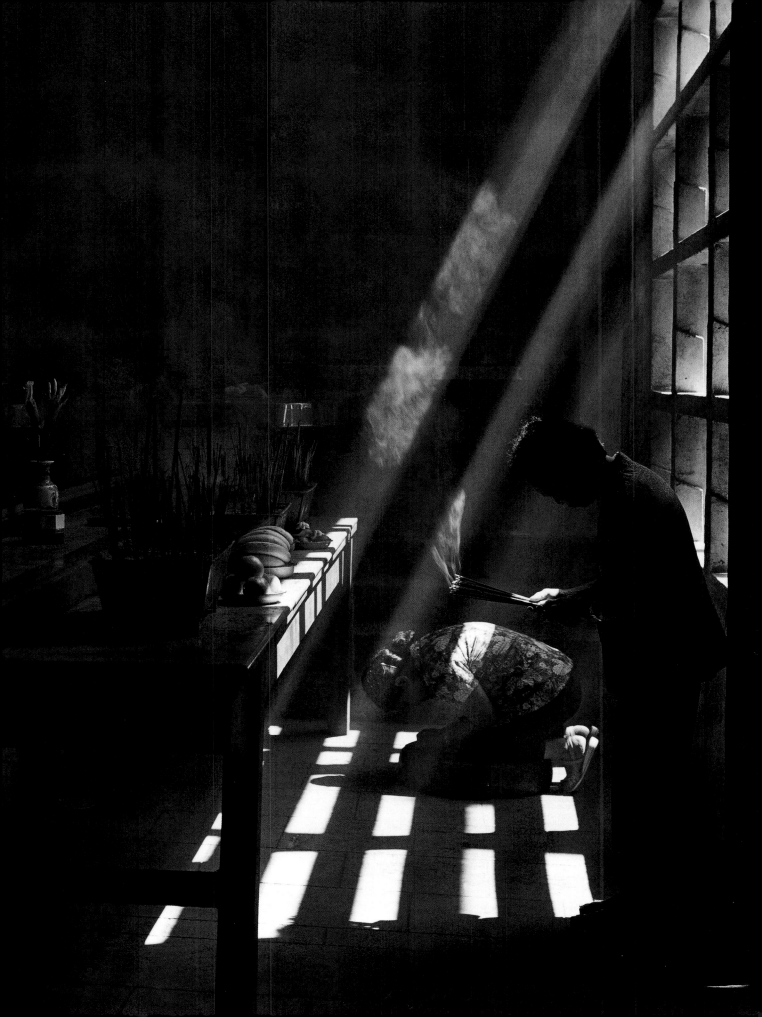

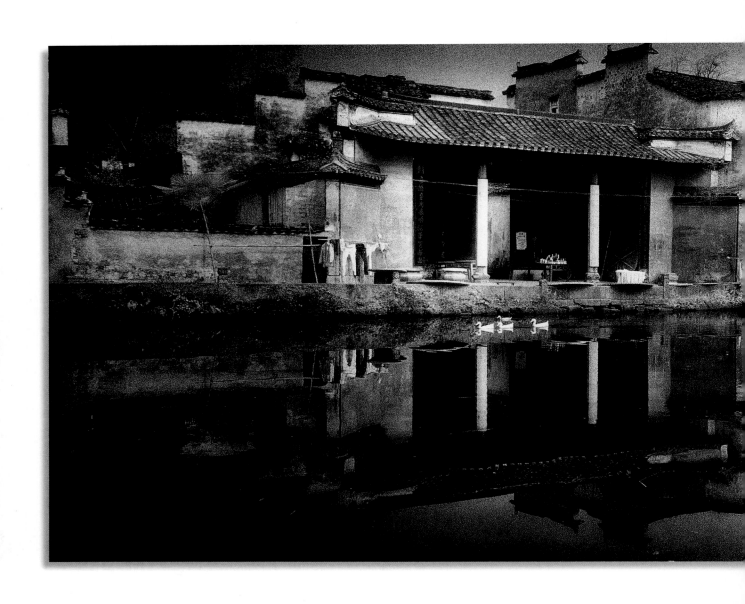

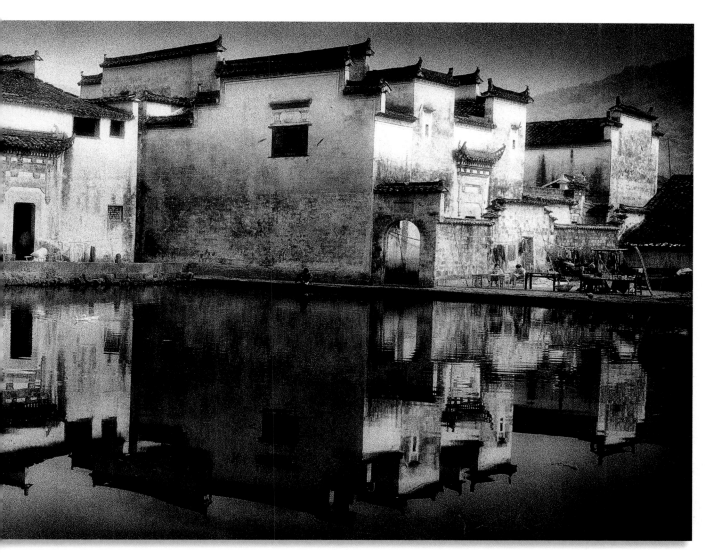

Dennis Wong
HONG KONG
Huang Shan City, China
Hasselblad X-Pan 45mm Kodak HIE

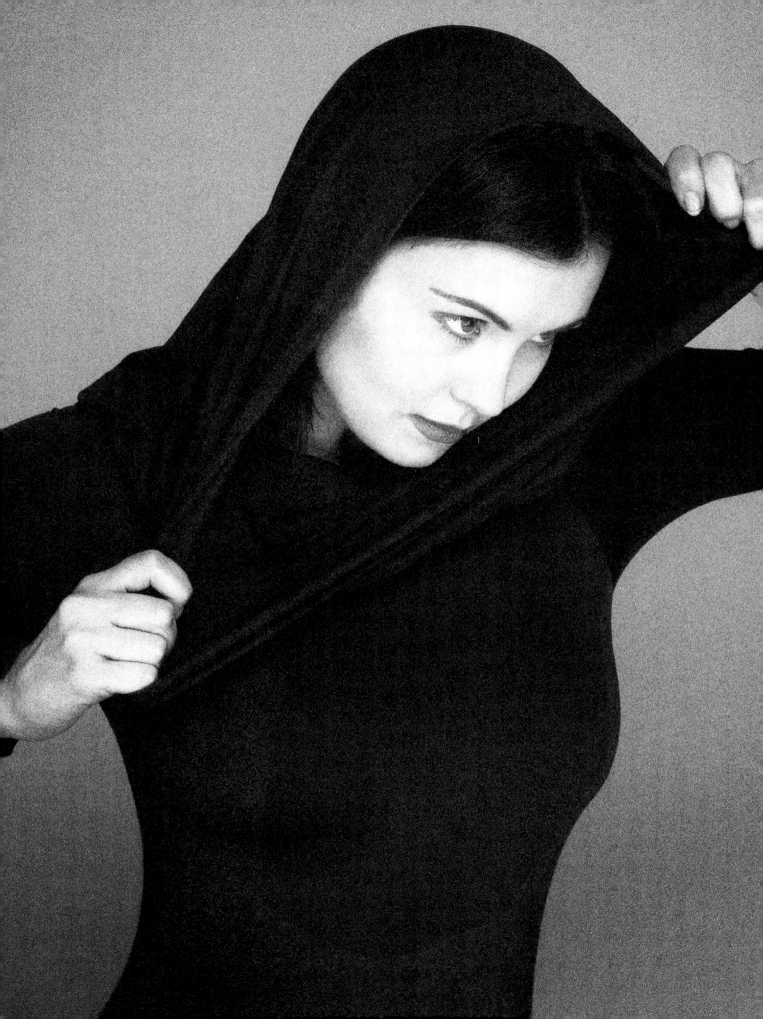

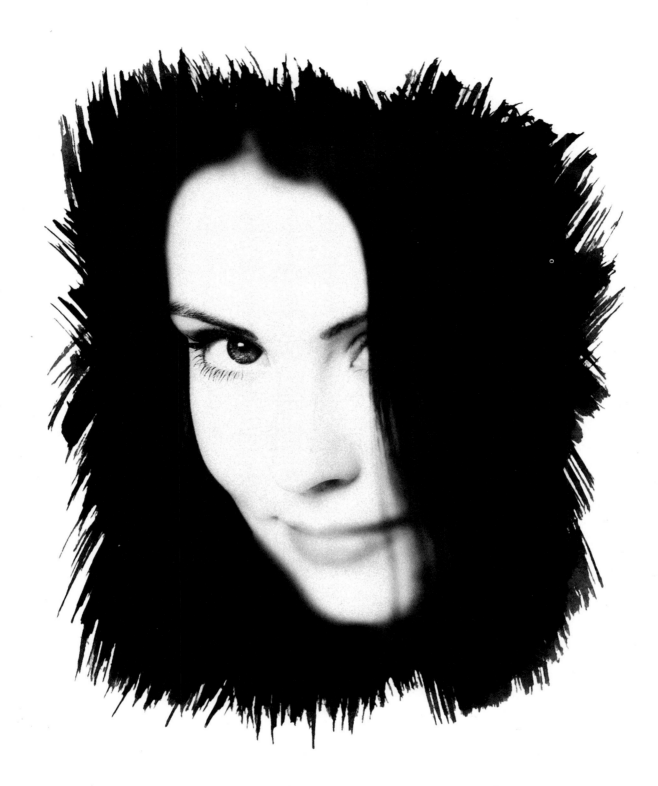

Rob Wilkinson
UNITED KINGDOM

Kryssy2

Hasselblad Fuji S1 Pro
Quartzcolour Lights
Electronic Flash

Rob Wilkinson
UNITED KINGDOM

Kryssy1

Fuji S1 Pro Quartzcolour Lights

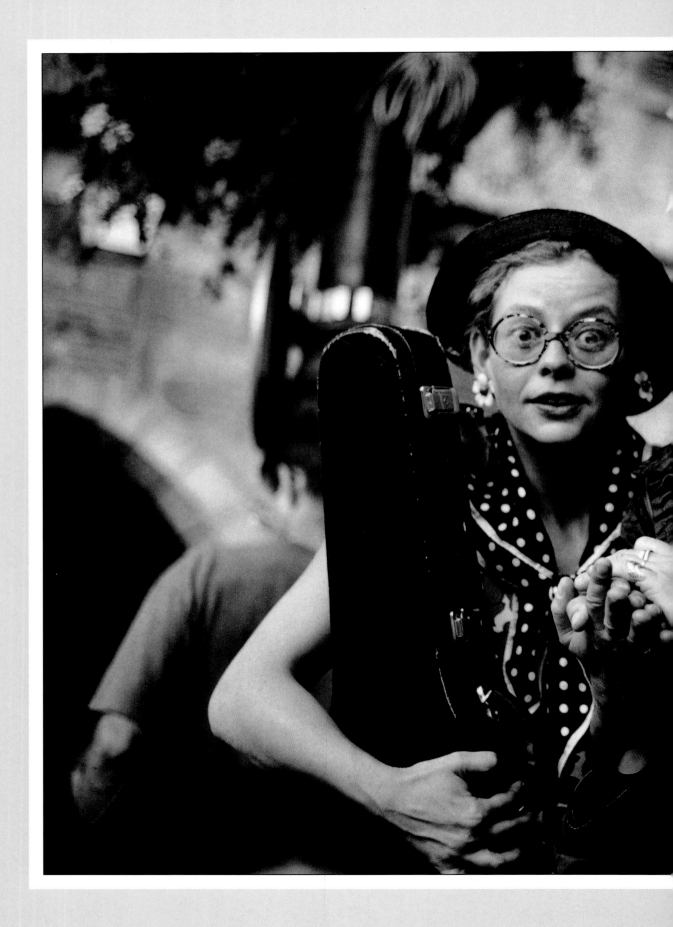

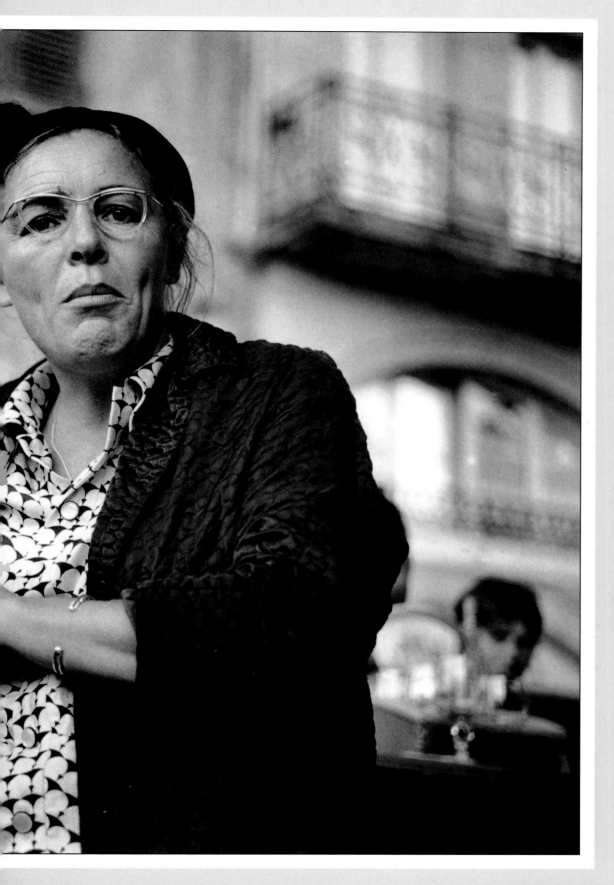

Noël Kingsley
UNITED KINGDOM
France

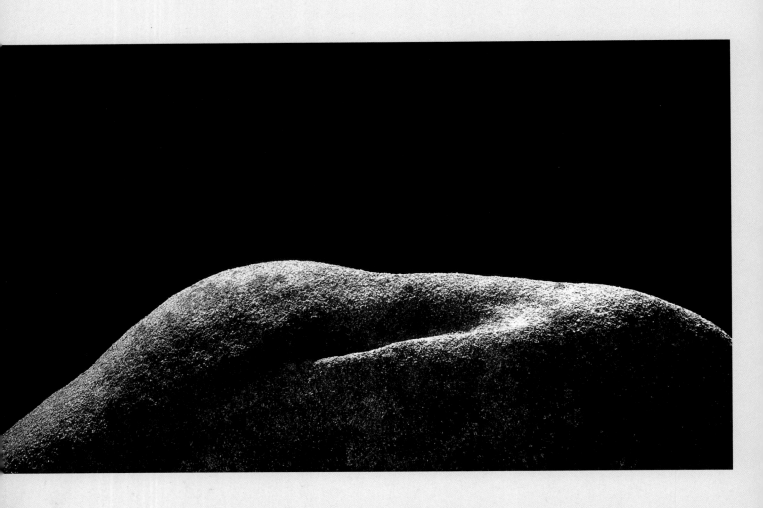

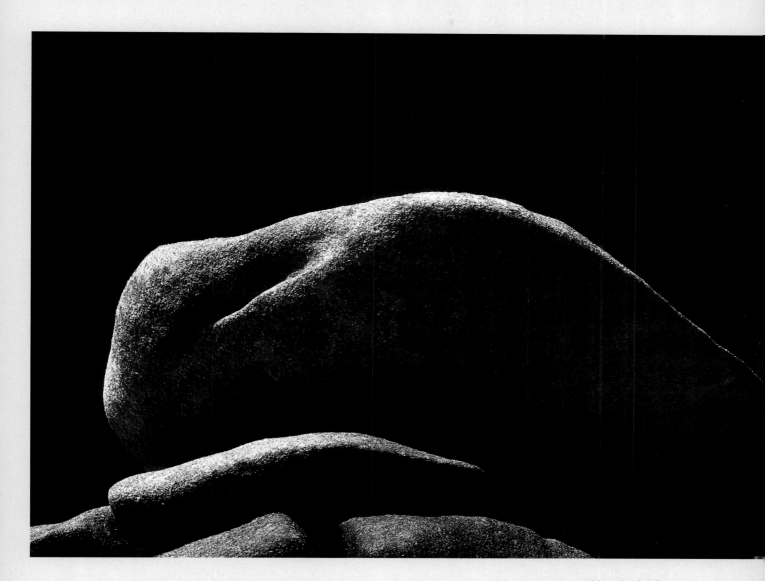

Hugh Milsom
UNITED KINGDOM

Rocks, Cheesewring,
Bodmin Moor, Cornwall

Maco Infrared Film

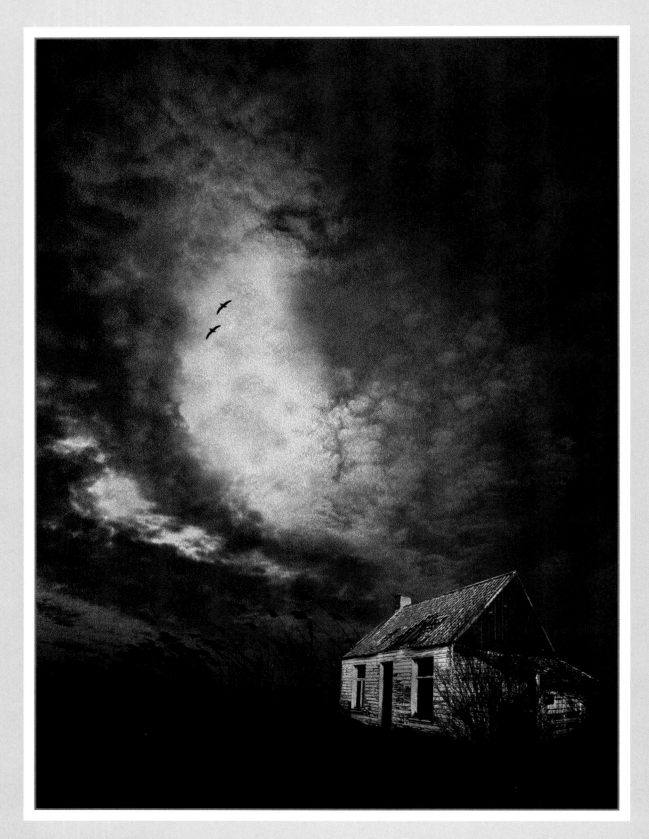

Gilbert de Deckere
BELGIUM
Antwerp, Belgium
Nikon F90 Nikon 28-70mm Agfa 400

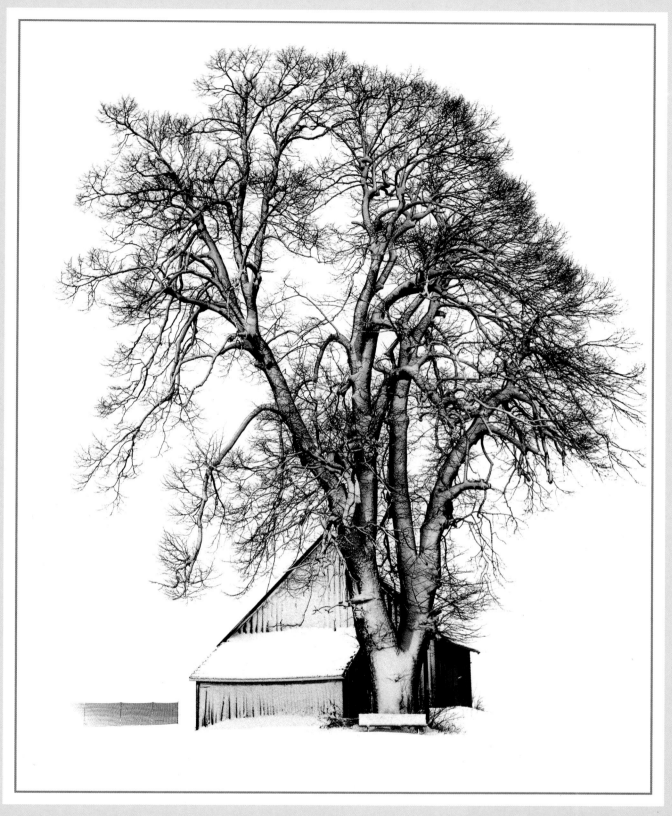

Rolf Lindel
GERMANY
Böhmenkirch, Germany
Nikon FM2 Nikkor 50mm Ilford FP4

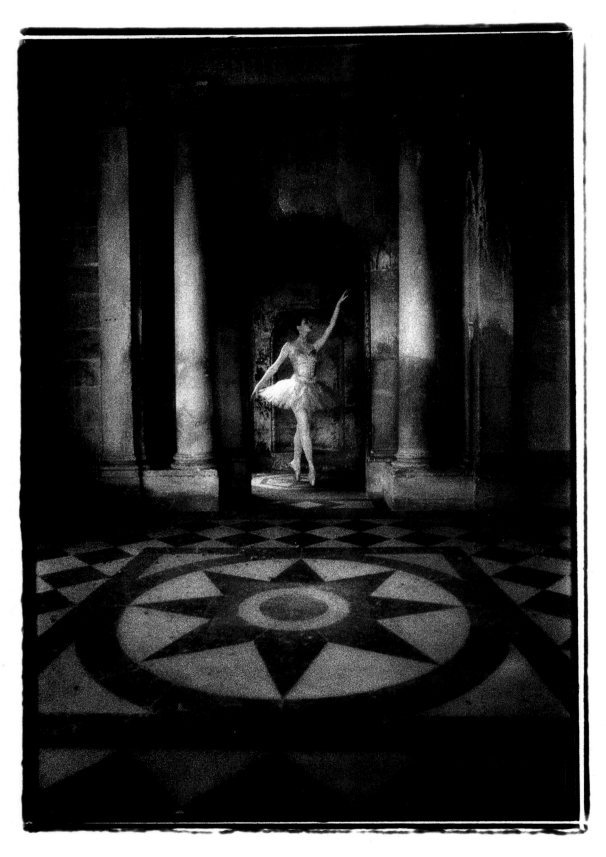

Ray Spence
UNITED KINGDOM

Ballet Dancer

Kodak High Speed infrared film

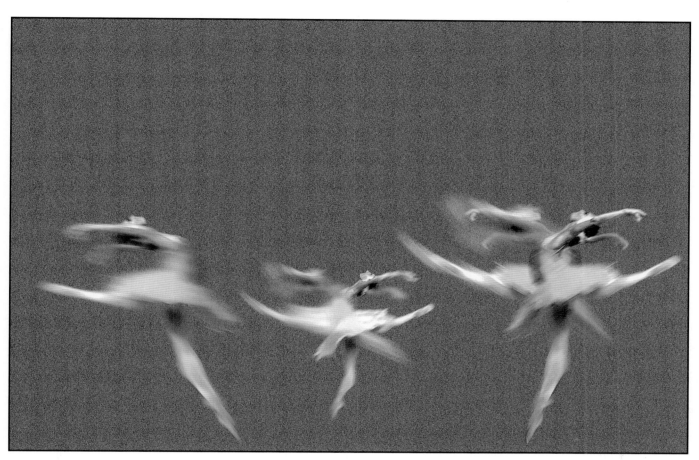

Giuseppe Cartolano
ITALY
Theatre in Cellatica, Italy
Nikon F3 Nikkor 75-300mm

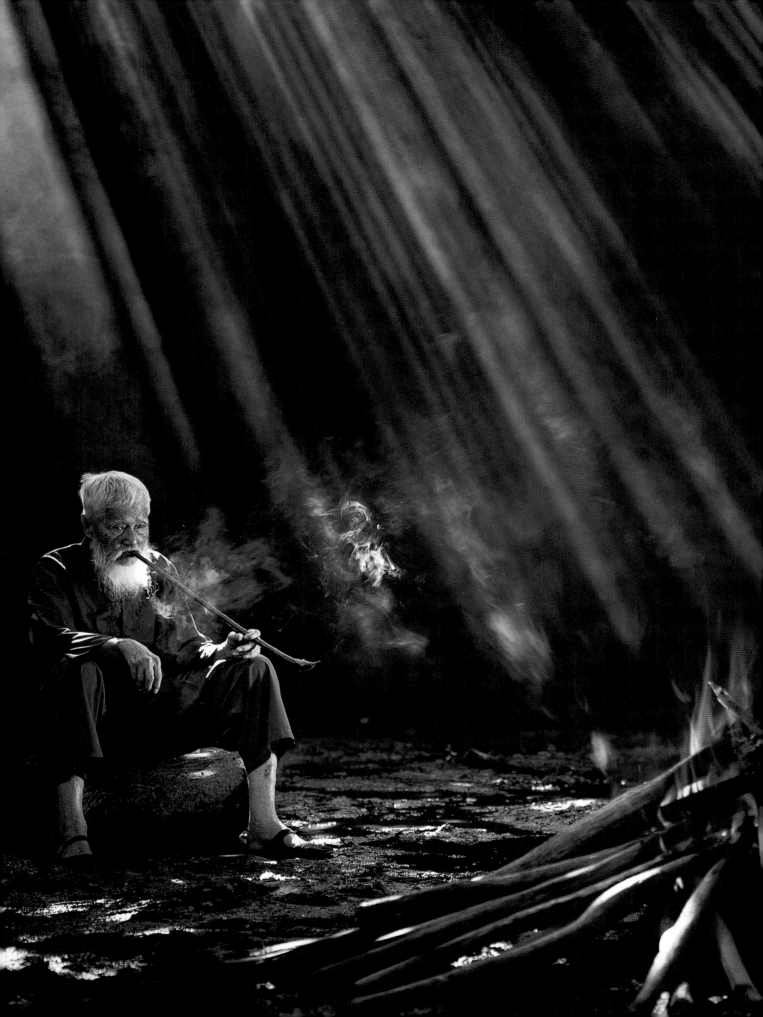

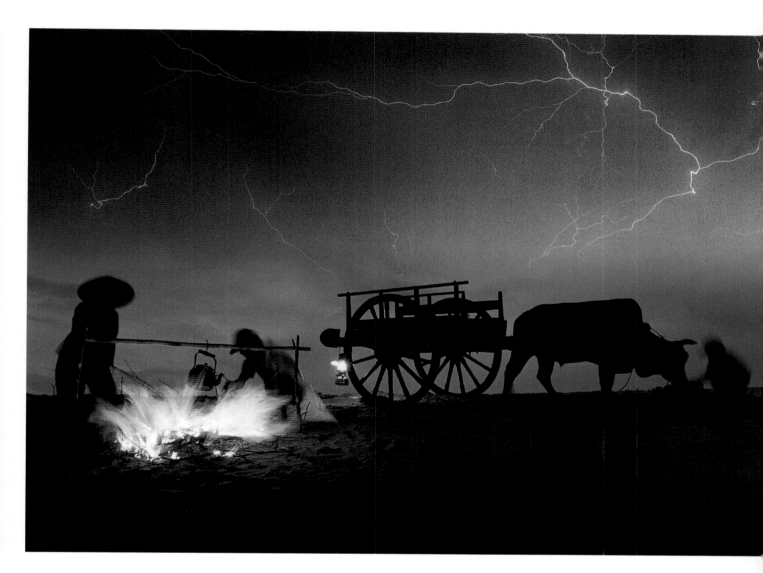

Pham Thi Thu
VIETNAM
Phan Thiet, Vietnam

Nikon FM2 Nikkor 24mm 1:2:8
Fujichrome Superia 200ASA

Teo Bee-Yen
SINGAPORE

Singapore

Hasselblad 503CW Zeiss Planar 150mm
Kodak 100

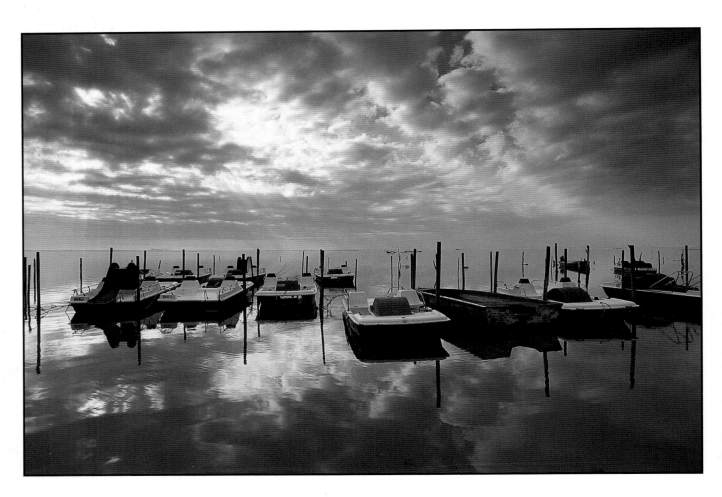

Valter Nanut
ITALY
Grado, Italy

Nikon 801S Nikkor 20mm
Fujichrome Sensia

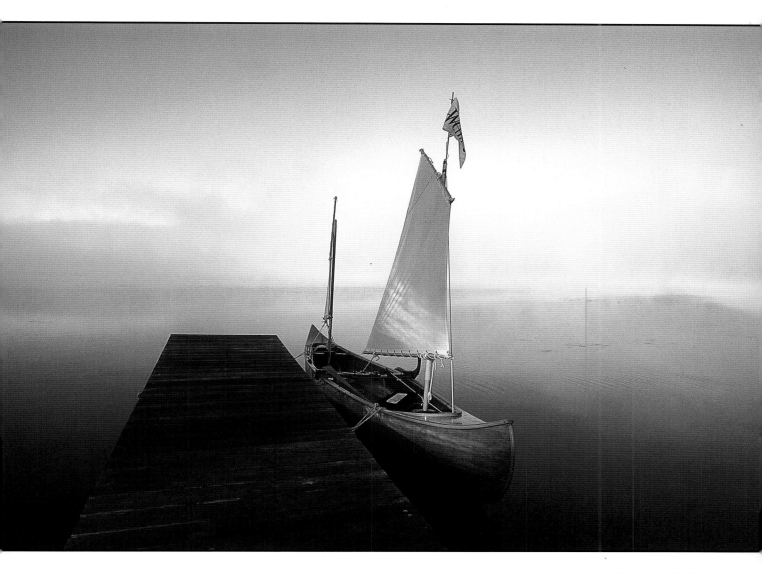

Stuart Fall
USA

Early morning,
New York

Nikon F5 Nikon 20mm
Fujichrome Velvia

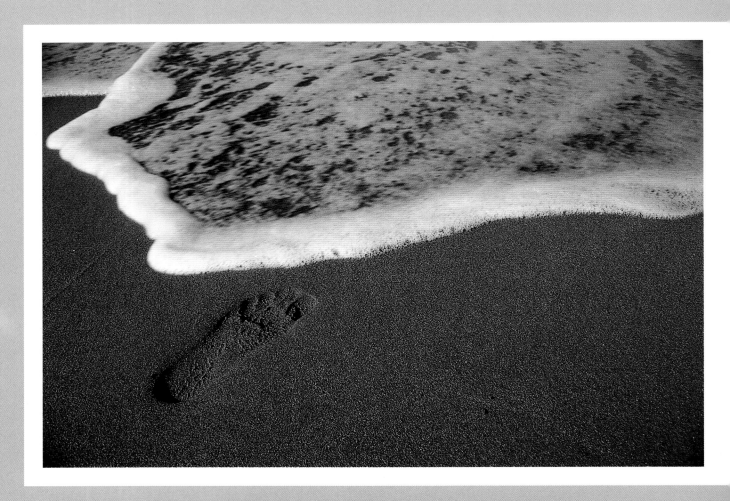

Luigi Marengoni
Gozo Island, Malta

Pentax MZ-5 Sigma 28-70mm
Fujichrome Velvia

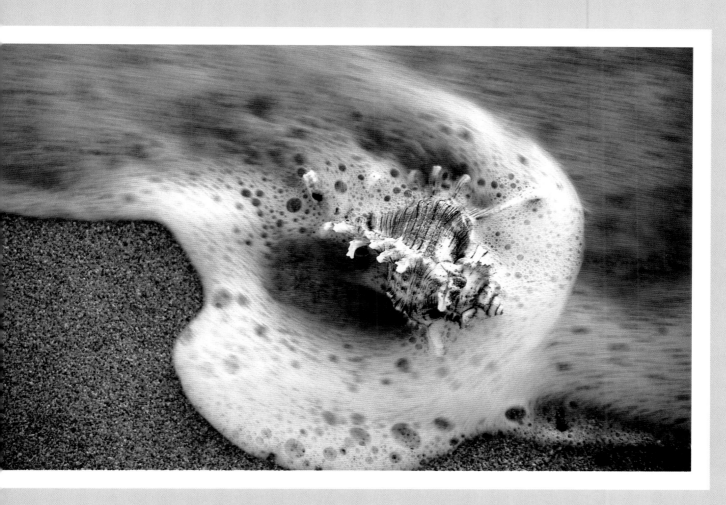

Brian Crick
UNITED KINGDOM
St. Ives, England
Canon A1 Tamron 70-210mm
Fujichrome Sensia 100

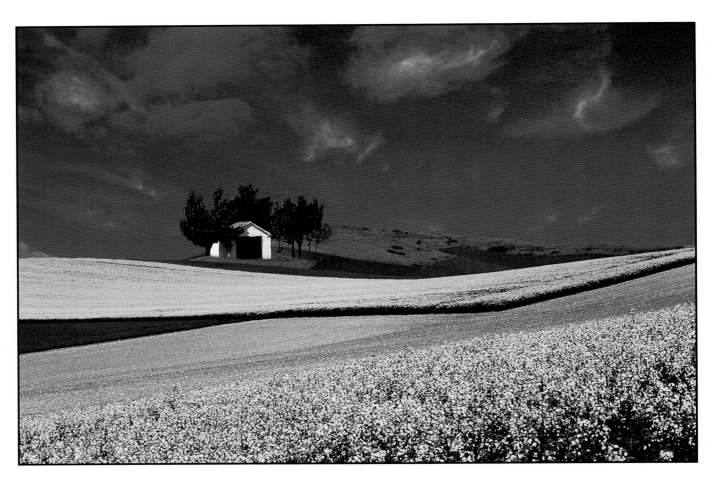

Anette Mortier
BELGIUM

Cape Blanc, France

Nikon F90X Nikkor 24mm
Fujichrome Velvia

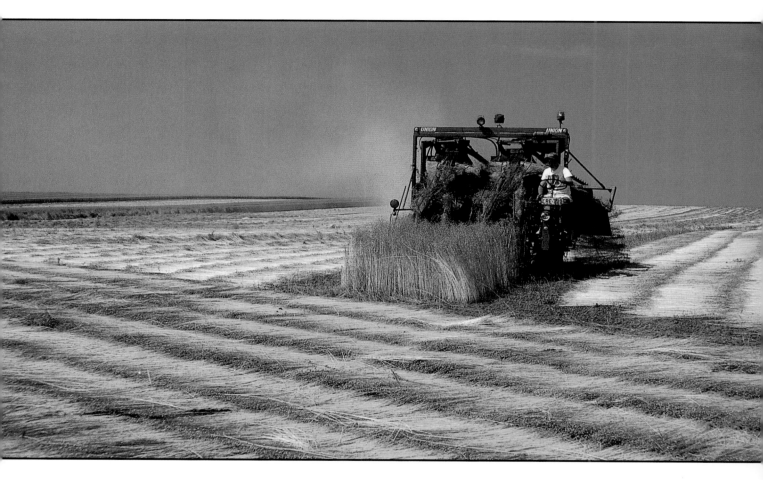

Martin Nysen
BELGIUM

Liege, Belgium

Nikon F4 Nikon 80-200mm
Fujichrome 100

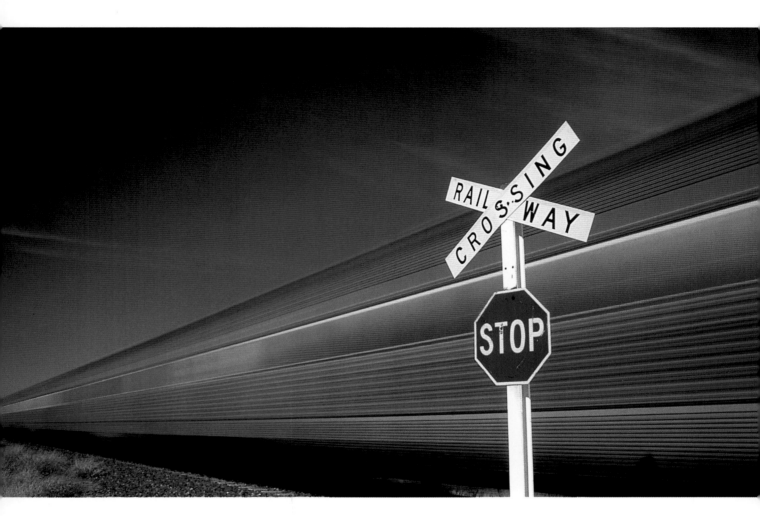

James Cowie
AUSTRALIA

The legendary Ghan № 2,
Alice Springs, Australia

Canon EOS100 Canon 28-80mm
Fujichrome Velvia

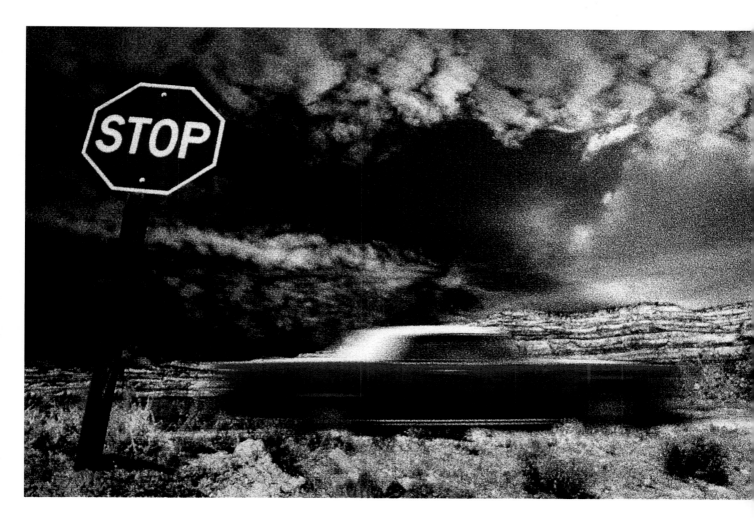

Colin Harrison
UNITED KINGDOM
Canon Kodachrome 64
Digitally manipulated

Feriano Sama
ITALY
Castelluccio, Italy

Nikon F3 Sigma 70-300mm
Fujichrome Velvia

Roland Zanettin
AUSTRIA
Volterra, Italy
Nikon F5 Nikkor 28-85mm
Kodak Elite

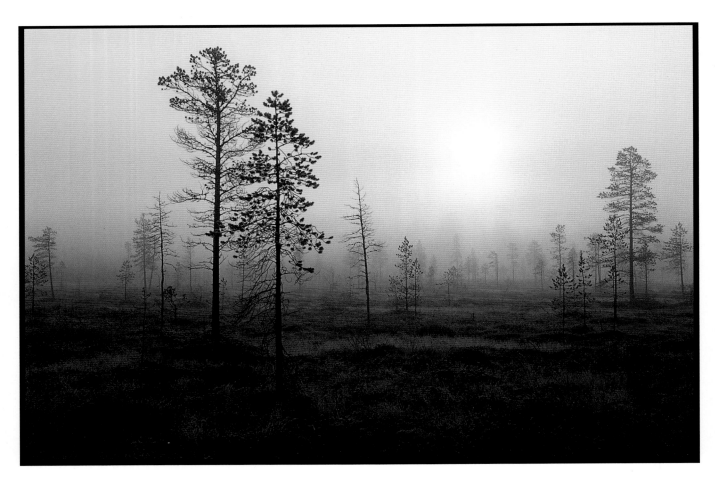

Antti Ketola
FINLAND

Äkäslompolo,
Finnish Lapland

Nikon F90 Sigma 18-35mm
Kodak E100VS

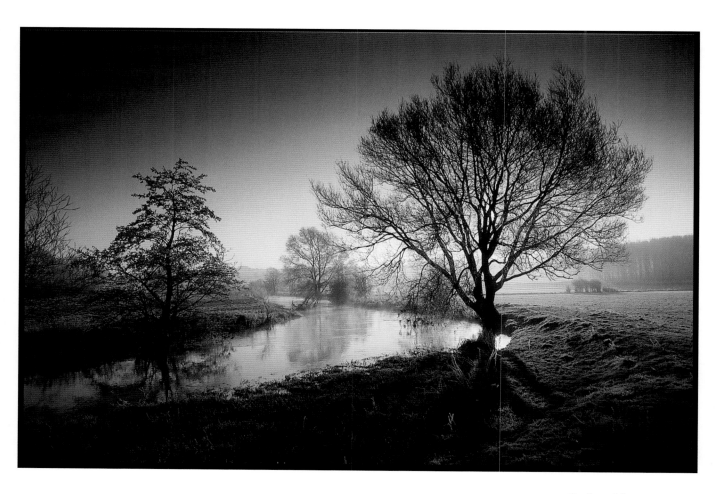

Colin Harrison
UNITED KINGDOM
River Windrush, Burford,
United Kingdom

Canon T90 Canon 24mm Kodachrome 64

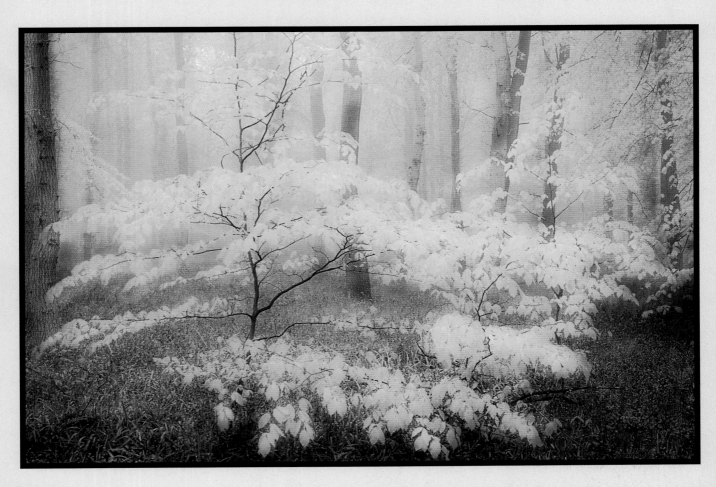

Paul Exton
UNITED KINGDOM

Hertfordshire, England

Canon EOS1 Canon 28-80mm
Fujichrome Sensia 100

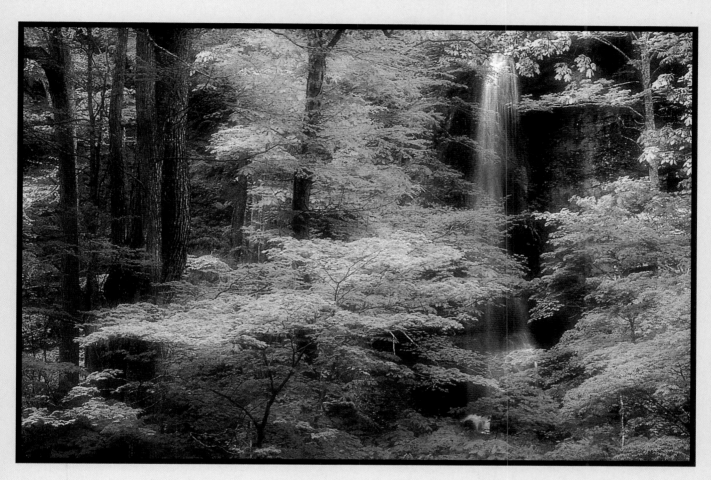

Gerald Appel
USA
Forest and Falls

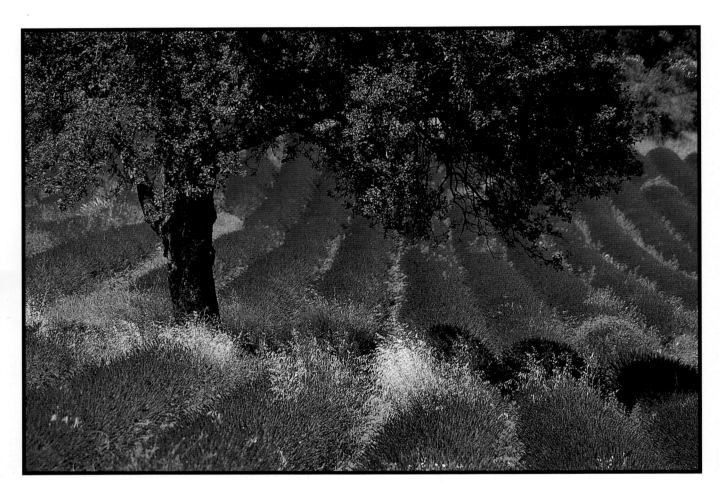

John Devenport
UNITED KINGDOM

Provence, France

Canon F1 Canon 70-210mm
Fujichrome Velvia

Alberto Goiorani
ITALY

Provence, France

Nikon F3 Nikkor 300mm
Fujichrome Velvia

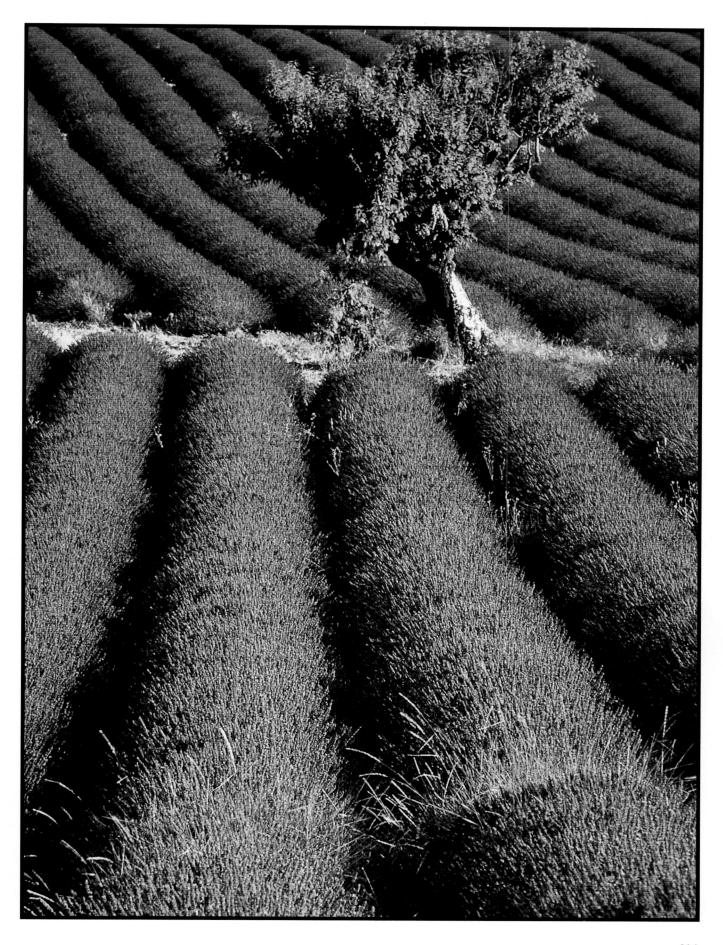

Herbert Reinl
GERMANY

Garmisch-Partenkirchen,
Germany

Leica R8 Elmarit 100mm
Fujichrome Sensia

Siegfried Claussen
GERMANY
Riquewihr, Alsace, France

Minolta X-700 Zoom Tokina SD 70-210mm
Agfachrome CT 100

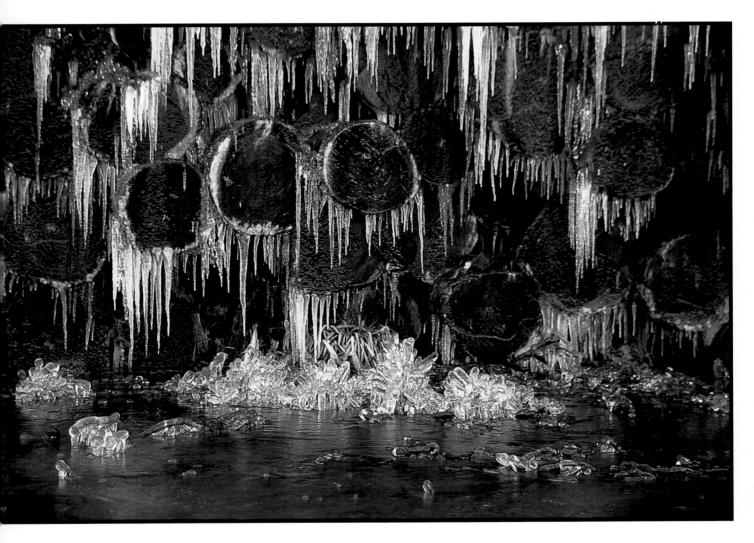

Thomas Kreher
GERMANY

Rheinland Pfalz,
Germany

Canon T90 Canon 50mm
Fujichrome Sensia 100

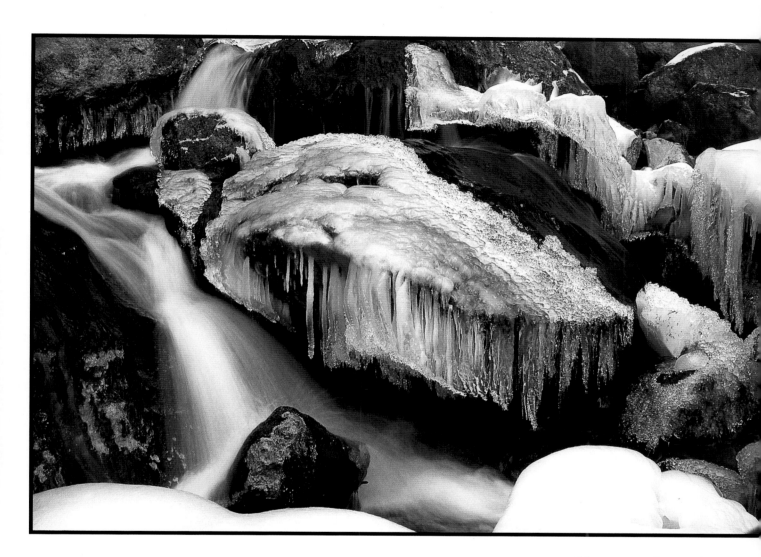

Christian Gritsch
AUSTRIA

Mirafälle, Austria

Canon EOS5 Canon 28-105mm
Fujichrome Sensia 100

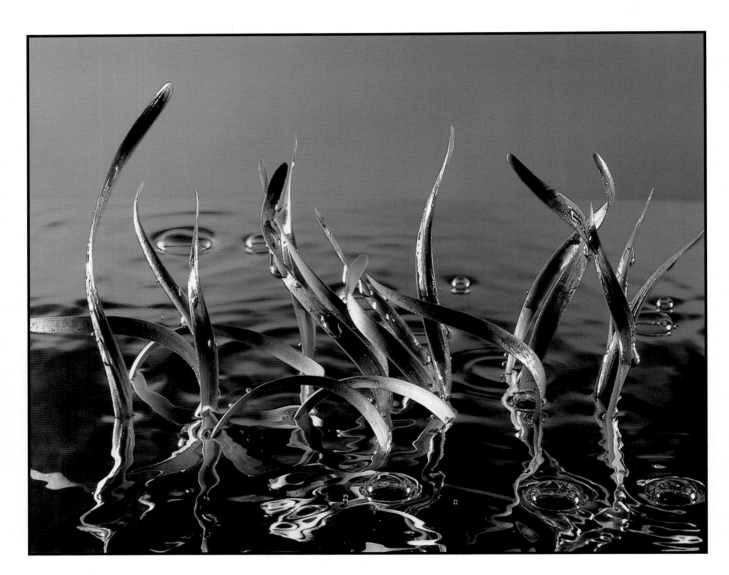

Phill Callow
UNITED KINGDOM

Studio

Cambo 5x4 6x7 Back
150mm Lens 1/200 F32.5
Fujichrome Velvia

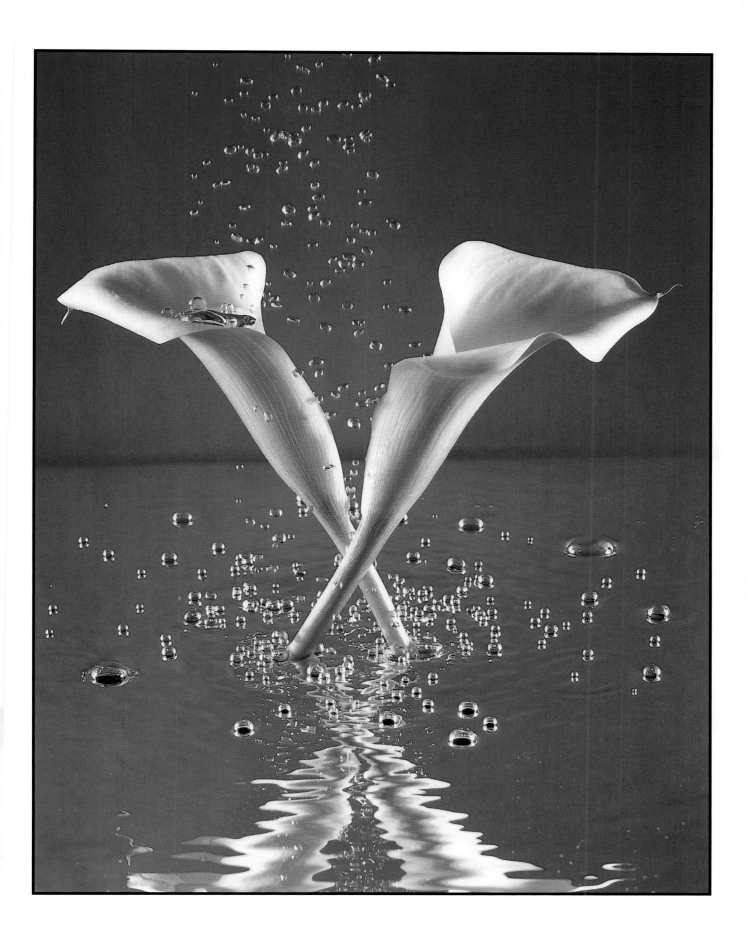

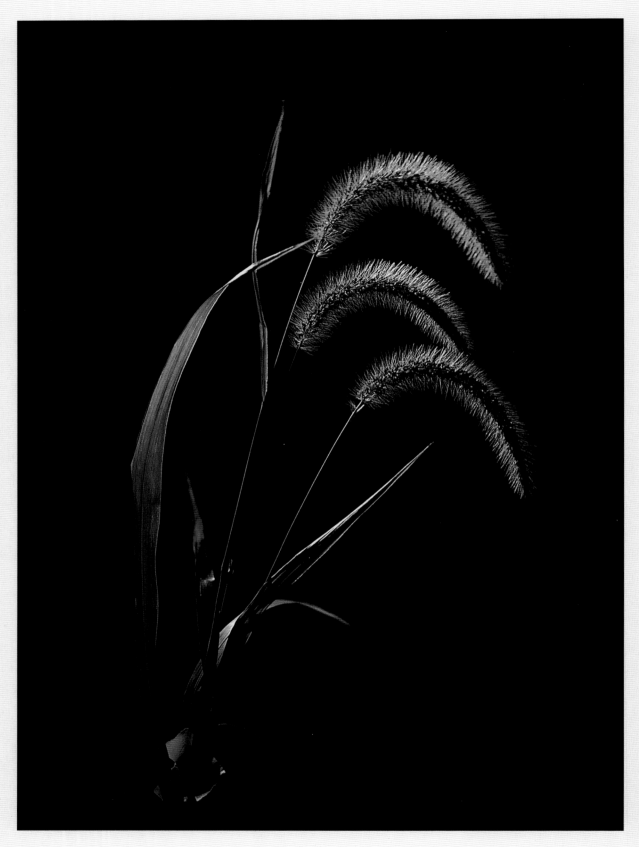

Robert K. Smith

Foxtails, Studio

Nikon FZAS Nikon 100mm Kodachrome 64

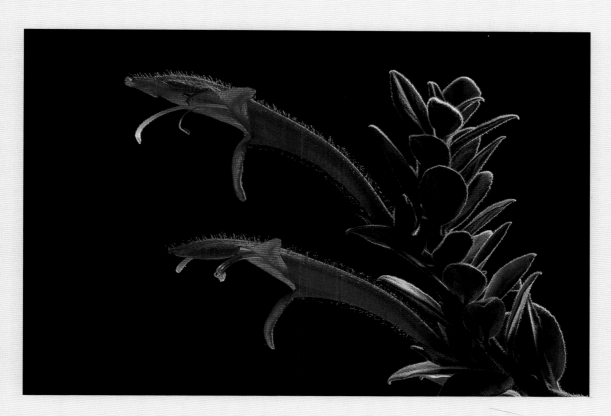

Karl Reitner
AUSTRIA

Steyr, Austria

Minolta XGM Minolta MD 100mm Macro
Fujichrome 50

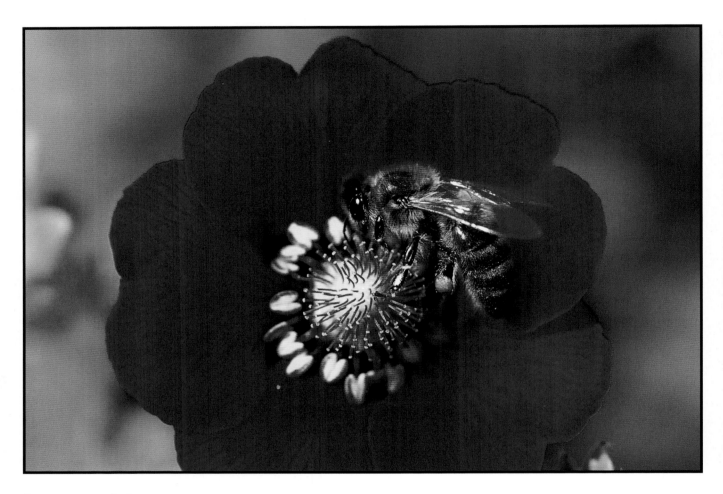

Rosemary Calvert
UNITED KINGDOM

Honeybee visiting
Potentilla flower

Canon EOS10 100mm Macro Lens
1/125 f6.7 Kodak Elite

Rosemary Calvert
UNITED KINGDOM

Spider Lily and
Convergent Lady Beetle
near Houston, Texas

Canon EOS10 100mm Macro Lens
1/125 f6.7 Kodak Elite

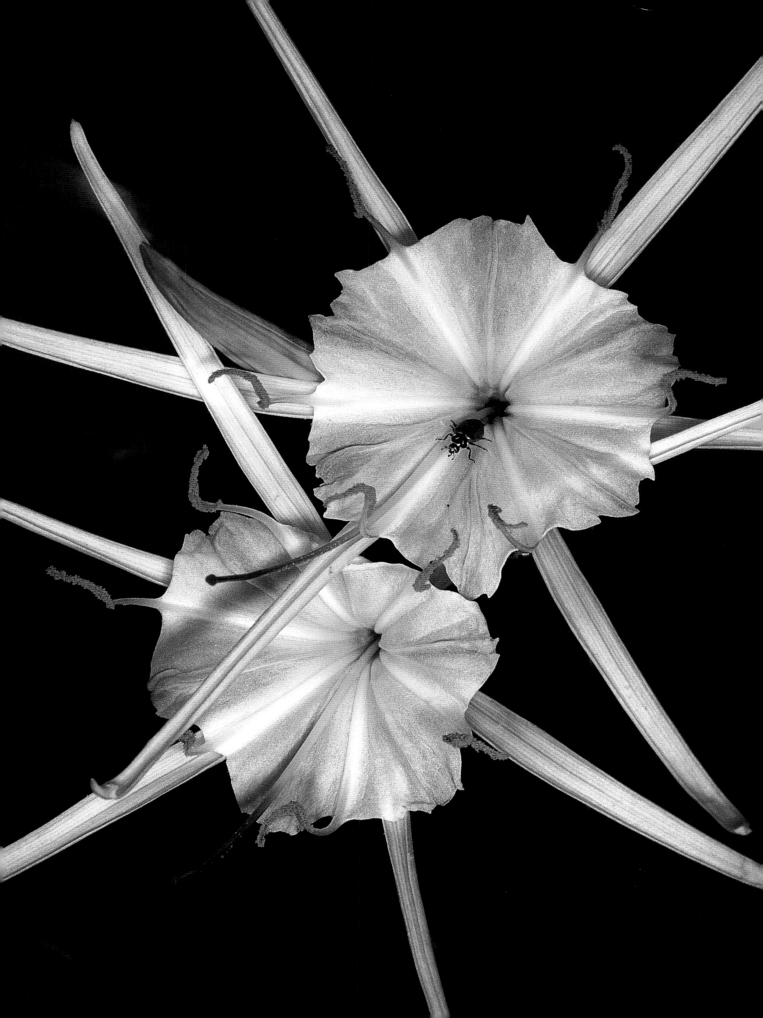

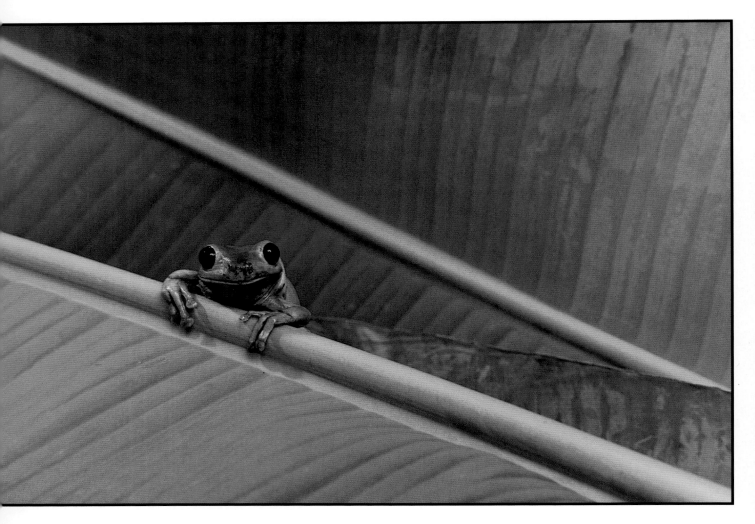

Li Ping Fai
HONG KONG

Studio shot

Hasselblad 503CX Zeiss Planar 120mm
Fujichrome Superia 100

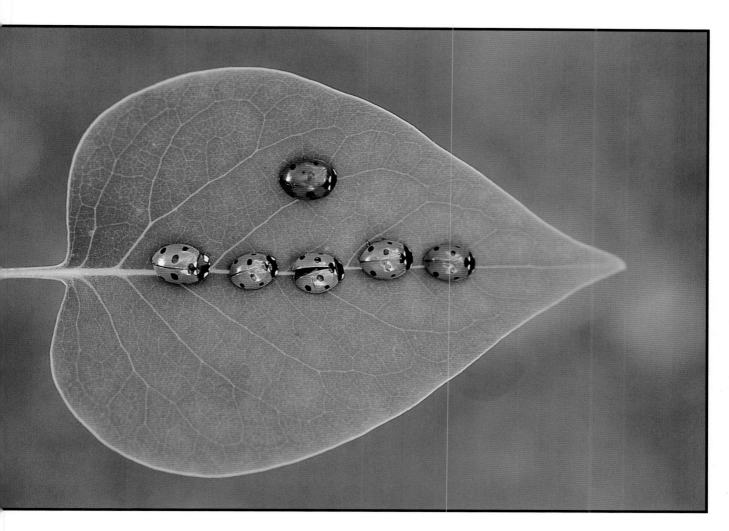

Ilkka Niskanen
FINLAND
Iisalmi, Finland

Canon EOS5 Sigma Macro 105mm
Fujichrome Provia

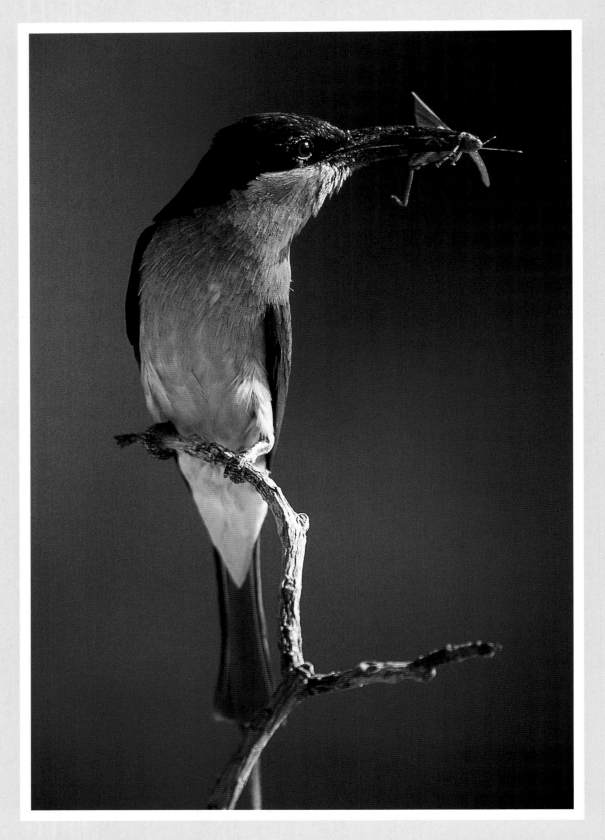

Tien Chian Foong
SINGAPORE

Bee eater

Michael Weber
GERMANY

Sarasota, Florida, USA

Canon F1 Canon 300mm Teleconverter 1.4
Fujichrome Velvia 50

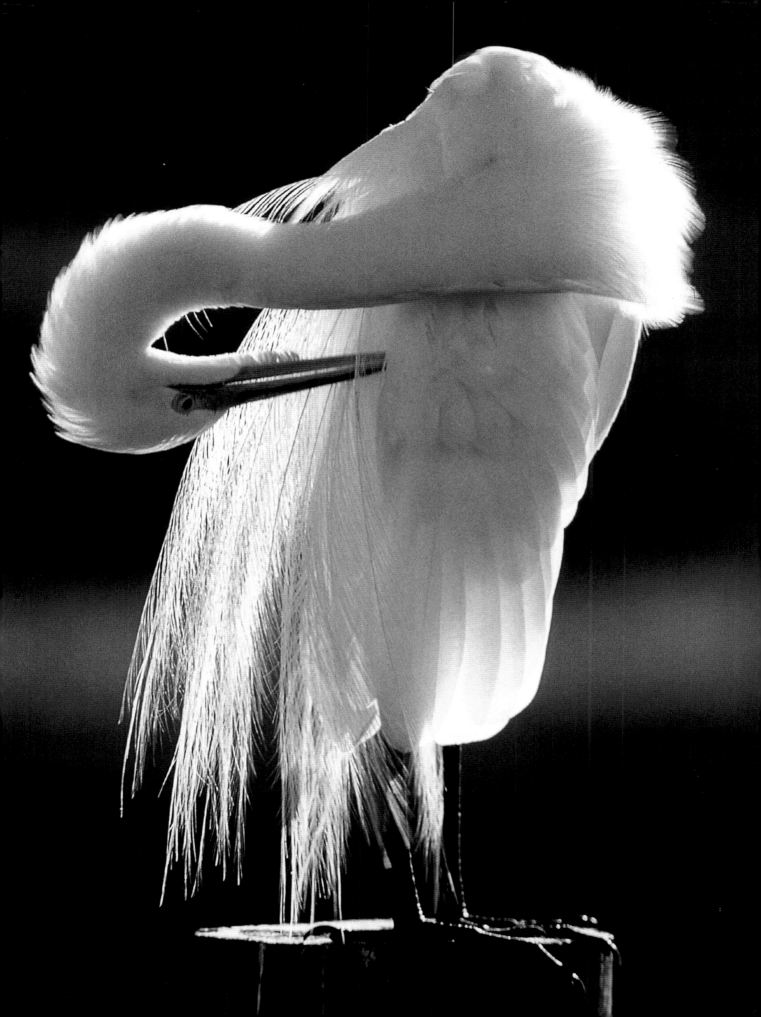

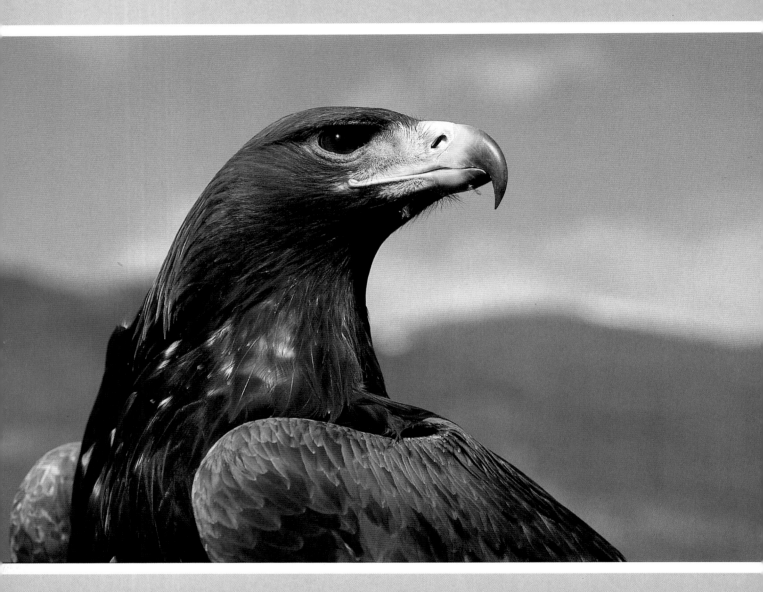

Dietmar Streitmaier
AUSTRIA
Steinadler, Landskron,
Austria

Canon EOS3 Canon 100mm
Fujichrome Sensia

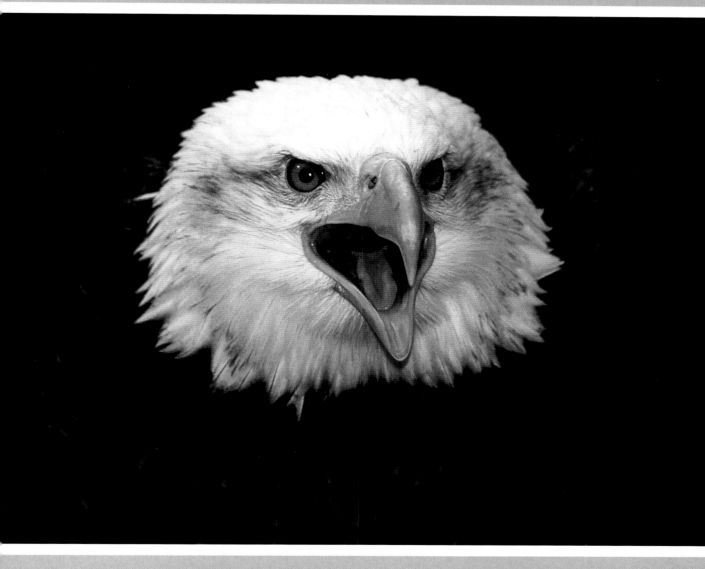

Hugo Strohmenger
GERMANY

White Headed Sea Eagle,
near Coburg, Germany

Minolta 700n SI Sigma 70-300mm
Fujichrome Sensia

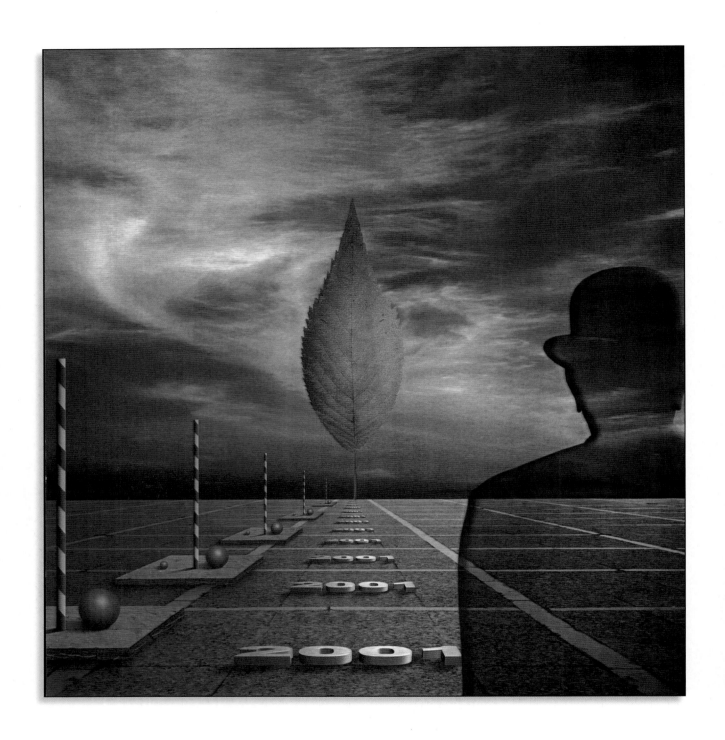

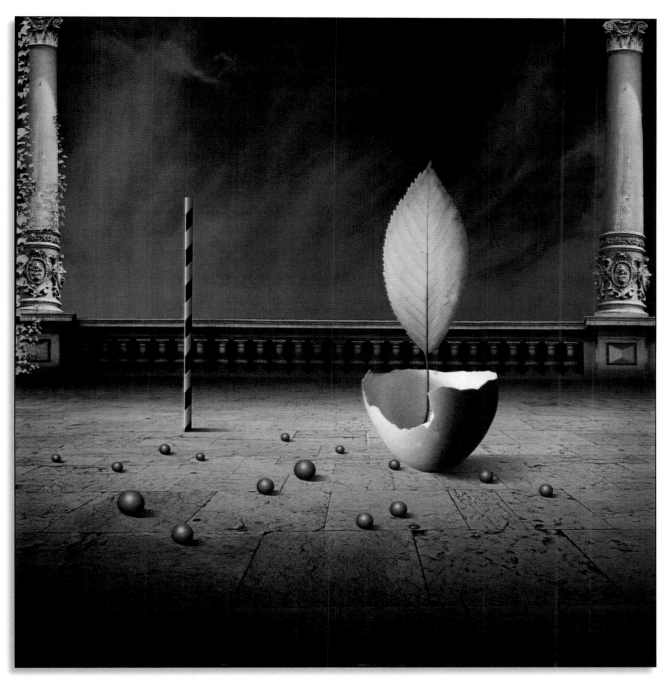

Pavle Jovanovic
SERBIA

Digital Montage

Canon F1 Canon 50mm
Konica 100ASA

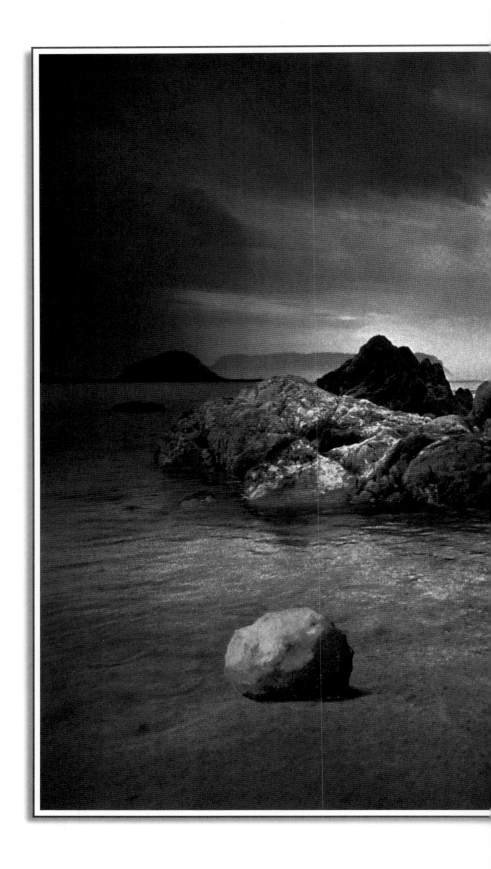

Giulio Montini
ITALY

Sardinia

Minolta 700SI Minolta 20mm
Fujichrome Provia 100

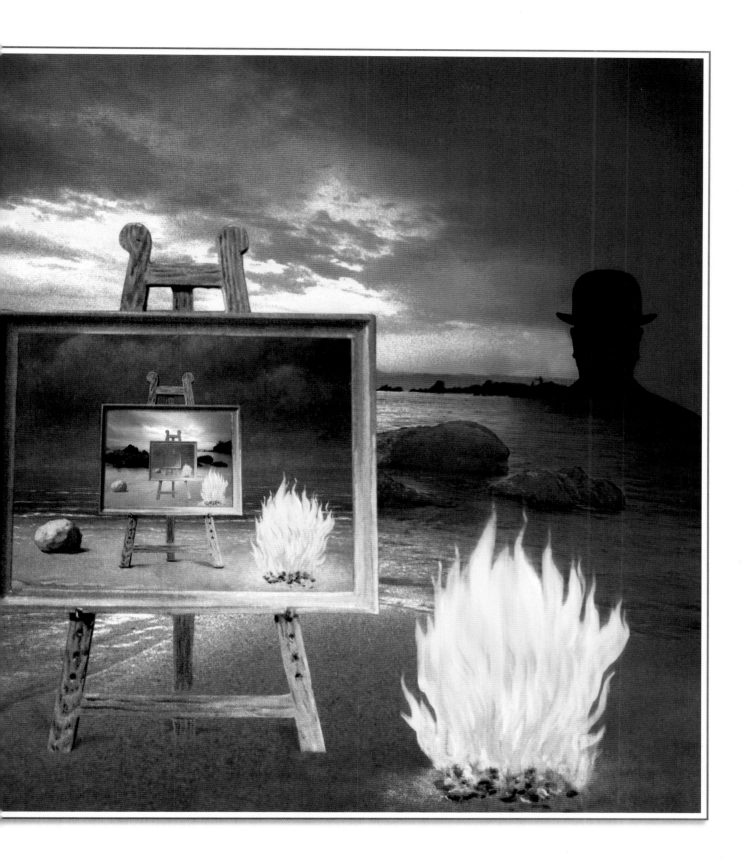

Joseba Ibarra Amor
SPAIN

Hondarribia, Spain

Polaroid SX70 Fixed lens
Polaroid instant SX-70

Joseba Ibarra Amor
SPAIN

Pasai Donibane, Spain

Polaroid SX70 Fixed lens
Polaroid instant SX-70

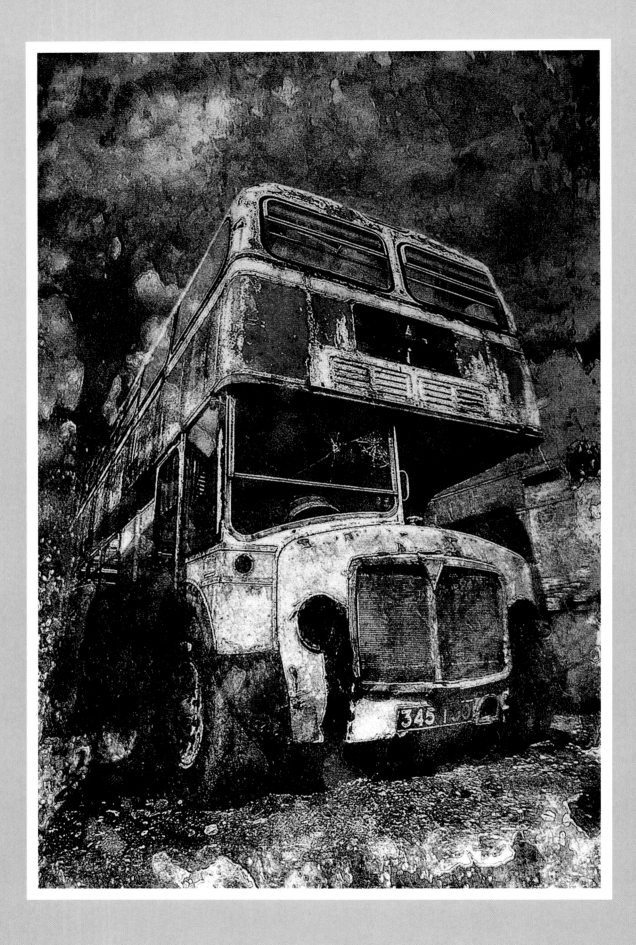

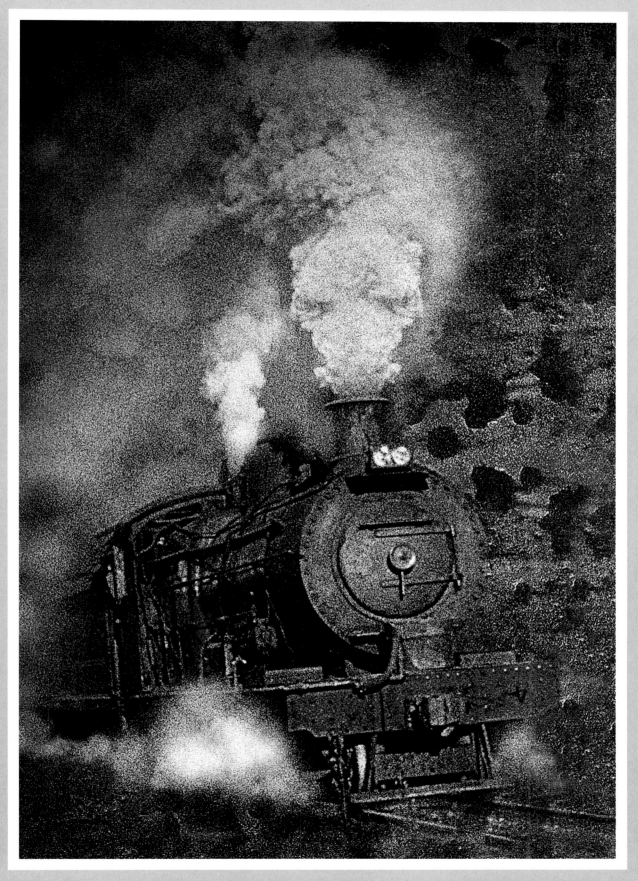

Colin Harrison
UNITED KINGDOM
Canon Kodachrome 64 Digitally manipulated

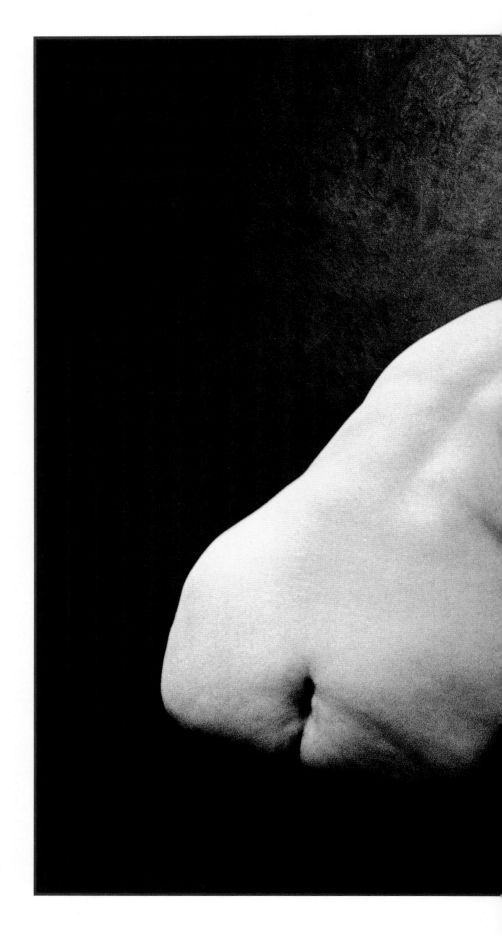

Elena Martynyuk
UKRAINE

Girls

214

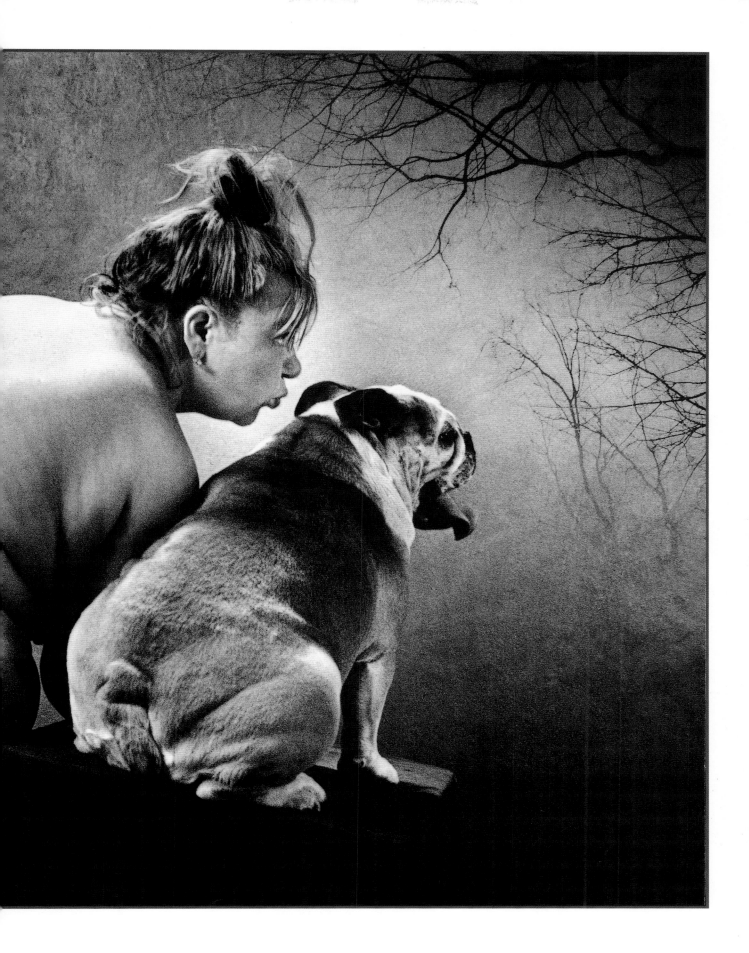

**THE ART OF
CLOSE-UP PHOTOGRAPHY**
Joseph Meehan
ISBN 0 86343 356 1

**THE ART OF
WILDLIFE PHOTOGRAPHY**
Fritz Pölking
ISBN 0 86343 322 7

**THE ART & TECHNIQUE OF
UNDERWATER PHOTOGRAPHY**
Mark Webster
ISBN 0 86343 352 9

**THE ART OF LANDSCAPE
PHOTOGRAPHY**
Chris Coe
ISBN 0 86343 337 5

LEICA IN COLOUR
Paul-Henry van Hasbroeck

This is the only book to illustrate all the Leica screw and bayonet, range-finder models from 1924 onwards in full colour.

160 page hardback with dustjacket
colour photographs throughout
ISBN 0 855667 487 7

PHOTOGRAPHY & IMAGING YEARBOOK
This book presents the most comprehensive selection of photographic and digital images available in one volume.
2000 ISBN 0 86343 333 2
2001 ISBN 0 86343 378 2

**WILDERNESS
LANDSCAPE
PHOTOGRAPHY**
A photographic
journey through
the landscape
Rob Beighton
ISBN 0 86343 372 3

**BEYOND
MONOCHROME**
A Fine Art
Printing Workshop
*Tony Worobiec
& Ray Spence*
ISBN 0 86343 313 8

**Larry Bartlett's
BLACK & WHITE
Photographic
Printing Workshop**
ISBN 0 86343 366 9

**THE NUDE
Creative
Photography
Workshop**
Bruce Pinkard
ISBN 0 86343 39

INFRA-RED PHOTOGRAPHY
A complete workshop guide
Hugh Milsom
ISBN 0 86343 373 1

NATURE PHOTOGRAPHY
A studio and location
workshop
Arnold Wilson
ISBN 0 86343 348 0

**DIGITAL LANDSCAPE
Photographic Workshop**
John Doornkamp
ISBN 0 86343 319 7

PHOTOGRAPHIC HINTS AND TIPS
Photographing
BUTTERFLIES
AND OTHER INSECTS
Paul Hicks

**Photographing
BUTTERFLIES AND
OTHER INSECTS**
Paul Hicks
ISBN 0 86343 332 4

PHOTOGRAPHIC HINTS AND TIPS
Photographing
BIRDS
IN THE WILD
Paul Hicks

**Photographing
BIRDS IN THE WILD**
Paul Hicks
ISBN 0 86343 357 X

PHOTOGRAPHIC HINTS AND TIPS
Photographing
ANIMALS
IN THE WILD
Andy Rouse

**Photographing
ANIMALS IN THE WILD**
Andy Rouse
ISBN 0 86343 362 6

PHOTOGRAPHIC HINTS AND TIPS
Photographing
PLANTS
AND GARDENS
John Doornkamp

**Photographing
PLANTS AND GARDENS**
John Doornkamp
ISBN 0 86343 363 4

PHOTOGRAPHIC HINTS AND TIPS
THE COMPLETE
PHOTOGRAPHER
A complete practical guide to every aspect of photography
Ron Spillman

**THE COMPLETE
PHOTOGRAPHER
A Complete Practical
Guide to Every Aspect
of Photography**
Ron Spillman
ISBN 0 86343 342 X

**MARA-SERENGETI
A Photographer's Paradise**
Jonathan & Angela Scott
ISBN 0 86343 398 7

Jonathan Scott's
SAFARI GUIDE TO EAST AFRICAN
BIRDS
Revised and updated by Angela Scott

Mara-Serengeti
A PHOTOGRAPHER'S PARADISE
Jonathan & Angela Scott

Jonathan Scott's
SAFARI GUIDE TO EAST AFRICAN
ANIMALS
Revised and updated by Angela Scott

**Jonathan Scott's
Safari Guide to
East African Birds**
*Revised and updated
by Angela Scott*
ISBN 0 86343 318 9

**Jonathan Scott's
Safari Guide to
East African Animals**
*Revised and updated
by Angela Scott*
ISBN 0 86343 323 5

**VENICE
Reflections of a City**
Francisco Hidalgo
ISBN 0 86343 304 9

VENICE
FRANCISCO
HIDALGO

Wildlife Photographer
of the Year
Foreword by CHARLOTTE UHLENBROEK
PORTFOLIO NINE
BBC WILDLIFE MAGAZINE & THE NATURAL HISTORY MUSEUM with BG plc

**WILDLIFE PHOTOGRAPHER OF THE YEAR
PORTFOLIOS ONE TO NINE**
Still available

Creative Elements
LANDSCAPE PHOTOGRAPHY – DARKROOM TECHNIQUES
Eddie Ephraums

CREATIVE ELEMENTS
Landscape Photography – Darkroom Techniques
Eddie Ephraums – ISBN 0 86343 397 9

THE REPRODUCTION OF
COLOUR
Dr. R.W.G. Hunt
Sixth Edition

**THE REPRODUCTION
OF COLOUR**
Dr. R.W.G. Hunt
New Sixth Edition
ISBN 0 86343 368 5

**MEASURING
COLOUR**
Dr. R.W.G. Hunt
Third Edition

**MEASURING
COLOUR**
Dr. R.W.G. Hunt
ISBN 0 86343 387 1

IMAGES OF
WILDLIFE
THE BEST OF INTERNATIONAL WILDLIFE PHOTOGRAPHY
Volume One

**IMAGES OF WILDLIFE
The Best of International Wildlife Photography**
Volume One Edited by Harry Ricketts
ISBN 0 86343 367 7

The Nikon Handbook
A COMPLETE GUIDE TO CAMERAS, LENSES & ACCESSORIES
Peter Braczko

**THE NIKON HANDBOOK
A Complete Guide to Cameras,
Lenses & Accessories**
Peter Braczko
ISBN 0 86343 383 9

FOUNTAIN PRESS
Newpro UK Limited, Old Sawmills Road, Faringdon, Oxon SN7 7DS England
Telephone: 01367 242411 Fax: 01367 241124
E-mail: sales@newprouk.co.uk